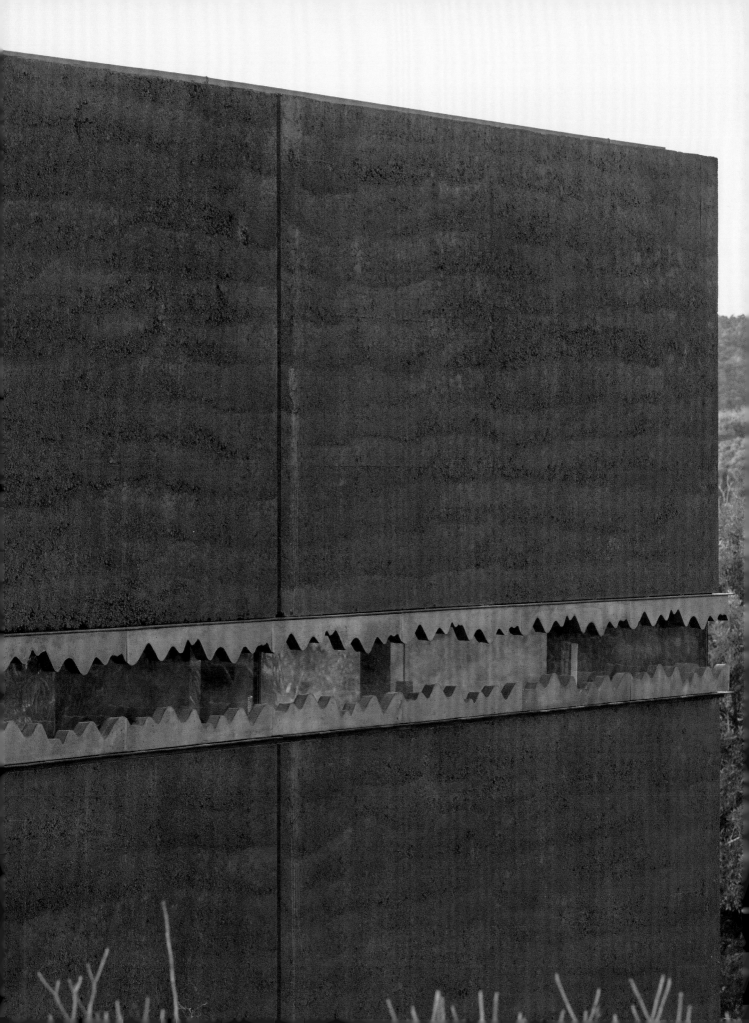

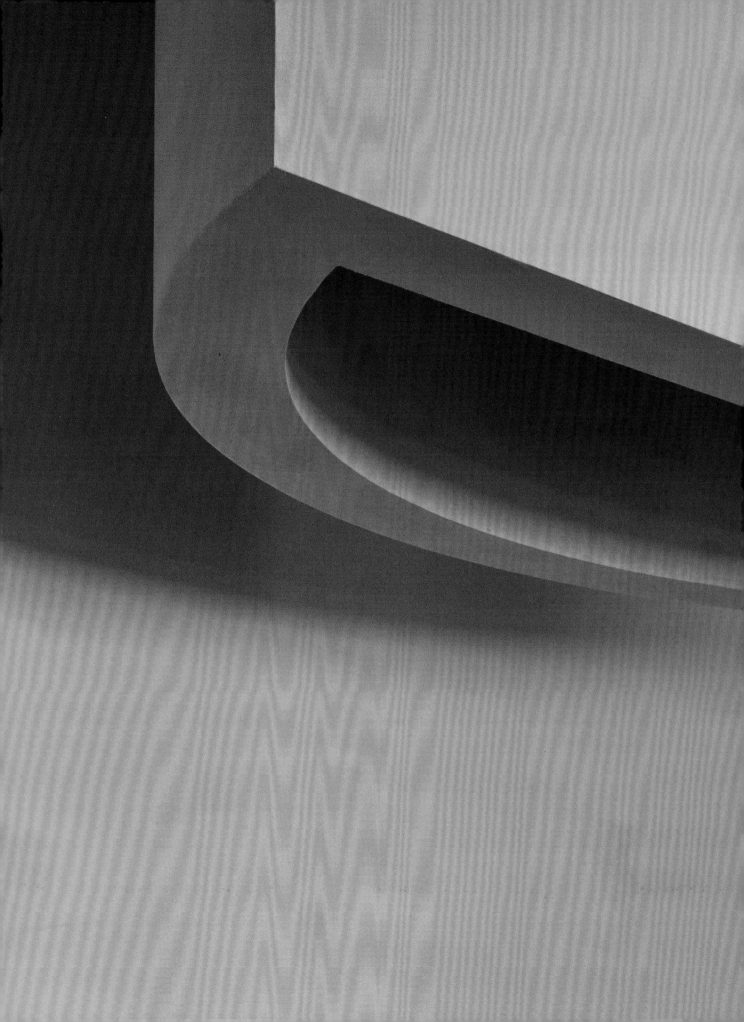

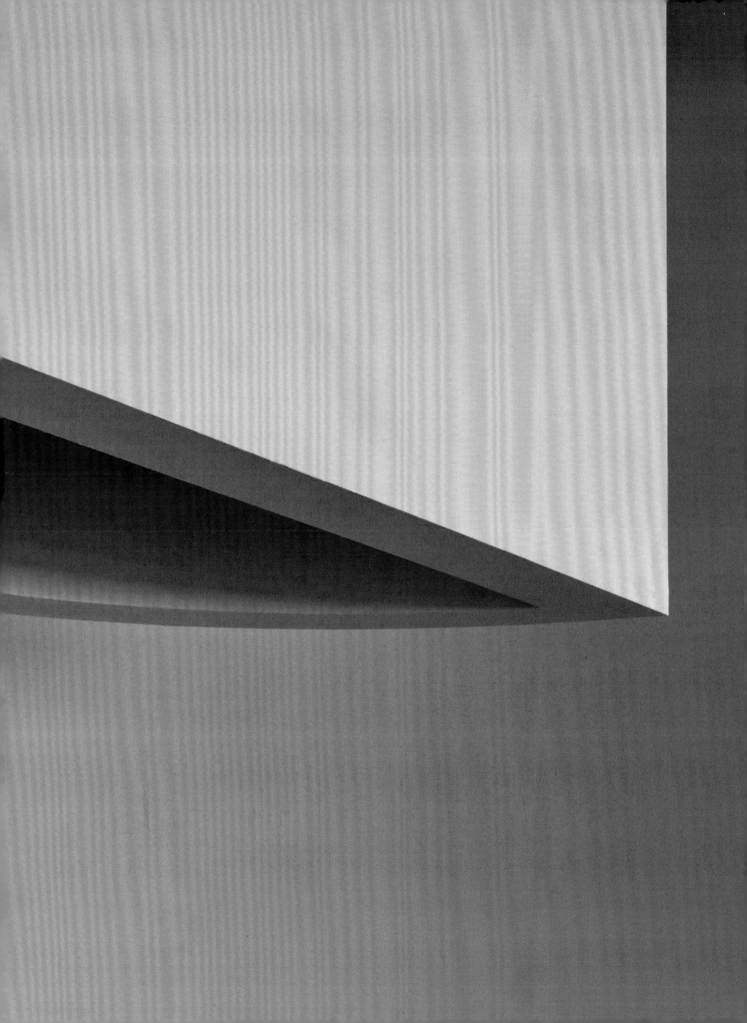

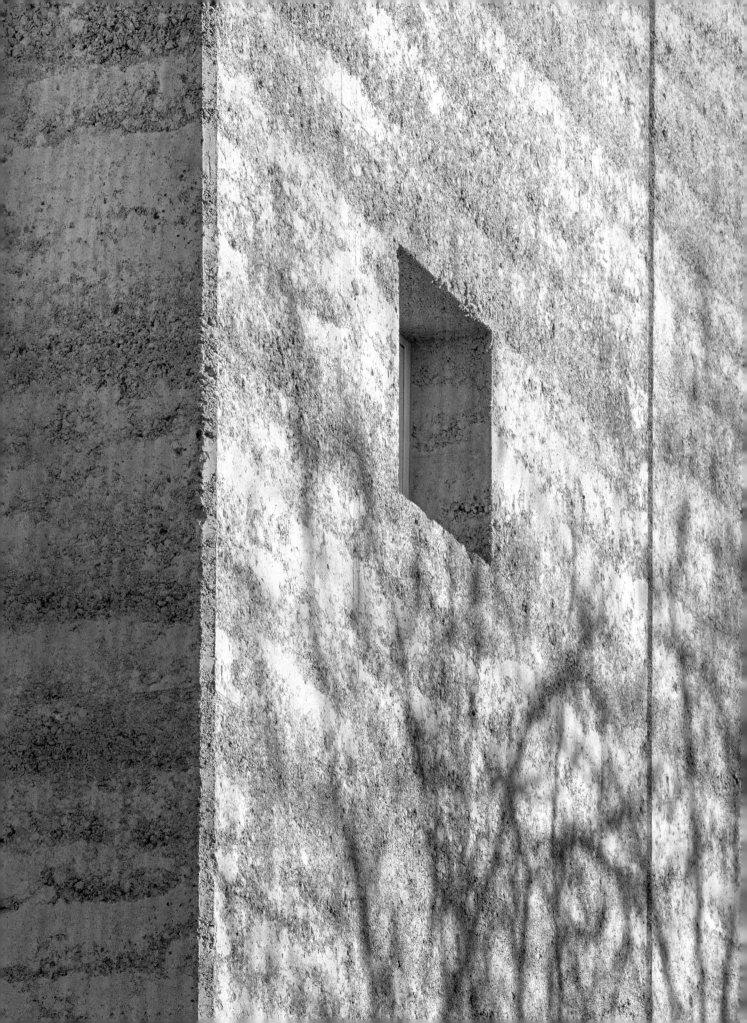

Consolidation

Ideas, process and spatial storytelling

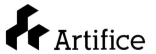

Branch Studio's work has a strong experimental character, seeking a specific identity in each project.

This is a fundamental condition of architecture, a discipline that responds to problems that have to be understood as unique. The liberty in this studio's answers shows a willingness to reflect, starting from each project to achieve results that are translated into various materialities and several coherent formal liberties.

Opposite | Sketches and model in the architects' studio

BRANCH

/

Brad Wray
& Nicholas Russo

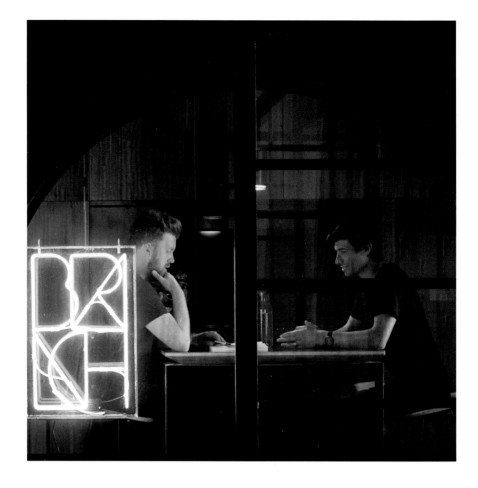

Brad Wray and Nicholas Russo have worked together for ten years. Both were educated at RMIT University in Melbourne, with Wray also spending a year abroad studying at the Accademia di Architettura di Mendrisio in Switzerland. Their design-intensive studio Branch Studio Architects was founded in Melbourne in 2012. A small team of six, the practice creates buildings for a diverse range of people, and they pride themselves on their hands-on crafted approach to every project, no matter how small or large. They find educational projects particularly rewarding. Wray and Russo work collaboratively in the studio in their respective roles as Design and Creative Director and Director of Project Realisation. They have spent the last decade building on the practice's foundations in preparation for the next chapter, for example through their first book, *Proemial*, which was released in 2017. Branch's work has been published extensively, and they have won over 25 local and international awards for buildings that often push the boundaries of client briefs and make the most of limited budgets. Notably, their Piazza Dell'Ufficio reimagining of Caroline Chisholm Catholic College's administration offices in Braybrook, Victoria, won Best Interior Project of the Year and Best Small Workplace of the Year at the 2019 Dezeen Awards in London. Wray and Russo have been guest design critics at a variety of institutions including RMIT and the University of Melbourne. In 2017, they were invited to lecture at the Shelter: Redefining Refuge symposium at the School of Architecture at Taliesin West in Scottsdale, Arizona. In 2020, Wray was invited to lecture at the National Gallery of Australia in Canberra as part of the esteemed Contemporary Australian Architects Speaker Series.

CONTRIBUTORS

Peter Clarke

Peter Clarke is an Australian architectural photographer with over 20 years' experience in the field, during which time he has extensively documented the built environment, as well as natural and manmade landscapes. His collaborative approach and strong vision have seen his unique graphic style gain recognition both locally and internationally through various media and exhibitions. His work was recently featured in the group exhibition "1 Shot 22: Defining Moments In The Built Environment", curated by the Image Makers Association Australia, showcasing the work of Australia's most celebrated architectural photographers. This new organisation – of which he is a strong advocate – represents professional and emerging photographers in Australia and works to protect and promote their rights through education and industry connections. He currently collaborates with many of Australia's most prominent and creative architecture and design practices, including Branch, for whom he has been documenting projects for over eight years.

Conrad Hamann

Conrad Hamann, BA Hons, PhD, Hon. FAIA, was born in 1951. He gained degrees in History and Art History at Monash University in Australia, then further pursued his studies in the United States as a recipient of a Harkness postdoctoral fellowship, attending Columbia and Yale. He is currently an Associate Professor of Architectural History at RMIT University in Melbourne. His extensive wealth of knowledge in architectural history, both locally and globally, has made him an important voice in Melbourne's architectural community for over 50 years, increasing understanding and appreciation of architectural heritage. His published works include *History of Australian Architecture Part 3: 1901–45* (Educational Media, 1985); *Kevin Borland: Architecture from the Heart*, with Doug Evans and Huan Borland (RMIT, 2007); and two editions of *Cities of Hope: Australian Architecture and Design by Edmond and Corrigan, 1962–92* (Oxford University Press, 1993, and Thames & Hudson, 2012).

Michael White

Michael White is an architect based in Melbourne, and the co-director of Freadman White Architects, the practice he founded in 2010 with co-director Ilana Freadman. He completed his Master of Architecture degree at RMIT University in Melbourne in 2005, and earned a PhD in Architecture from the city's Monash University in 2010. He is dedicated to the profession, and Freadman White has gained acclaim and a significant reputation throughout Australia and abroad. Their work has been extensively published and recognised through numerous awards, including the Australian Institute of Architecture National Awards in 2020 for their multi-residential projects at Whitlam Place and Napier Street in Fitzroy. For Freadman White, architecture encompasses more than just the built form. Their designs prioritise the human response to architecture, emphasising the experience and atmosphere it creates. Their thoughtful approach considers modulations in light and shade, proportion, function and flexibility. These are expressed through uncompromising construction, enduring materials and a minimal yet warm aesthetic, ultimately aiming to evoke a profound and positive human response.

Stephen Varady

Stephen Varady is a practising Australian architect with 40 years of experience, and a writer, competition advisor and educator. His practice, Stephen Varady Associates, has designed projects in Australia and overseas, and organised some of the most successful architecture competitions in Australia. He received a Bachelor of Architecture degree with honours from the University of New South Wales in 1987. In 2002, he earned a Masters of Architecture degree from RMIT University in Melbourne. He is recognised as an advocate for design excellence. His writings have been extensively published in Australia and overseas, and his projects have also been featured in publications and exhibitions including in Berlin in 2007 and the Venice Architecture Biennale in 2008. He has been a lecturer and tutor in architecture and professional practice since 1985, teaching at various architecture and design schools in Sydney, Melbourne and Newcastle. He has curated the Australian and International Brickworks Architecture Speaker Series, and served as the Creative Director of the Royal Australian Institute of Architects (RAIA) National Architecture Conference in 2006.

CONTENTS

PROJECTS

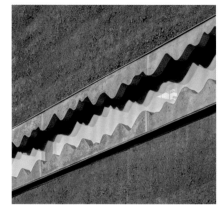

IN CONVERSATION

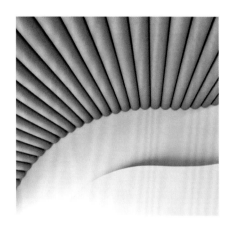

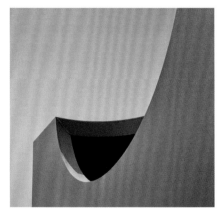

ESSAY

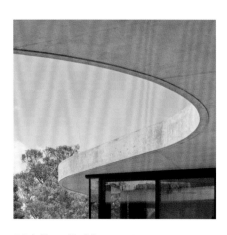

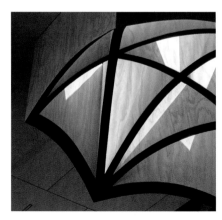

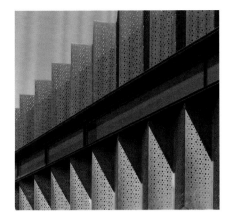

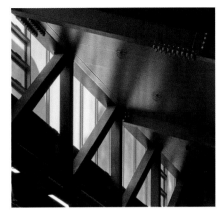

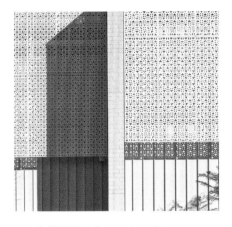

INTRODUCTION
/
by Stephen Varady

What is architecture? This is a significant question, and one all architects should address early in their career, although many don't realise how important it is to do so. The answers will differ depending on the architect, and their location in time and place.

Branch Studio address the question repeatedly and sensitively with every project. What is the architecture we are creating? How does this project relate to our ongoing approach and thinking? How do we infuse this project with ideas and narrative? How does our architecture fit within and/or lift the surrounding context? How do we layer the project with far more than what the brief has asked for? How can we design something that will enrich the lives of all who encounter it? How does our architecture engage with the depth and breadth of all architecture?

They explore the fundamentals of architecture – form, material, place and experience – interrogating them appropriately for each project, depending on client, brief, site and budget.

Branch Studio also explore light, the other fundamental tool of the architect, in their work, paying very specific attention to its qualities: natural and artificial, or direct and reflected. The questions they ask reveal a deep understanding of light's importance, and the role of shadow, its twin. How will light be used to create the place? What part does light play in the experience? How will light help shape the form? How will the materials be affected by light?

MAKING PLACE

The making of place and how each individual user of their architecture will experience it appear to be the drivers for all Branch Studio's projects. Although they use geometry as an important tool when creating their designs, I contend that although geometry is fundamental to form-making in their projects, form-making per se is of less importance than making a place through the use of that geometry. In some projects, such as ARCO and Piazza Dell'Ufficio, Branch Studio even create place where no place existed before.

With ARCO, the bland entry to Sacred Heart Catholic Primary School in St Albans, Melbourne, has been transformed into a place of wonder. The architects' imagination used geometry, with allusions to architectural and historic precedent, to deliberately conjure a place to spark the imaginations of the schoolchildren and carry them beyond the everyday. They have created a positive space within which to shelter, to linger, to view from, to view into, and to enrich the spirit. The material used, plate steel, has been understood structurally and used economically to form a self-supporting structure that is far more impressive than the budget might have suggested would be possible, and in a way that lifts the entire project to another level. Intelligently poetic!

In Piazza Dell'Ufficio, to quote the architects themselves, "the existing conditions were a rabbit warren of bad disproportional and singular office spaces that offered no positive form of human interaction for staff members or between staff and students". Given the directive to improve these spaces, Branch Studio studied the traditional piazza to inform their thinking for the design.

The existing office plan lacked a geometry conducive to creating such a space, so in the same way a stage set may not contain a faithful recreation of a "real" place, an inspired creative dexterity has been employed to shape the plan just enough to allow for a piazza-type feel to the finished spaces. Open, informal spaces link to more closed, private areas through the use of piazza-like vinyl floor patterns. While columns have been used to connect these spaces, they do not mimic any kind of historic colonnade but rather take the form of a cross between colonnade and curtain, creating a wonderful illusion of a piazza. The illusion is made especially impressive by the fact that the columns are merely inexpensive

Opposite | Placemaking device – central clock tower, Piazza Dell'Ufficio

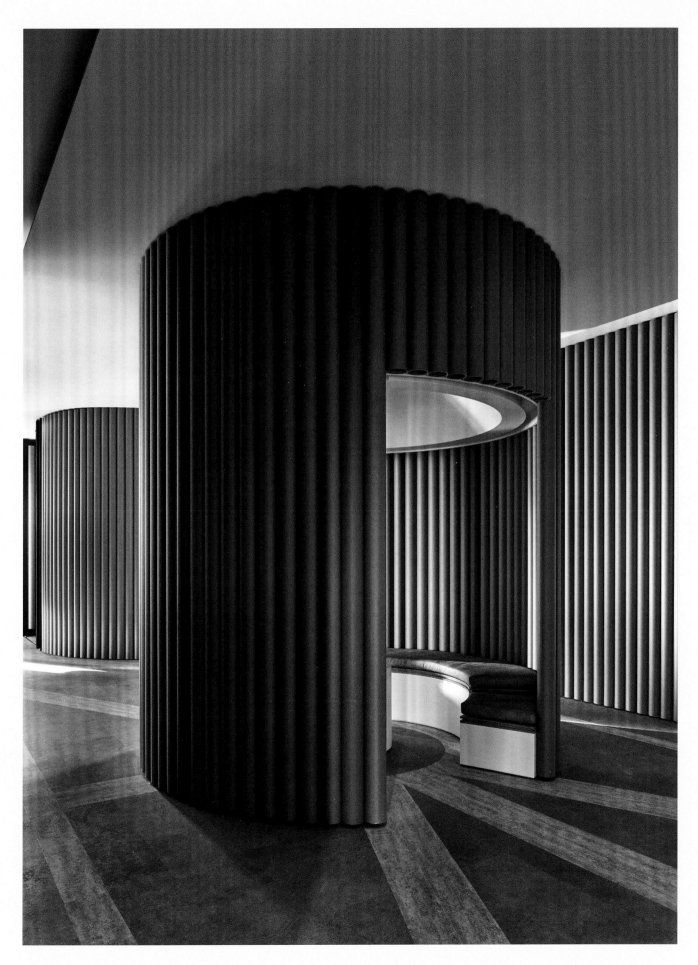

CONSOLIDATION

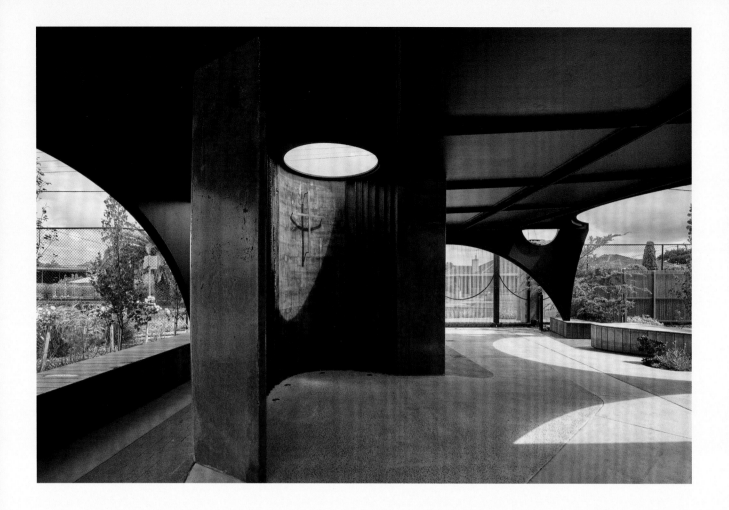

cardboard tubes – and how inspiring that sleight of hand will be upon the young students' imagination! Branch Studio have once again created a place out of "no place", with an effect both sensual and uplifting, which is quite a feat.

Branch Studio frequently reference the great architectures and public spaces of the ancient past, and analyse and assess the ways their richness relates to each of their own projects. For the Flyover Gallery project at Caroline Chisholm Catholic College in Braybrook, Victoria, the Ponte Vecchio in Florence became a prime reference, particularly the idea that a bridge can be more than a connection from one side to the other; that it can contain built elements and multiple functions. Tasked with enclosing an existing walkway from the school's Art Wing to the Science Wing, they seized the opportunity to create something unique for the students and turned it into their own artistic version of a multi-layered bridge.

Externally this structure is a simple façade of folded metal on both sides, but internally it has been given depth and complexity. The existing width was manipulated to create a seat on one side and display cases on the other. The sectional complexity alludes to cave-like spaces, but results in a combined, light-filled meeting place, gallery space and learning place. Branch Studio's collective interest in the arts and artists means the practice constantly explores and re-evaluates the connection of art to their architecture. In this project, they referenced the work of American artist Christopher Wool to create the pattern of holes in the metal and the frit pattern on the glass, both times playing with light and shadow to enrich the building.

For the GPFLA Learning Centre at St Francis Xavier College in Beaconsfield, Victoria, geometry was again at the centre of the planning process. An exploration into breaking the traditional classroom into something better and more flexible

resulted in a seemingly simple, repetitive square pattern. This was subsequently developed into a complex three-dimensional interrelationship between spaces, where larger and smaller classrooms connect and intersect with other classrooms and overlook the larger teaching/learning spaces. This three-dimensional complexity allows a large building to be broken into a composition of harmonious smaller elements, creating a more sensitive relationship with the existing school buildings to the north and presenting a less monolithic face to the adjacent railway line to the south.

While the Giant's Causeway in Northern Ireland may have been their initial inspiration, the landscape elements contain the same geometric DNA of the GPFLA building and are as important as the building itself. The final platforms, steps and gardens create a rich, cascading interface of concrete, timber and planting between the old and new buildings.

Finally, external metal screens imprinted with an abstraction of the repetitive square pattern of the classrooms create a gentle veil over the façade, making the entire building feel much richer than its basic construction elements of concrete, block and metal sheeting. While the veil is apparent internally, it also casts a wonderful filigree of light and shadow across the walls and floors, moving and changing throughout the days and seasons.

This project successfully elevates the experiences of the students, and I can only wonder about how this combination of geometry, landscape, materiality, light and shadow will make their day-to-day activities more exceptional. One has to admire a design that, through such a rigorous repetition of pattern, still results in a sensitive and positive learning environment.

"I can only wonder about how this combination of geometry, landscape, materiality, light and shadow will make their day-to-day activities more exceptional"

MATERIALS AND JUXTAPOSITION

There appears to be a joy in Branch Studio's approach to materials – how they look, how they feel, how one is juxtaposed against another. They also do not fear balancing frugality with beauty. In fact, they strive to make the most banal concrete block sing against a patterned metal sheet, or a finished timber grain shine against a bare concrete wall.

The Pavilion Between Trees extension to the house in Balnarring is a beautiful example of this sensual approach to materiality, but it is also a showcase of Branch Studio's juxtapositions – of materials, place, light/dark, rough/smooth, internal/external views – and an extremely sensitive exercise in spatial compression/expansion. This house extension appears to be a building; just a rectangular box with a sliced end and an indentation to accommodate a tree. However, it is far more complex than that and its series of interior spaces need to be experienced in person to be fully appreciated. It is only after carefully studying photos and drawings that I began to appreciate the spatial changes and the overall subtleties of the architecture.

This is the kind of thinking that permeates all of Branch Studio's projects: sensitivity, sensuality and subtlety, and the practice keep pushing themselves ever so gently, to revisit, refine and improve the language they have created.

The House With Earthen Walls in Hepburn Springs, Victoria, builds upon this approach, once again exploring materials and juxtapositions. A heritage cottage in need of improvement has been altered and extended on two sides with an evolution of the design language used in the Pavilion Between Trees, but this time adding to and including the existing house within the design. The composition of a black concrete blade wall, a white concrete box and a brown timber-clad element with a splayed glass wall wraps around those two sides of the existing cottage. This rejuvenates the original, creating new volumes of experience provided

through explorations of compression, openness, light, dark, small openings, large openings, timber, concrete, glass, and even a touch of lyricism with a squiggly concrete aperture through which to view the distant landscape.

NARRATIVE AND FORM

Branch Studio describe their love of narrative, and how that drives their design approach for each project. The idea and the narrative are a vehicle to allow them to structure the project, to bring form to their design. But those ideas and narratives don't overwhelm the completed buildings and, in the end, it isn't really necessary to know what they were to be able to engage with the building.

For the Arts Epicentre at Caroline Chisholm Catholic College, Branch Studio had a clearly articulated goal: "to provide a real landmark for the college and build a public interface with the local community. From its inception the project was treated as a public building similar to that of a public performing-arts centre rather than just a distinct college campus school building." The architects had great ambitions for the project, and have also sought to imbue the building with a delight that similar school buildings seldom possess. With overlapping spaces and uses, the Arts Epicentre leans into the potential of theatricality with black curtains and stairs, small splashes of colour, and transitions from dark to light spaces. The German architect Hans Poelzig's 1919 Grosses Schauspielhaus (Great Playhouse) theatre became the inspiration for the skylight shades while the patterns of old pianola music rolls inspired the design of the external metal screens. The goal of creating something more civic than the average school auditorium was achieved, in the form of a school building to spark every student's imagination.

> "The architects had great ambitions for the project, and have also sought to imbue the building with a delight similar school buildings seldom possess"

In some ways, Branch Studio's Multi-Purpose Hall at Caroline Chisholm Catholic College has been infused with some of the theatricality of their Arts Epicentre. The black interior with its crisscrossing structure and ceiling immediately strikes the viewer. As in the theatre, darkness focuses attention upon the action within the space rather than on the building, and the players become the performers – which any sporting team is to the spectators of a game. The fact that the space will be used for a multitude of other purposes further justifies this approach.

Overall, the straightforward, initial architectural moves of a single box with an oversized overhanging roof, kicked-up highlights and a simple, robust exterior align with the building's required functionality, and these elements have been assembled with great dexterity and sensitivity. Light and dark – translucent polycarbonate, glass and pale concrete meet black beams, walls and ceilings – are successfully combined to achieve Branch Studio's ambitions to evoke Structuralist precedents, including the influential 1956 Melbourne Olympic Swimming Stadium.

CHALLENGING AMBITIONS

It may be worth reflecting on the balance of projects in this book: three houses, seven school buildings and one competition entry. Seventy per cent of Branch Studio's built work is school buildings. I would suggest, in a very positive way, that this is an unusual balance of projects for a young practice, barely ten years into their career. And these are not ordinary, generic, formulaic buildings. Despite the tight budgets, each project is still very specific to its task. Branch Studio have not been daunted by the budgets or the scale of these buildings, and have managed to create delight with an incredible frugality. Each one is designed to be a special, carefully crafted, uplifting place of wonder for the students and staff, enhancing the potential joy of learning for students and all who enter by means of an inspiring, positive built environment. Branch Studio's desire to "give more" to the students has been a very conscious goal, but they have also been blessed with the support of enlightened and extremely supportive clients – particularly

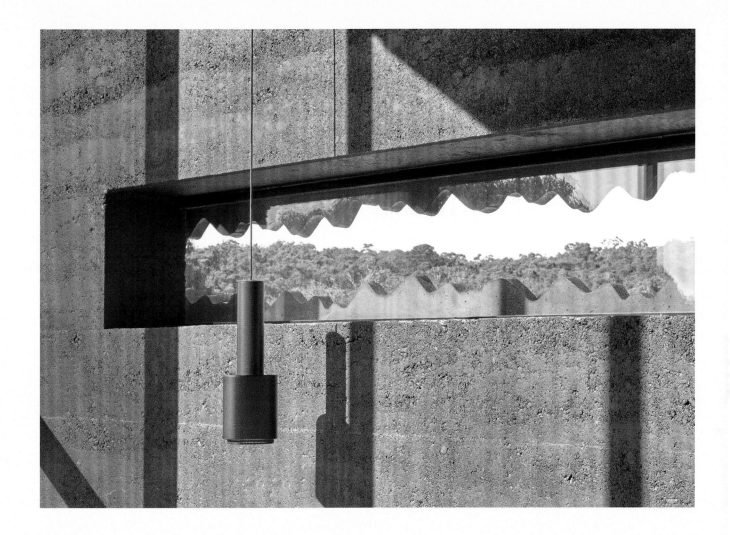

Above | Dialogue with landscape.
Bedroom interior with horizon window
House With Earthen Walls

Caroline Chisholm Catholic College and St Francis Xavier College – who have continued to work with them on multiple projects, each time building on their knowledge, and further challenging their ambitions.

WHERE TO FROM HERE?

The works of Branch Studio showcased in this book demonstrate the generosity and positivity of these architects, both in their design approach and in how they continually endeavour to inspire others through their work. The strength of their ideas, layering of narratives, richness in materiality, sensitivity of detail, and their never-ending search for the experiential to make every place they design more special, poetic and uplifting must be celebrated. In answer to my initial question: this is what architecture should be.

Branch Studio appear to be greatly inspired by the small European atelier practice model rather than by the larger corporate American practice model. They have no ambition to become a large practice, although they do want to design all types of projects, both small and large. Brad and Nicholas care about being fully engaged with each project, being immersed in each design: making, sketching, and working hands-on while making the large and small decisions themselves rather than simply managing others to do so.

As is shown by this book, they are already successfully doing just that – and all within just a decade. They have shown that you don't need to be a large practice to do larger projects in Australia, and that you don't need to sacrifice deeper design ideals or relinquish control over detail, materiality and the overall experience to do so.

IDEAS, PROCESS AND SPATIAL STORYTELLING

/

by Branch Studio Architects

When we talk about ideas in relation to our buildings, we are referring to something more profound than a passing catchphrase or a reference to their formal character. An idea is what we believe turns the making of buildings into the architecture of fine art, moving it away from the "marketplace of architecture".

We approach each project with a driving idea or series of ideas which underlie the project's fundamental fabric. Often the driving idea can begin with a quite whimsical line of thought, an image, or other source of inspiration; or sometimes ideas derive from a more theoretical or analytical perspective. Nevertheless, it is imperative to us that each project has its own identity and meaning that can in some way link its inhabitants more comprehensively to their environment, place, and – importantly – to a moment in history and time.

We deeply respect the history of art and architecture, and strive to create a dialogue with it in our work.

We want our buildings to transcend the physical and become an experience which has links to something far deeper. A great building can often be measured in both the physical and humanistic effect it has on its viewers and inhabitants, and the fact that such an experience can have an effect on our psyche, a deeper emotive experience, is important – great buildings have a soul. As Swiss architect Peter Zumthor said during his "Atmospheres" lecture in June 2003, and in its subsequent publication: "Quality architecture to me is when a building manages to move me."[1]

Louis Kahn also described this most important quality in his "Silence and Light" lecture of 1969 at ETH Zürich: "It brings to mind the difference between the garden, the court and a piazza. Because your connections are not going to be just colonnades and that sort of thing, it's going to be mental – the connection. You're going to feel it in some way."[2] There is something wonderful about walking into a space, or through a sequence or series of spaces, and the experience becoming a moment of discovery. Every time we return, more of the idea, more of the heart and soul of the building, reveals itself.

For us, in many ways, this philosophy has launched us on a journey into history. We see the importance of the town piazza, or the arcade or the Roman amphitheatre as architectural forms which we think are still highly relevant to thinking about contemporary space. Not in the sense of replicating nostalgic fragments of postmodernism, but as strong architectural devices for mediating complex conditions of the contemporary world. Our Pavilion Between Trees residential master suite celebrates Pompeii's ancient bathhouses. The Piazza Dell'Ufficio office square uses the concept of the Italian piazza to break down barriers between staff and students. ARCO uses a medieval city archway to inform a school entrance pavilion. The Flyover Gallery references the Ponte Vecchio in Florence to create a link between two school departments, and provides an example of how programme can be injected into a bridge structure.

Our process relies heavily on the strength of an idea. Our ideas are not necessarily consequential to a specific material and certainly not to a budget. Materials are hugely important to us as enhancers of an idea, but if the strength of the idea is strong enough, it should read true no matter how it is materially expressed in reality.

For us, process is about a way of thinking – primarily about space, with a strong sense of optimism, looking analytically but also beyond the pragmatics and specifics of the client brief to find something more in what might be just another design exercise for others. For example, in the case of the Flyover Gallery, our client came to us with an exclusively pragmatic brief to enclose an open breezeway, essentially creating an outdoor corridor. The process for us was not about "corridor". It was about linking and transitional space and,

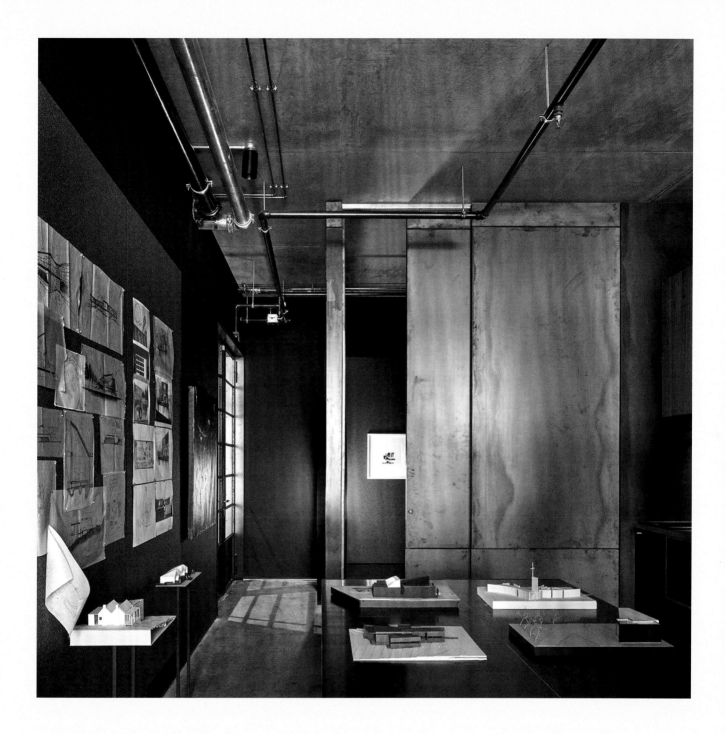

Above | A place for ideas and exploration. The architects' studio

as Kahn called it, "a place of happening".[3] The linking of an existing science department at one end with an existing arts department at the other end became the linking of the disciplines of science and art.

The idea took the form of a geological cave injected with art: a cave in section with art boxes embedded into walls. The result was an existing corridor transformed into an art gallery. The idea is constructed in plywood. It would have been wonderful to construct it in formed concrete, but the budget simply did not allow for it. However, the idea was strong enough that it could have even been rendered in white plasterboard if necessary, and been just as successful.

The consolidation of these ideas, thinking and process in the evolution of our work has been ten years in the making and continues to develop further with each new opportunity we undertake as a practice.

CONSOLIDATION

ENDNOTES

1. Peter Zumthor, *Atmospheres: Architectural Environments, Surrounding Objects*, Birkhäuser (Basel), 2006, p 11.

2. Louis I Kahn, *Silence and Light*, Lecture at the Department of Architecture, ETH Zürich, 12 February 1969, edited by Alessandro Vassella, Park Books (Zurich), 2013, p 33.

3. *Ibid*, p 35.

Project	A PAVILION BETWEEN TREES
Type	Residential
Location	Balnarring, Victoria, Australia
Project duration	2015–16

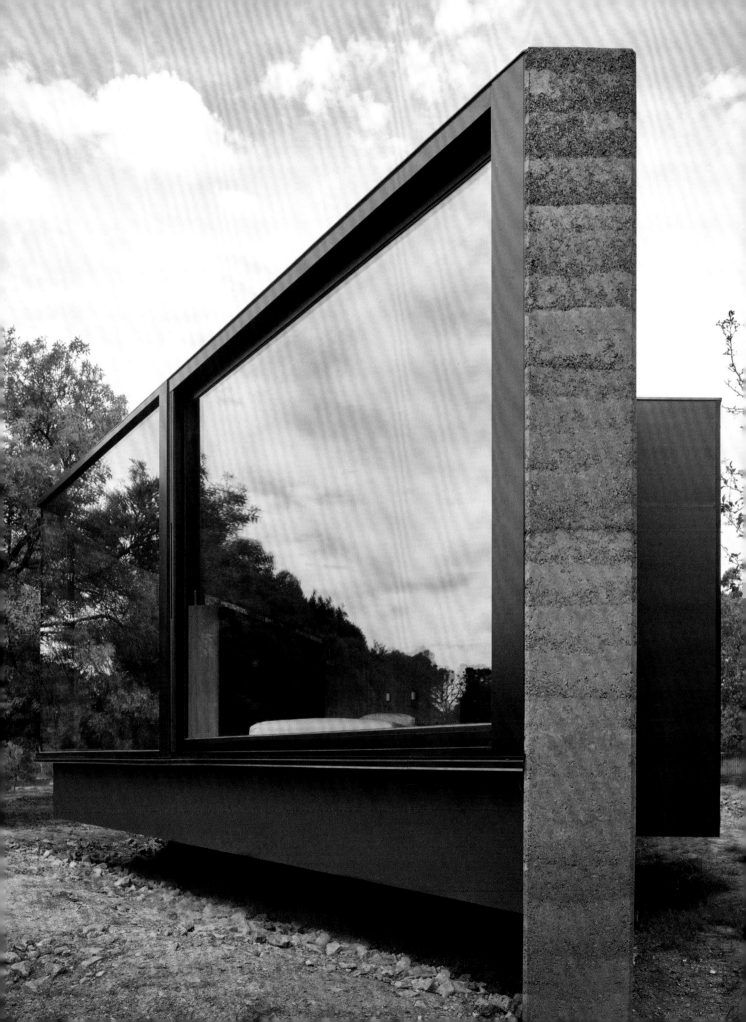

When presented with the opportunity to design a master suite for an existing 1990s owner-build inherited property, it was exciting to discover a number of established trees irregularly spaced across the proposed site immediately to the west of the building. The clients' brief called for a bedroom, an en suite and incorporated wardrobes/ancillary spaces, and a strong connection to the surrounding garden areas and landscape. The design strategy was to create a semi-detached pavilion with its own identity, providing private spaces with a sense of calm and intimacy away from the open-plan family home.

It was decided early on that the trees on the site would not make way for the new building; rather, the concept would explore a more meaningful relationship with the landscape by having the building interact with them. A slender form fits between the trees and links three distinct programmatic areas linearly, with an overall modernist aesthetic. Deliberate formal gestures reference the existing context, including a small courtyard space to house an established silver birch tree. The courtyard separates the bathroom and bedroom areas and provides seating for relaxation. Two extruded window boxes interact with the trees, and the angular slice to the end of the pavilion orients it towards a view corridor through existing vegetation, towards the setting sun.

Entry to the pavilion is via an extended central corridor from the main house. This "boardwalk" splits the en suite areas into two distinct spaces before becoming two circulation paths around a central arrangement of joinery that defines and divides the wardrobe areas. Gradual floor-level rises are achieved by a series of ascending platforms that divide the spaces across the building's length.

The "bathing" area features an indoor and outdoor shower and a bath on the internal-external building line, connected to a narrow external courtyard and on to the garden via full-height folding glass doors. A half-height rammed-earth wall and steel mesh screen give privacy without interrupting the views of the treetops and sky.

The wardrobe areas float just above ground level with direct links to the landscape. "Hers" incorporates built-in seating arranged around the silver birch/courtyard, with a long integrated seat/dresser anchored to the rammed-earth wall. "His" has clerestory windows above the joinery through which canopy trees provide filtered northern sunlight. The extruded window box provides an open and transparent seating space within an otherwise private "locker room" type space.

The bedroom unifies the separate zones, the central joinery "forest" that previously divided the wardrobe zones becoming a low-height bedhead. Built-in cabinetry encloses the area with informal seating and day-bed areas. A second, higher and larger window box extrudes from the solid rammed-earth wall. This, and the "point" of the space, where full-height glazing slides open above seating, provides a unique vista of the orchard, stables and trees beyond.

The external material palette of charcoal rammed earth, timber, steel and glass is left natural and raw in response to the rural context, and is designed to weather and patina over time. Internally, charcoal rammed earth, timber and honed bluestone again predominate, with concrete and steel used for some of the joinery and brass trims to accentuate material junctions.

The pavilion creates a natural atmosphere for its occupants at the beginning and end of the day, when the space is most commonly used. Indirect lighting ensures that the rooms are not over-lit, providing the quiet and intimacy appropriate for such spaces. The discreet lighting preserves the sensory qualities of natural light, allowing the tones and textures of the building's materials to reflect the ambience of the external climate, and the atmosphere within to vary depending on the weather outside.

Previous pages left | Southern courtyard cut around existing birch tree

Previous pages right | Grounded and floating above the landscape – northern façade

Opposite top | Reflecting nature – window box exterior

Opposite bottom | Framing device – window box interior

Overleaf | Afternoon light, pavilion in dialogue with its landscape

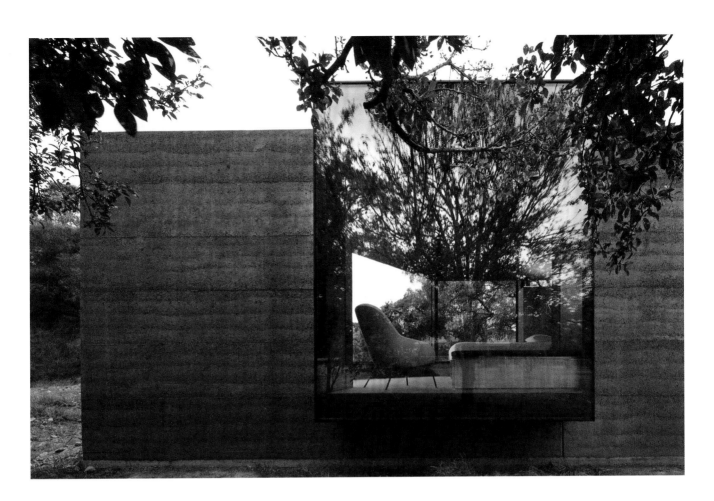

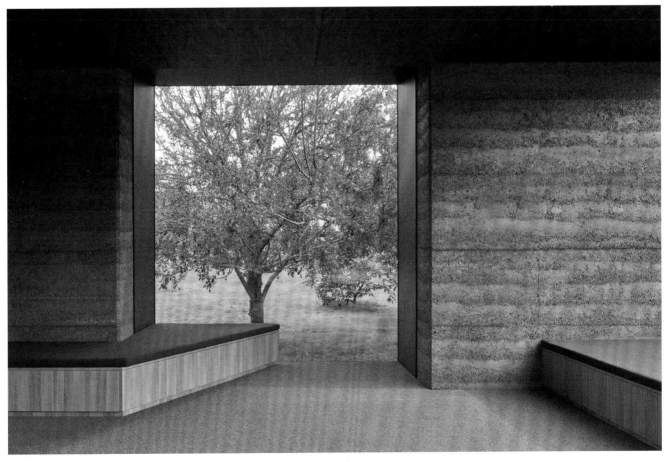

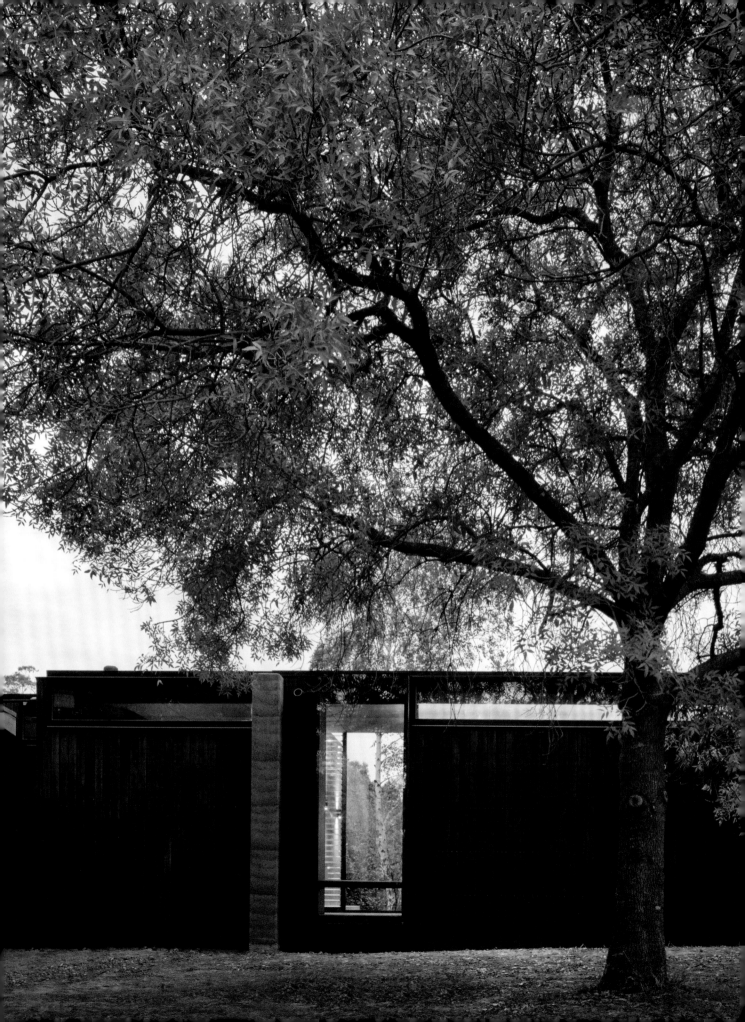

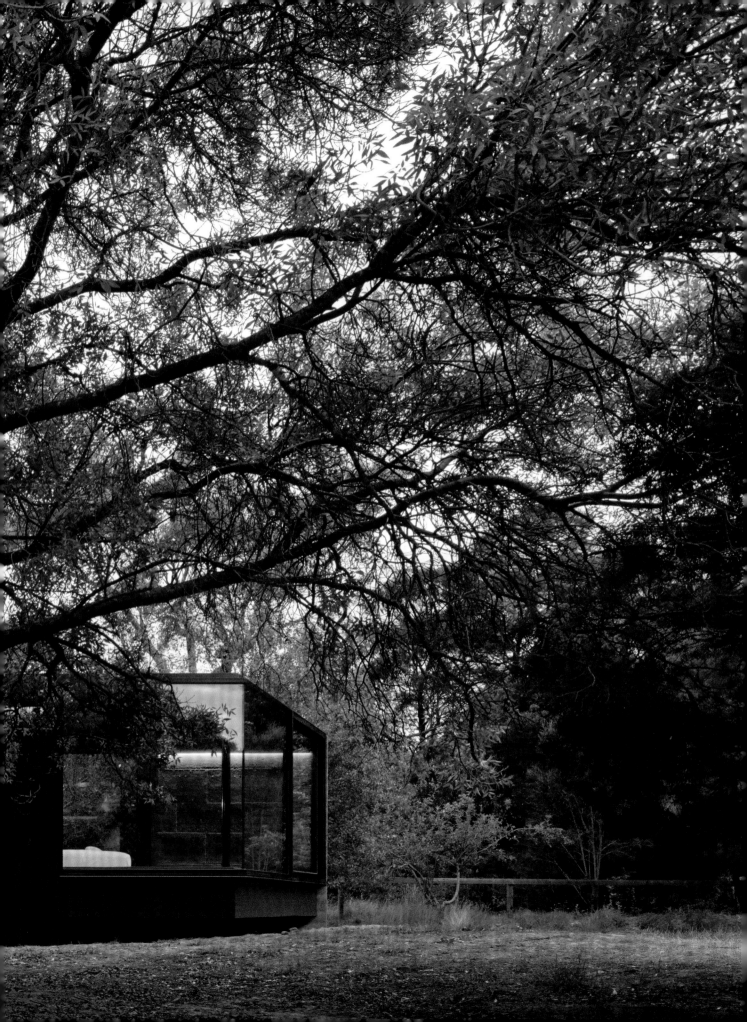

A PAVILION BETWEEN TREES
IN CONVERSATION
/
Michael White
/
Nicholas Russo
/
Brad Wray

Michael White I really admire how you've maintained quite a strong manifesto, and I'd like to learn more about how that has evolved and changed. Your first publication, *Proemial*, was five years after you started your practice, and now it's ten years. We're all maturing – how has that level of maturing affected your practice and thinking? Let's begin with your Pavilion Between Trees project.

Brad Wray I feel like the Pavilion Between Trees was a great moment of, let's say, affirmed clarity for us. We did all this work up to a point, and then that project specifically opened a whole new perspective, on what we were doing, to begin to refine a way of thinking and approaching the work, moving forward. It compressed all these things we were working towards and focused it down into one project. For us, there was a certain overall cohesion.

Nicholas Russo Even just seeing how Peter Clarke [photographer] saw and captured that project is perhaps different to how I originally saw it. Once I started seeing it through his eyes, there was this moment of realisation, just as Brad described: "Right. This is the kind of focus in the future."

MW And sometimes hearing it from others, we get that a bit too. That moment of clarity when you hear someone's interpretation of your work – particularly the photographer,

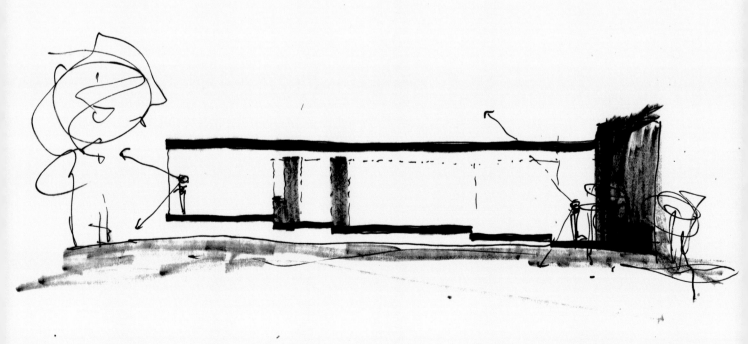

Above | Building as terrain – sectional sketch

I guess, because they're seeing those sorts of specific light qualities. I've seen a kind of connective tissue between your projects: a strong interest in light and how the materials are put together. The result is seemingly effortless. But it's the way the light is received – the curious moment of tension between light and shade, or textures and earthiness with elements of lightness – that really intrigues me.

NR I think you're right. And that's what Brad was saying about this project. It was probably the first residential project where we thought about this idea of contrast and even how volumetrically the plan or section could expand and contract or compress, and how natural light in these moments could really enhance the feeling or atmosphere of a particular space.

BW The sectional narrative in the project is really strong. The section compresses and opens between different spaces within a really small footprint, such as the bathroom, the robe area and even where you sit to put your makeup on and brush your hair, and then where the bed is. It is similar to the levels within a landscape. It's not trying to be a landscape specifically, but it gives the feeling of compression and expansion of a landscape. There is a dialogue present. One important part of this project was that we were starting on a trajectory of light and dark, where we were like "Just reduce everything back. Dial up the contrast", and really

bring the landscape in with fundamental but strong architectural elements such as light, shade, materials and textures.

MW Yes. To harden the senses and to be aware of the context.

NR Yes, there is a certain freedom, and it comes from the constraints of a tiny project. In 80 square metres, you can really focus and be clear and rigorous with those things. Similarly with elements that are just advantageous, as on this site, where there's beautiful greenery everywhere – subduing the interior and bringing in the exterior. But obviously you need all those things to work together. I think the scale and the site really drove us to intensify those aspects.

MW In all your projects, there's this finding connection to place, no matter what the context. Tell me about the location. It seems like it's a semi-rural setting and there's a cluster of other buildings on the side, bodies of water, a kind of lifestyle, and things like tennis courts.

BW Thinking back, it wasn't really the ideal location. It's not this vast open landscape. There's quite a lot of stuff around it. It's like many amazing buildings you see in photographs, the Villa Savoye, for instance. You imagine being in an open

Right | Cut across central floor plate showing stepped internal terrain with floating bench seat

Below | Sunken bathroom as initial grounding element to floor plate as it steps up the site

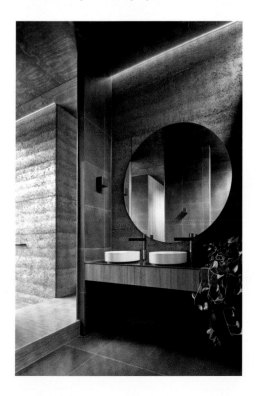

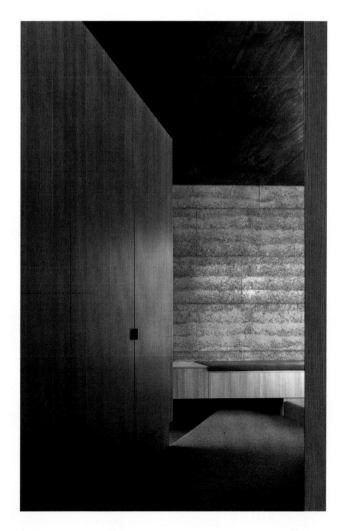

grassland, but in reality it's next to a school and in a dense residential area. The Johnson House is similar, and so is the Pavilion Between Trees. From the photos and the way that it's captured, it feels like it's in open terrain.

NR There's an existing house. It's a 20-acre site, with rural property, stables and equestrian arenas. A kind of farm, but more of a hobby farm than an actual farm. The house is from the 1980s, 1990s and is pretty uninteresting, but while we were working on an unrelated project, we were asked to look at extending it. Our strategy was to build a light connection – essentially designing a pavilion. And so, as Brad said, the project appears to be solitary, deliberately detached from the buildings.

BW It is beautifully defined within the landscape. And if you're in the space, it's quite cloistered. Other than framed moments through specific apertures, you really are quite visually secluded. We try to do this a lot, to create this sense of sanctuary that I really like.

MW A moment of reflection and a sense of tranquillity, detached from and unconfused by the noise around it. That seems like a very strong gesture – is it something you felt immediately when you came to the site? You mentioned the work on the previous project. Was it a logical spot right away, or was there some testing? I can see the project

footprint is quite graphic. There's testing and manipulating the plan, and a lot of model making. How does this relate to a site walk, for instance, in trying to understand the land? Do you go away and look through a series of photographs? Is it having the memory of walking through the space?

NR I think this specific project might be slightly different – there wasn't really another option in terms of the site for it because of the existing infrastructure. The site is quite narrow and defined really by its northern and southern boundaries. Given that it was an extension to the existing house with a really small budget, we didn't have the funds to rework the whole property. So, it just had to attach to the logical end of the original building, and so the pocket of the garden was always going to be the site. Some rigorous analysis followed, however. The garden has some really established and beautiful trees. It would have been a real shame to knock any of them down, so we suggested trying to design something that slithers in between them instead. The big tree to the north worked perfectly – it's a deciduous tree, so even from a solar aspect, it's such an under-utilised tool. We carved a courtyard around a beautiful silver birch to the south, and there's an avenue towards the northwest where the trees part and through which the sun sets, which can be viewed from the facing bedroom at the end of the day. So these kinds of elements are really big in our design

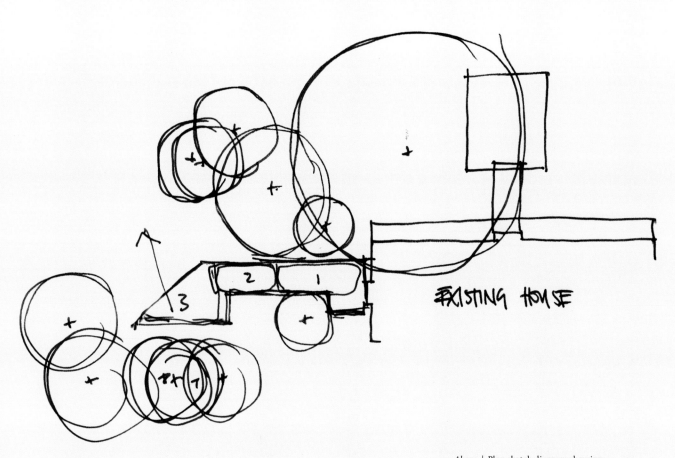

Above | Plan sketch diagram showing programmatic sequence of internal areas

considerations. Brad often describes them as the "rituals", which I think is a really good word.

MW Like the daily rituals of bathing and sleeping – the occupants are beginning the day there and they're ending the day there. Describe these ideas around rituals to me. Do they come from known classical typologies, or from your own ideas about how you would like to live and the core values of the clients?

BW I think our notion of the ritual was beginning at that time and has since become something quite constantly embedded within our thinking. We live quite hectic and often quite chaotic lifestyles, which is typical of modern-day living generally. So it's nice to just take some time, especially when we're designing these sorts of spaces, to hone in on some of those more traditional, classical, even quite Japanese ways of deriving spaces and sequential moments of space. There's a sense of the home being a place of tranquillity, refuge or sanctuary, as described earlier.

We love the idea of a narrative through daily rituals, and particularly how this has played out in the history of architecture. With this specific project, we talked about the bath houses in Pompeii. There was a strong quality to these places. Rituals play an important role in how a

space like a bathhouse was derived. For instance, how the levels begin to step down as you get closer to the water, so there's this kind of spatial connection to programme, and importantly a connection to light that creates this sense of internal sanctuary. We've definitely found that interesting over the years, and I think the more projects we do, the stronger that preoccupation becomes.

There's also a level of discipline involved in creating this sense of hierarchy and of narrative within our projects. A lot of houses these days, and spaces for that matter, are places that just flow to one another without any inherent sense of hierarchy – just big, open-plan, voluminous and quite often soulless types of spaces. We believe hierarchy is still an important element of architecture – how a simple change in levels of compression or expansion, for example, can make such a difference to an overall space and, importantly, how it feels.

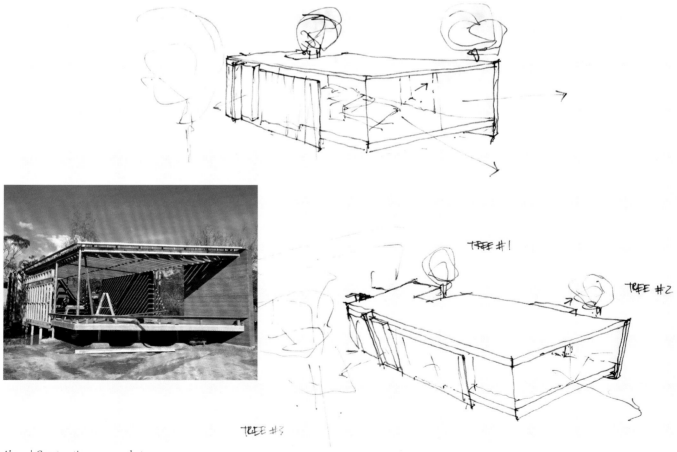

Above | Construction progress shot

Above right | Sketches exploring formal apertures and view lines with existing trees

FLOOR PLAN 1:100
01. Connection to existing house
02. Bathing
03. Outdoor shower
04. Vanity
05. w/c
06. Her robe
07. His robe
08. Bedroom
09. Courtyard
10. Existing house

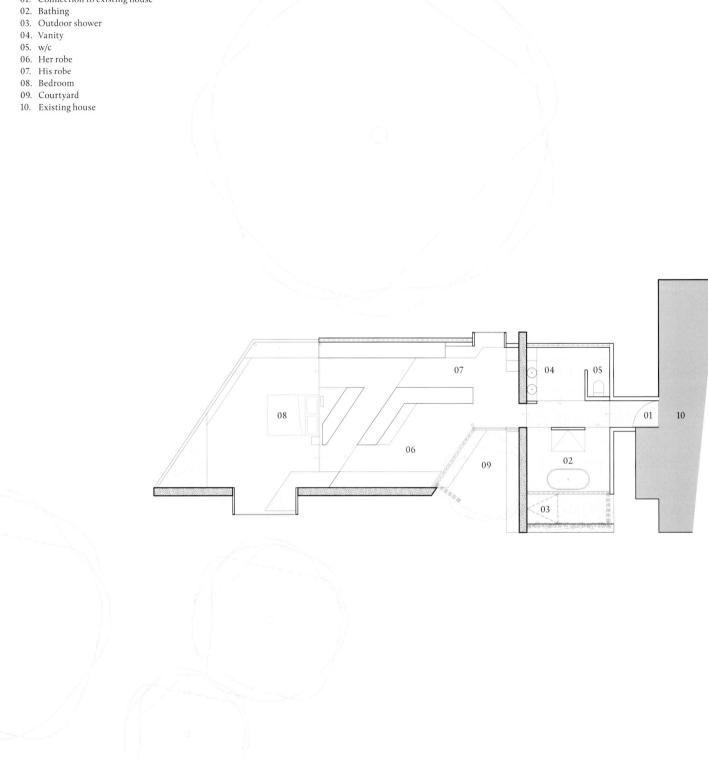

Opposite | Physical model

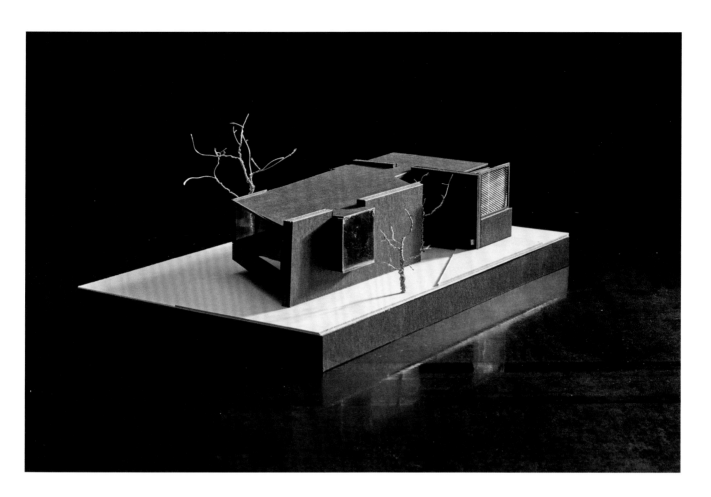

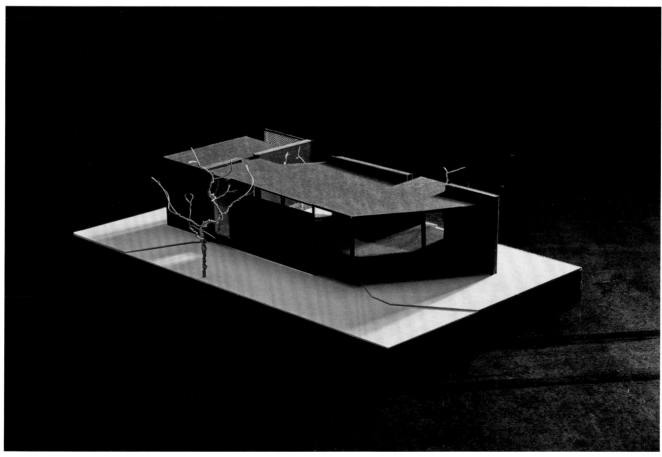

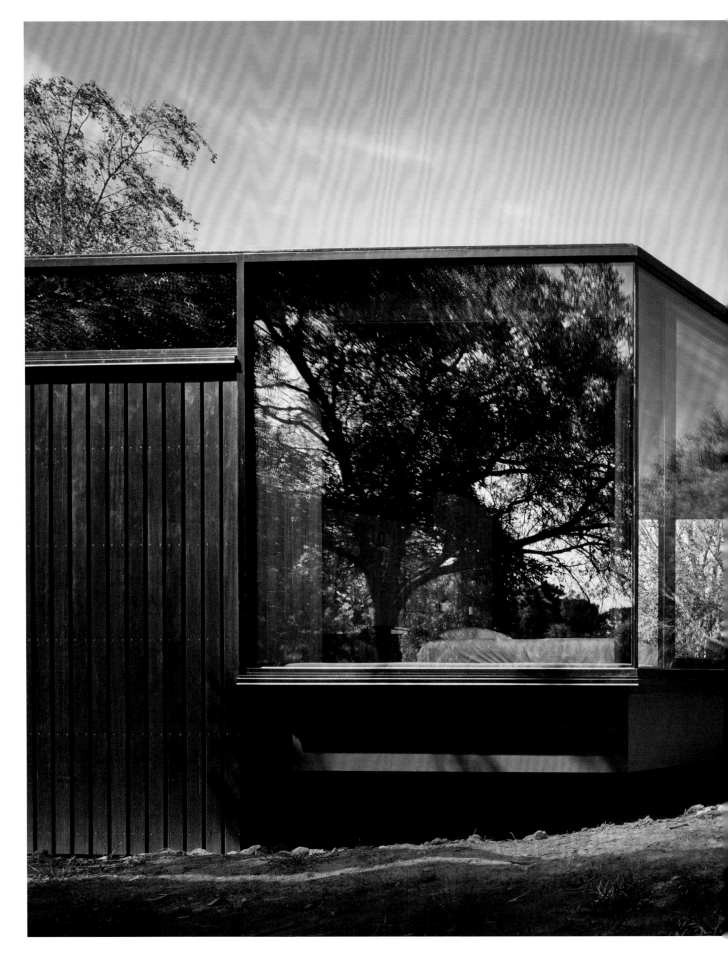

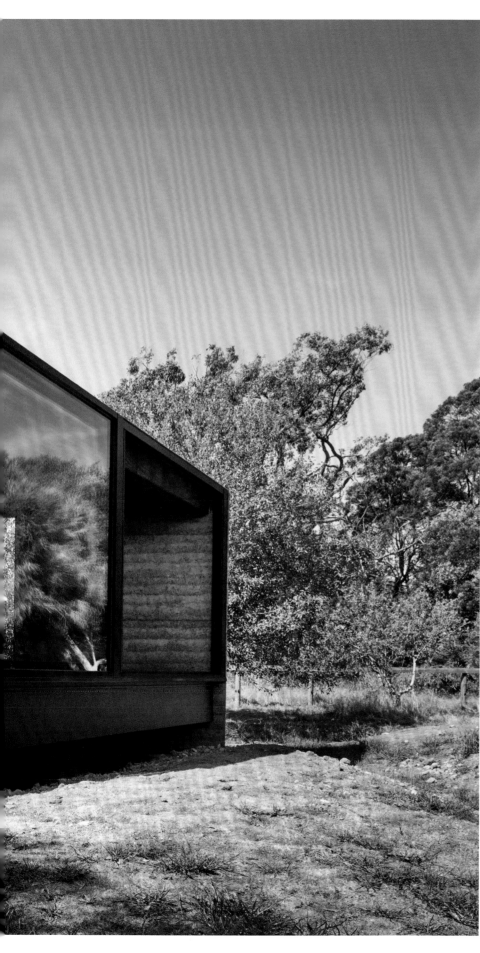

Left | Angled and transparent northern façade floating above its site to provide formal relief and visual intimacy with the larger landscape

Overleaf left | Central joinery unit defining the intersection of two distinct user spaces

Overleaf right | Diffuse high-level light creates a sensual atmosphere within internal spaces

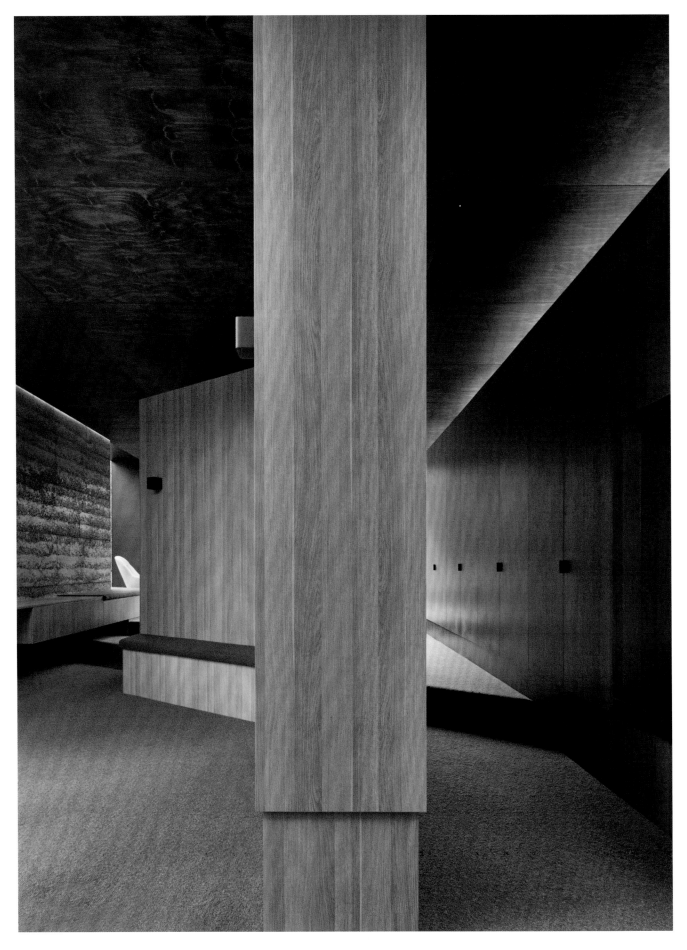

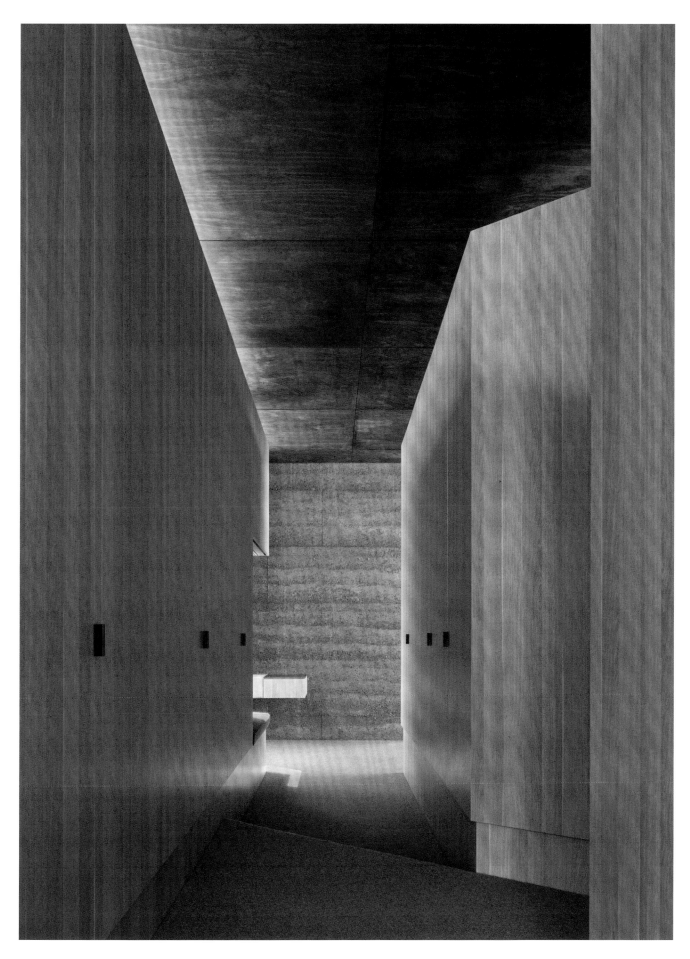

Project	HOUSE WITH EARTHEN WALLS
Type	Residential
Location	Hepburn Springs, Victoria, Australia
Project duration	2017–22

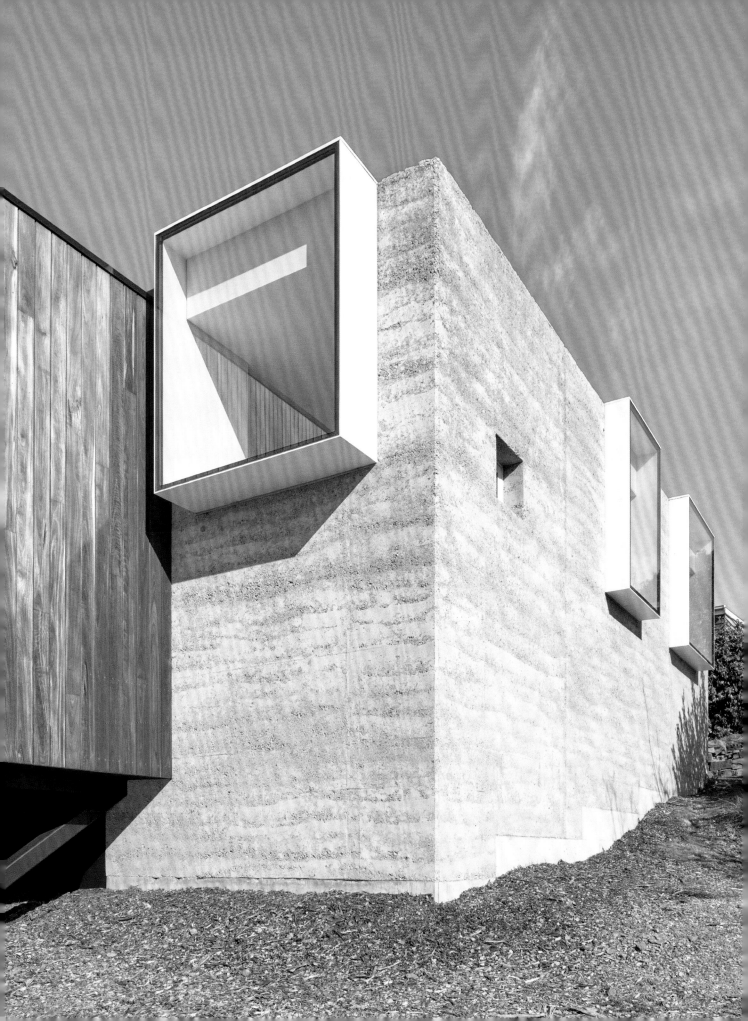

The clients approached Branch Studio Architects in 2017, after purchasing the run-down property, a historically significant double-pitched, weatherboard cottage located on the periphery of the Hepburn mineral springs bushland reserve, south of Hepburn Springs township. The secluded site slopes down from west to east, offering spectacular views from the southeast across to the northwest, with great potential for maximising the existing amenity. The house had been inhabited by the previous owners for several generations since its construction in 1911, and had become well known in the local area for the larger-than-life character Nora Ramsey, aka "Auntie T", who lived there for 75 years.

The brief was for a new extension containing a living area, master bedroom and en suite bathroom, in addition to removing an existing lean-to erected in the 1980s and replacing it with a contemporary bathroom and mud-room area. However, given the history and importance of the existing cottage to the local community, the clients were adamant about retaining its integrity. The design was therefore purposely developed so as not to overpower it, largely preserving the existing floor plan. The kitchen was retained and celebrated as the "heart of the house", with the new extension designed as a literal extrusion of it, pulled out towards the northeast and opened up with a glazed wall that maximises the view towards the bushland reserve and beyond.

Clad in vertical spotted-gum timber boards – both externally and internally – the materiality of the new living space enhances the relationship with the structure's surrounding context of dense eucalypt vegetation. A black-stained timber ceiling further enhances this relationship by dialling up the contrast between interior and exterior, bringing the landscape into the house.

A series of seven steps provides a physical reminder of the transition between old and new while also embedding the new extension's relationship to the sloping site. The master bedroom and en suite volumes are situated in the lower part of the extension, still hovering but physically closer to the earth. The interior materiality is purposely designed to be darker than the living area, creating an enriched relationship with the landscape and a sense of retreat.

A glass link provides a visible demarcation between the existing and the new structures. Consisting of a skylight and a narrow slot window inspired by the local bushland horizon that breaks up the solid black-oxide rammed-earth wall of the street elevation, it also offers a direct visual relationship with the surroundings. A central staircase between the two volumes provides practical and direct access to the landscape and, more importantly, creates a stronger continuity with it through the use of deeply penetrating light, void, reflection and materiality.

To the north of the original cottage, the former 1980s' cement-sheet lean-to was demolished and a new white rammed-earth mud room, laundry and bathroom designed in its place. Considerable effort was made to provide an inherent relationship with the existing structure yet create a new sense of permanence and enclosure to the space. White rammed earth proved a richly appropriate framework to achieve this, in essence creating a "contemporary finished ruin".

The delicately balanced design of the new elevation successfully contrasts with but respects the old structure; the old retains its "feel" and still tells its own story, and the new creates a narrative of its landscape.

Previous pages left | Hand-made horizon façade detail

Previous pages right | Bathroom and laundry volume formalised in a textural white-grey rammed earth

Opposite top | Renovated existing cottage from 1911 with new addition

Opposite bottom | Stepping in northern façade visually defines primary living and bedroom areas

Overleaf | A composition of three distinct formal identities. The angled northern façade provides optimum views to surrounding mountains

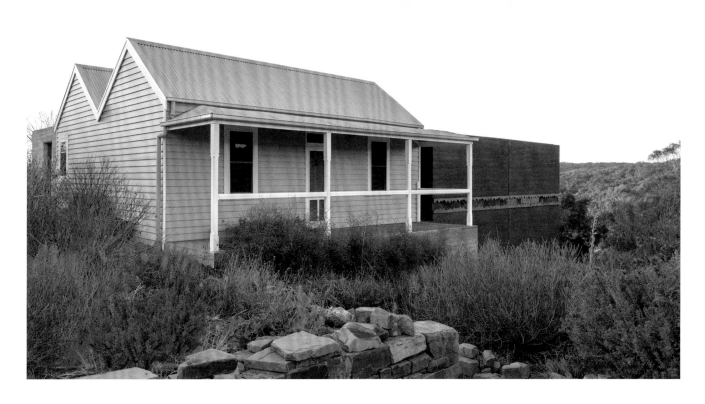

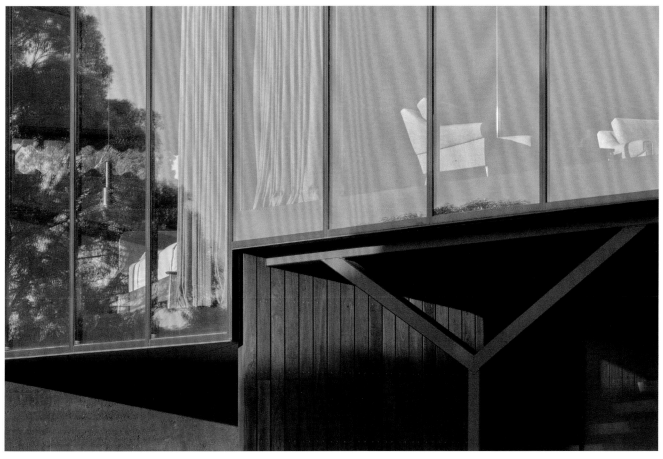

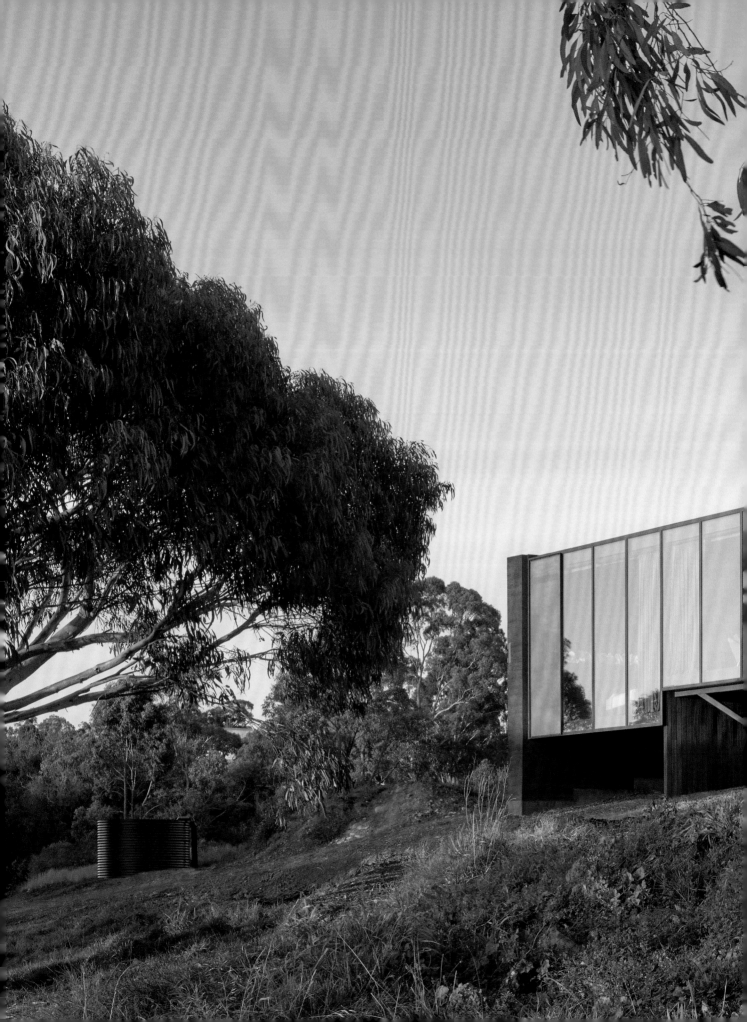

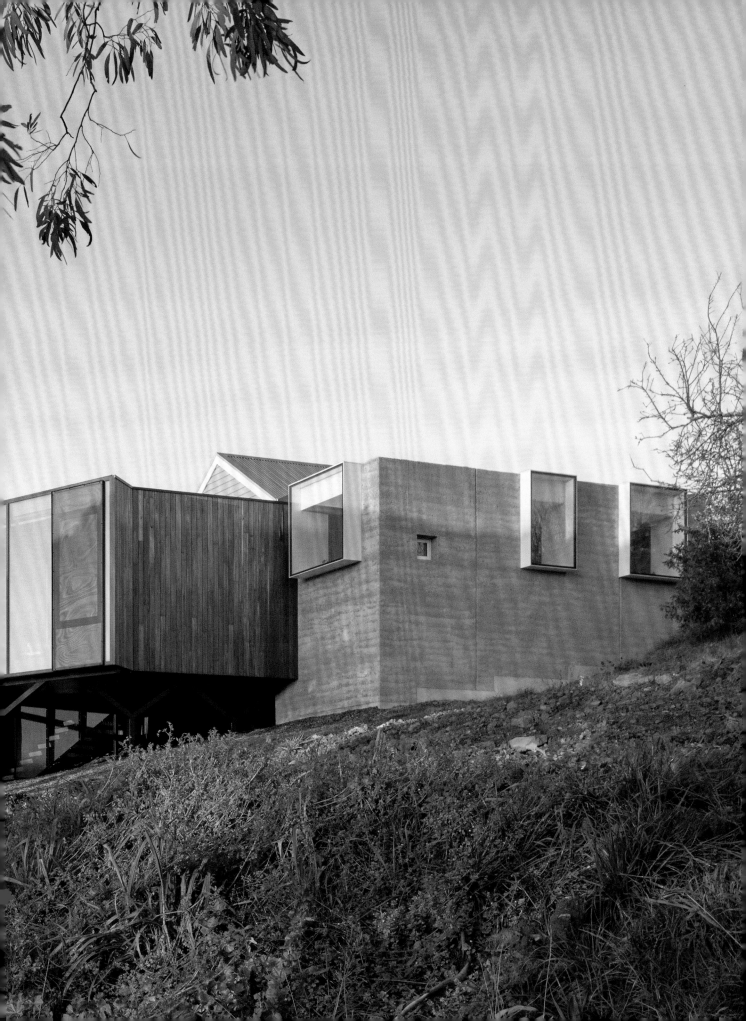

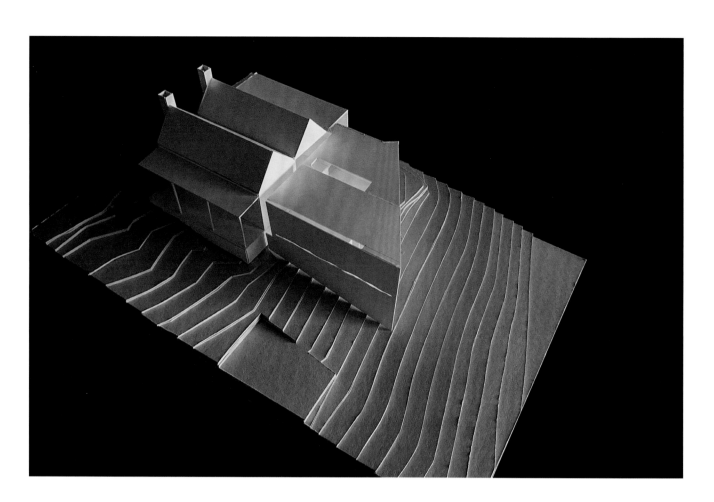

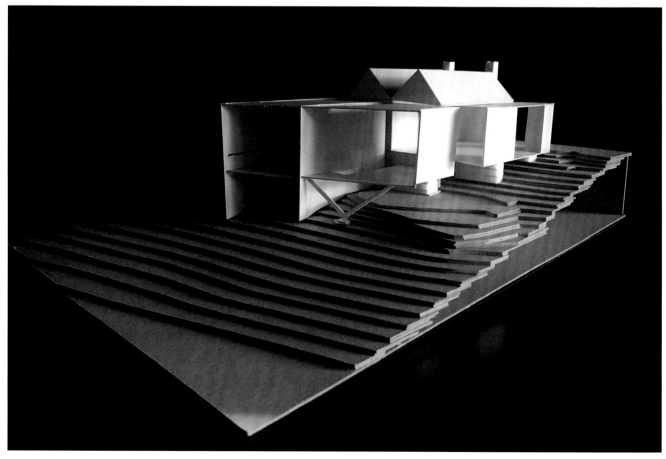

GROUND FLOOR PLAN 1:100

01. Entry
02. Bedroom
03. Dining
04. Kitchen
05. Mud
06. Laundry
07. Bathroom
08. Living

09. Stair to outside
10. Courtyard
11. Robe
12. Study
13. Primary bedroom
14. Bench seat
15. Skylight over
16. En suite

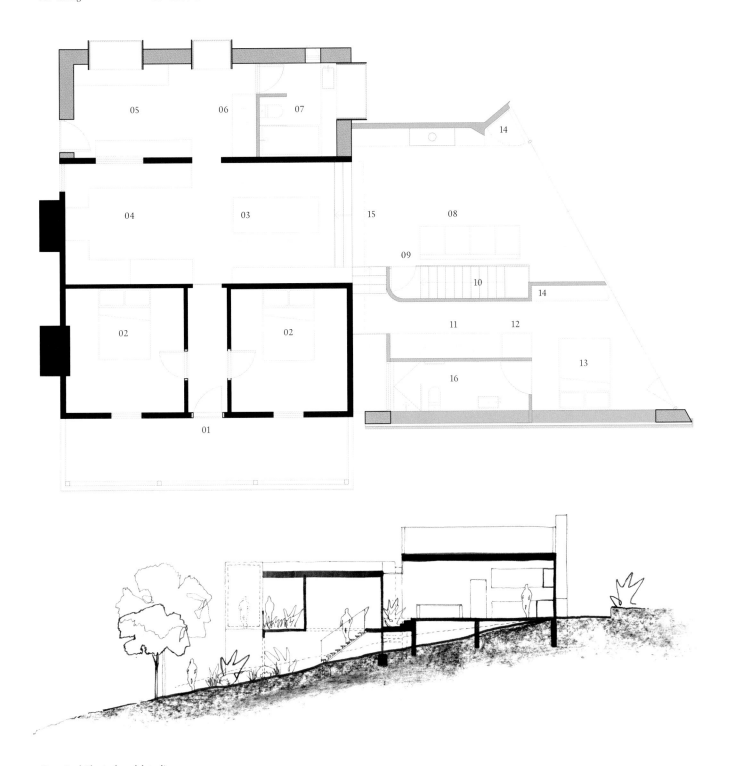

Opposite | Physical model studies

Above | Sectional sketch with
central stair creating a direct physical
connection to the landscape

CONSOLIDATION

HOUSE WITH EARTHEN WALLS

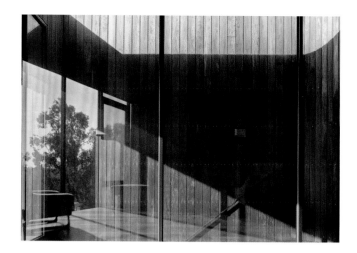

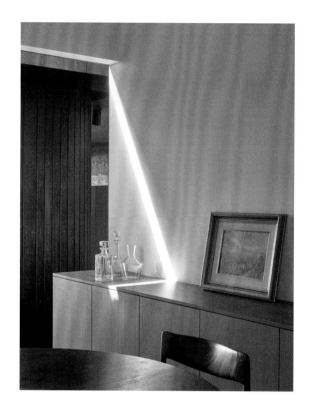

Above | Central stair void clad in timber provides a rich textural backdrop to living spaces

Left | A linear skylight visually defines the relationship between old and new parts of the house

Below | Primary living area with strong visual connection to nearby mountains

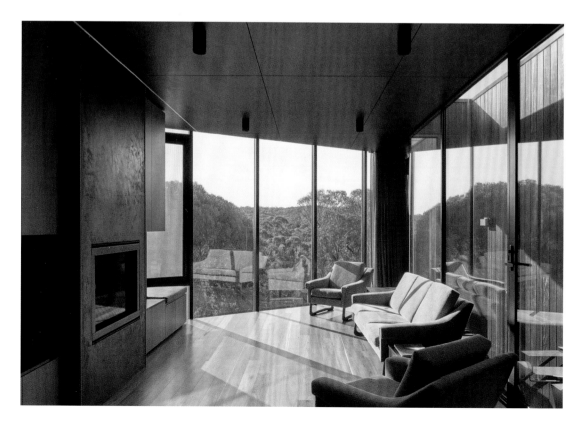

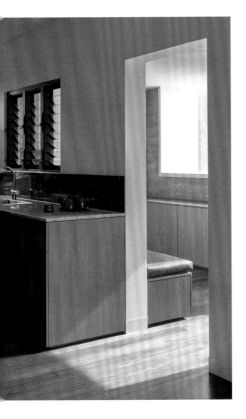

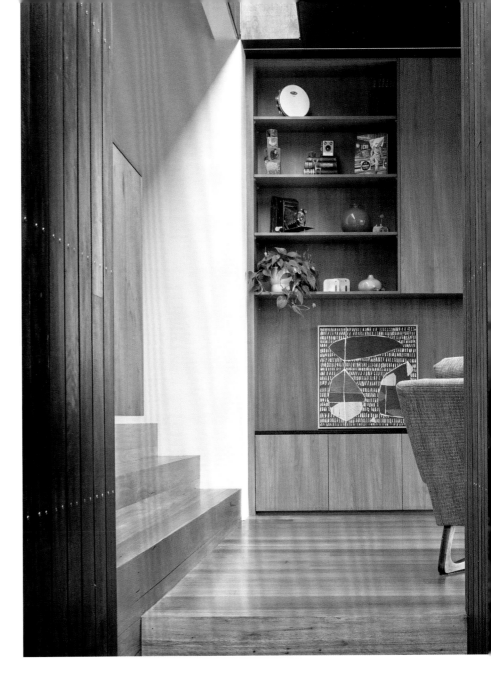

Above right | Emerging from lower bedroom wing into living space with skylight above

Above left | Junction between old and new kitchen into mud room

Left | Bedroom interior with the horizon façade creating a dialogue with nearby mountains

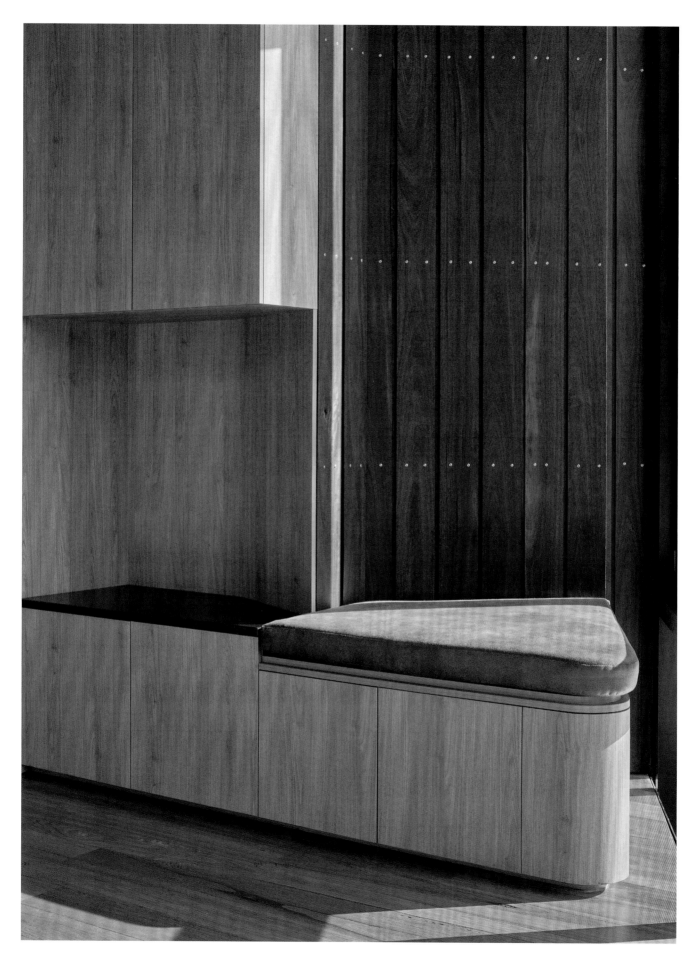

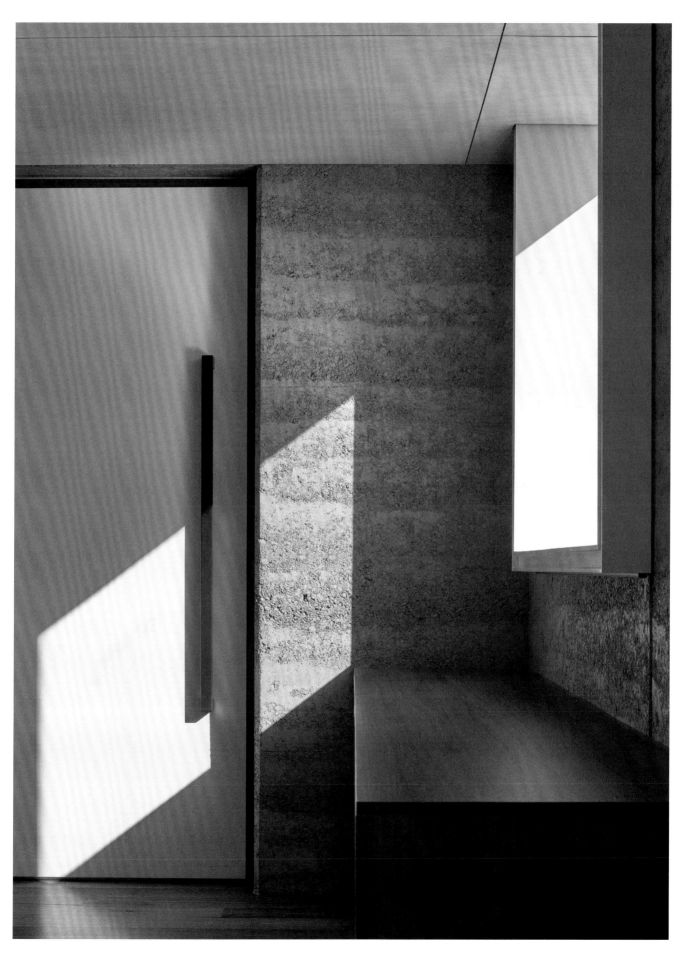

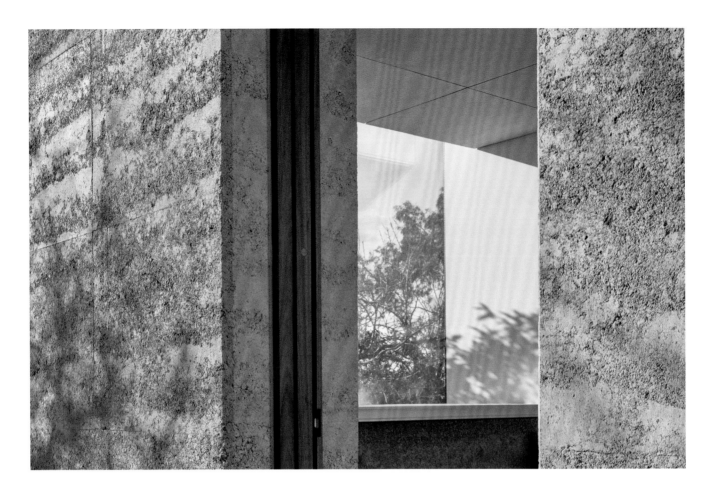

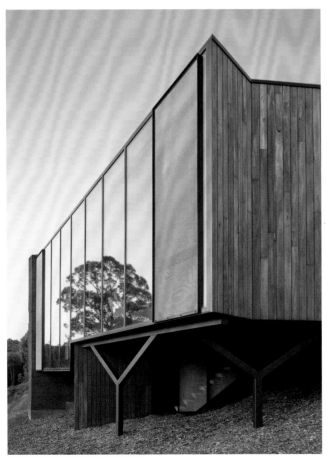

Previous pages left | An intimate space for contemplation. Window seat in living area looking out across mountains

Previous pages right | Mud-room composition

Above | View through white-grey rammed earth mud-room external entry with tree framing window box element beyond

Left | Timber and glass clad northern façade with Y-shaped support trusses to reduce massing with ground plane

Opposite | A black-rammed earth façade creates privacy from the street and flanks a glazed northern façade offering uninterrupted views of nearby mountains

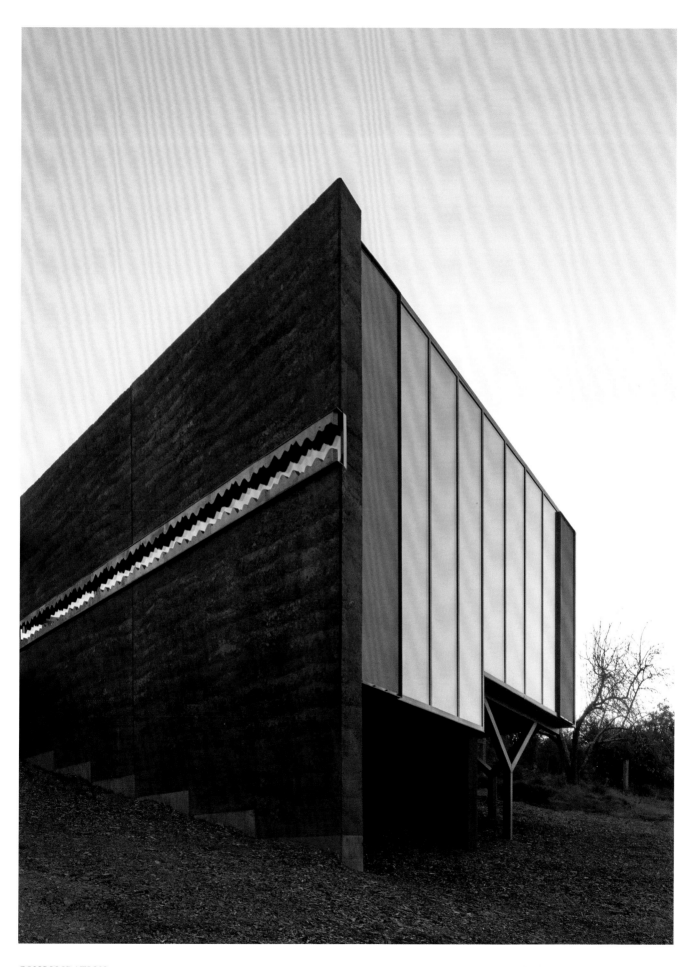

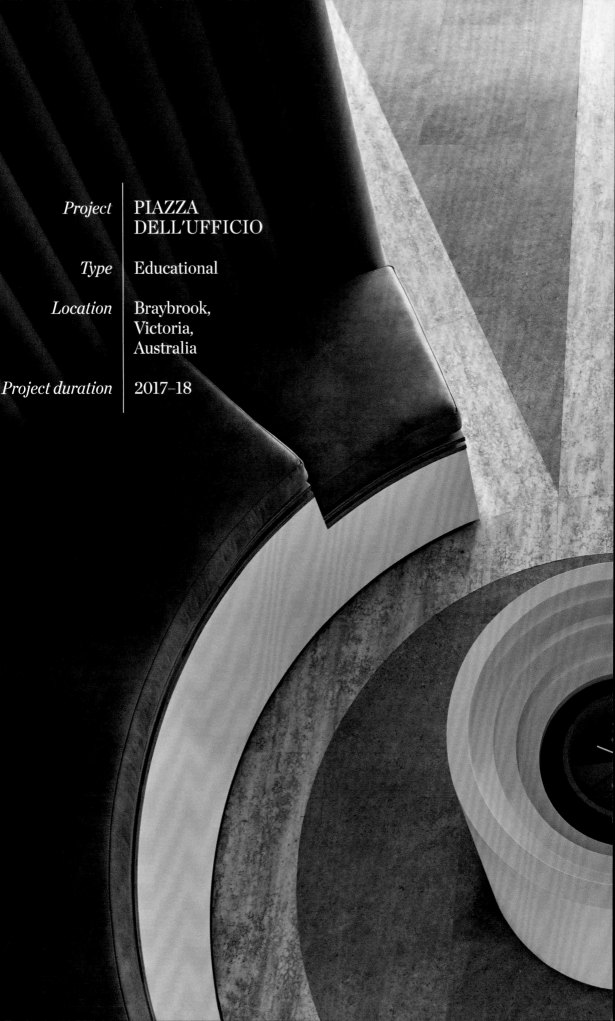

Project	PIAZZA DELL'UFFICIO
Type	Educational
Location	Braybrook, Victoria, Australia
Project duration	2017–18

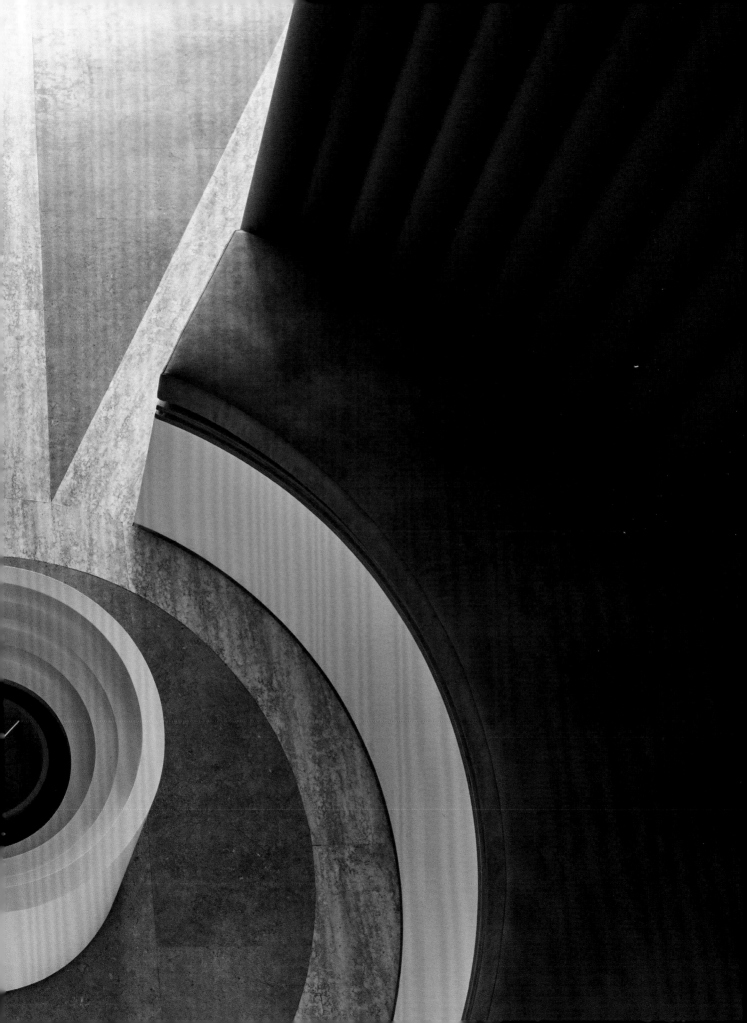

The Piazza Dell'Ufficio, which translates from Italian as "office square", is a reimagining of Caroline Chisholm Catholic College's former executive administration offices to provide spaces for school staff, the accounts department and student welfare, as well as various-sized areas for staff and student meetings.

The existing late-1970s block was a rabbit warren of dark, disproportional office spaces and a meeting room with little natural light. The use of space was inefficient and inflexible, providing no opportunity for social interaction for its users. Branch Studio Architects' objective was to create a well-lit, welcoming space with a dual function, enabling day-to-day administrative practices to be carried out efficiently while simultaneously catering for student welfare. The aim was to reduce the visual barriers between staff and student interactions but also provide a place where students could feel comfortable meeting up for a private chat with a staff member.

With this goal in mind, they developed the idea of using Italian town squares and their ability to facilitate human interaction as inspiration for the project, rationalising the space as a central public piazza linked by a clock tower and a public forum.

The central public plaza serves as a destination and primary meeting hub for student and staff interaction. It also acts as a forum when the need arises for management to address large numbers of staff. Working offices are situated off the plaza in a diverse variety of spaces, the formal composition of which caters for individual offices, shared office spaces, various meeting areas and hot-desking environments.

Cost-effective cardboard tubes line the interior along the peripheral walls and are also used as partitions to create nooks for meetings and breakout areas, sculpting the space into a visually cohesive, elegantly curved whole in warm, natural tones of buff enhanced by the white walls and grey-and-white stone floors. A profiled dropped ceiling extends the curvature of the interior spaces in section, and creates more intimate spaces at primary meeting points where dome-like coffers occur in the clock tower and public forum. Formal lines in the floor finish create visual axial links between the clock tower and public forum/sculpture space, and also link in the entry, meeting and office spaces.

Light is an important design element of the project, carefully controlled to extend the internal formal curvature and create a visual and contextual narrative that references the subdued light cast underneath the porticos and formal archways of 18th-century classical and neoclassical architecture. Classically inspired archways are used as a formal entry into the space from an existing school corridor, and also as entries into the three office wings from the main piazza.

Piazza Dell'Ufficio won the Dezeen Awards for the best small workplace interior and overall best interior project of the year in 2019. The judges commented: "It is a very simple intervention for very little money that gave the school something they could be proud of, which functions extremely well and teaches the children at a very early age the power of design."

Previous pages | Central clock tower as primary meeting point within the space

Opposite top | Curved walls and ceilings create a visual softness to the overall space

Opposite bottom | Central clock tower ceiling

Overleaf | Axial lineage upon entry
View of primary clock tower within central piazza space

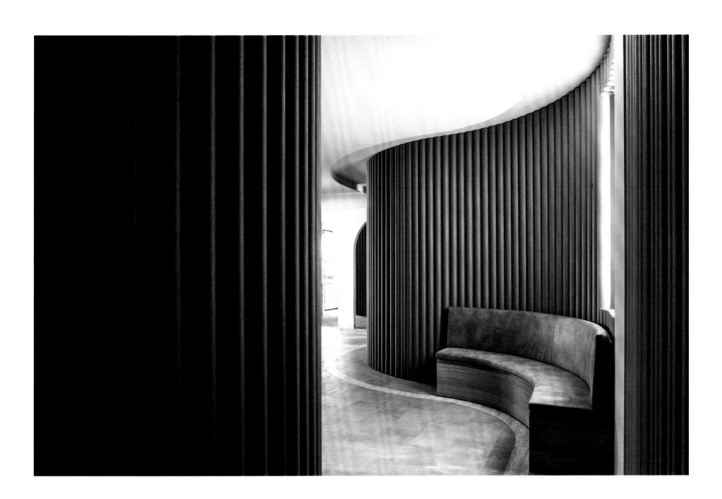

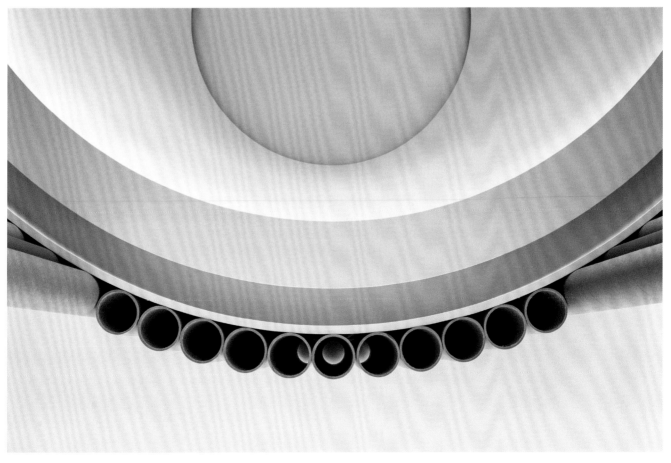

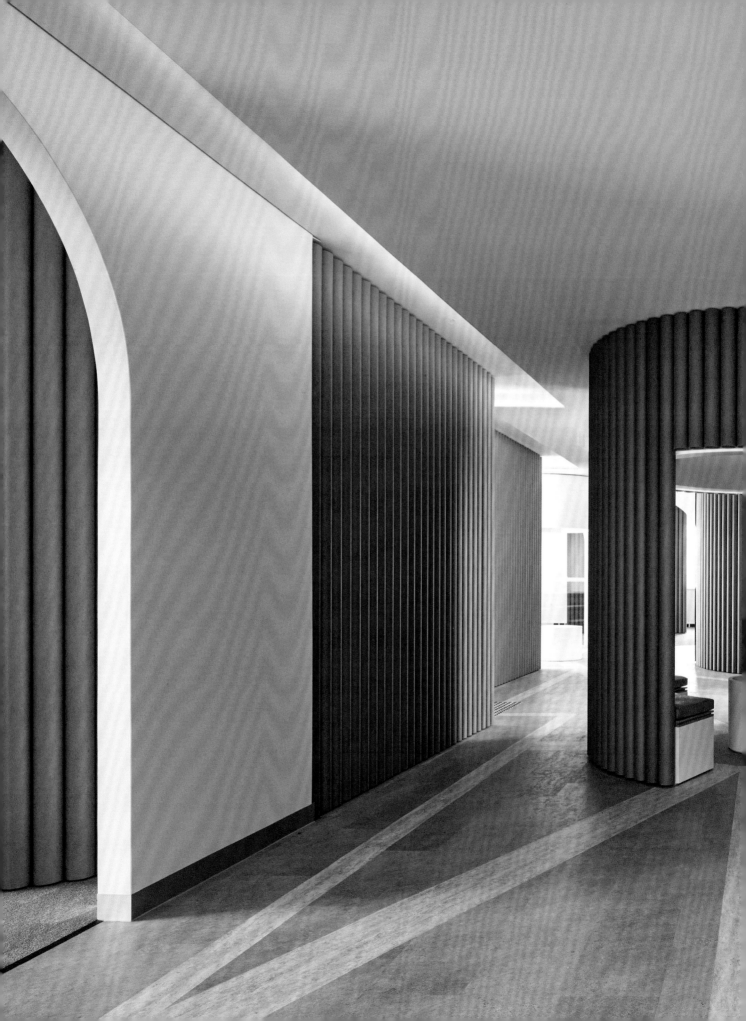

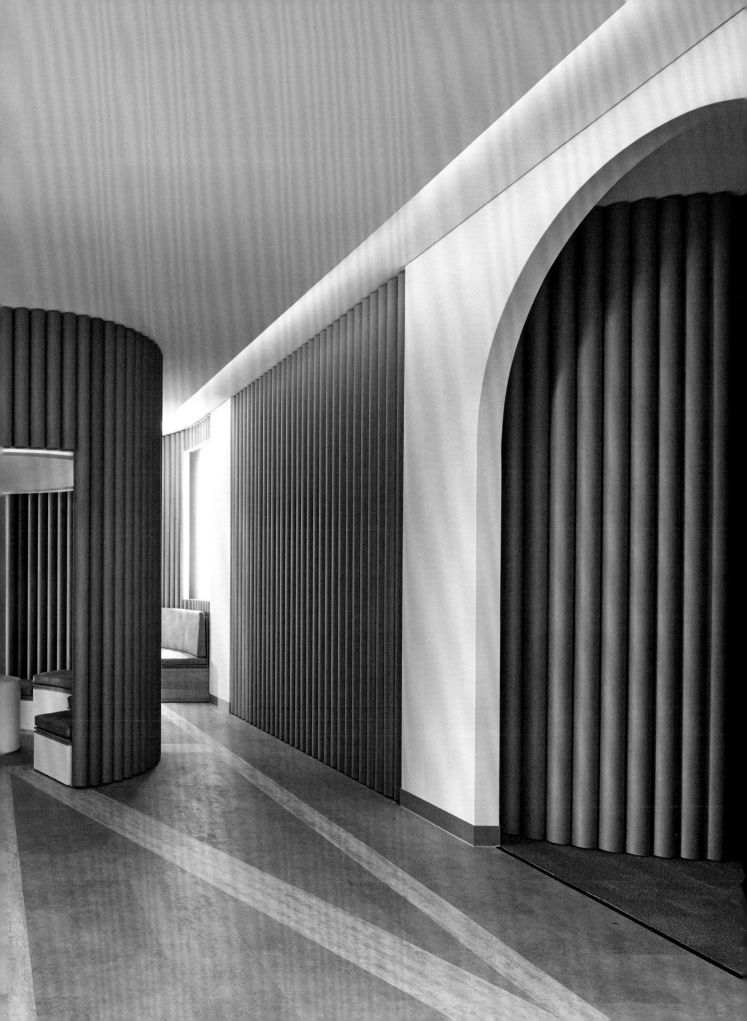

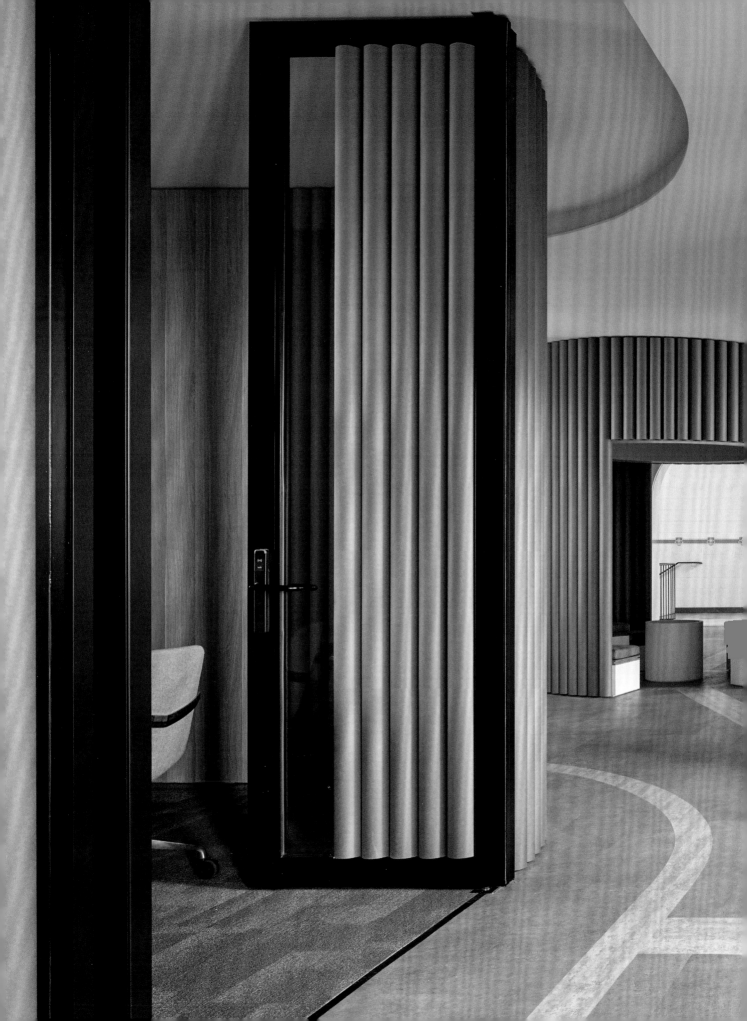

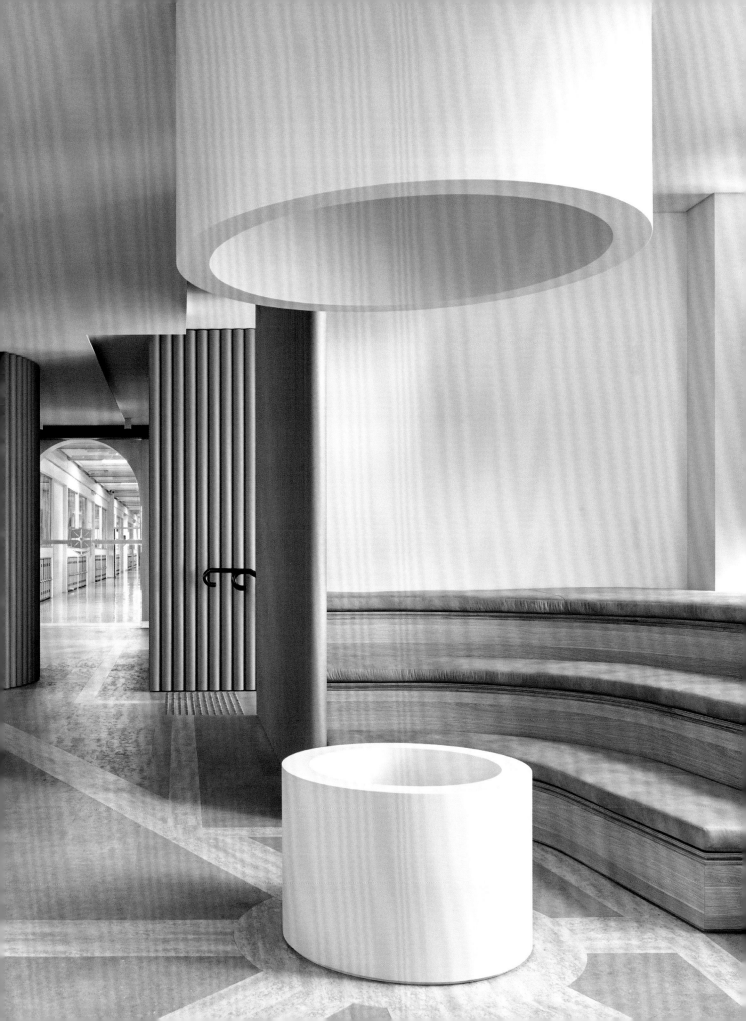

GROUND FLOOR PLAN 1:100
01. Entry
02. Clock tower
03. Sculpture tower
04. Forum
05. Piazza
06. Shared office
07. Flexible private office
08. Executive office
09. Hot-desk workstations
10. Meeting room
11. Informal meeting area
12. Shared toilets
13. School corridor

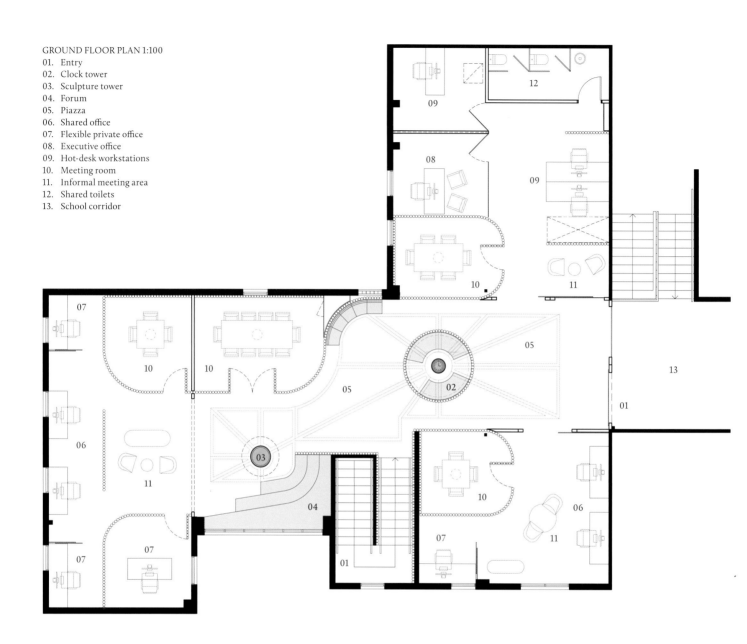

Previous page | View looking back towards entry.
Forum amphitheatre [right] – a place for small
group meetings and discussions

Above | Section – the spatial compression of the
central clock tower and sculpture tower define
important hierarchical areas

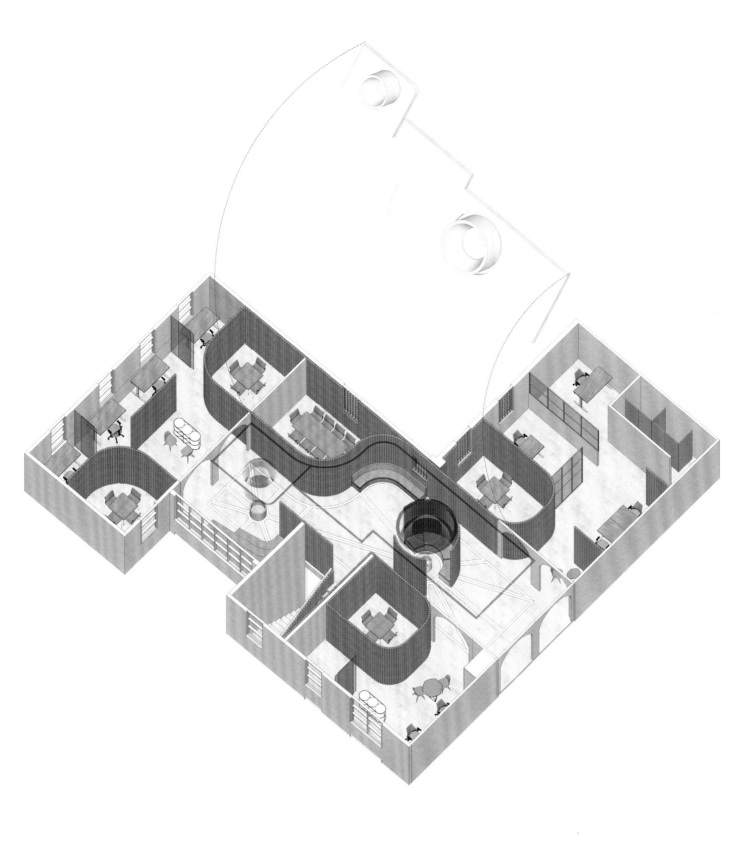

Above | Isometric with unfolded ceiling

PIAZZA DELL'UFFICIO
IN CONVERSATION
/
Michael White
/
Nicholas Russo
/
Brad Wray

Michael White After Pavilion Between Trees came the Piazza Dell'Ufficio. When did that come about?

Brad Wray Well, the Pavilion Between Trees was 2015/16, and Piazza Dell'Ufficio was 2017/18. But there are some fundamental similarities, and definitely a lineage between the two projects in terms of scale, narrative, and the reductive composition of the aesthetic, even the transmission of light and sectional space. Piazza Dell'Ufficio has been really important for us in relation to the multiple awards – particularly the Dezeen awards. This was huge for us.

MW Yes, that recognition, at a global level, must have given you confidence in validating your ideas. I think this is quite a courageous project in its design response to the brief. You've expelled any preconceived ideas and, through the material language and assured use of an everyday product, found an efficiency of scale to stretch the budget.

Tell me about choosing the materials. Is that something you always wanted to use? And thinking like Shigeru Ban in terms of using cardboard tubes, was it something you thought you could one day do in your own project? or did it sort of fall out of a discussion with the client?

BW It really was a response to a process. We had quite a strong idea about how to go about tackling the programme due to an ongoing conversation with the client, but like many of our school projects we had very little budget to work with. We've never used budget as an excuse, however, so we looked for a material that could establish an overall cohesion, to bring the space together, and that could create curves in a cost-effective manner. The concept of a "town piazza" as a narrative was used to break down the barriers between staff and students, to create the sense of a place to meet a friend or whoever for a quick chat before going off together to a café, for example, for a more in-depth discussion, as you would with a school counsellor. It's about opening up the humanistic interactions between staff and students, but also using the history of architecture to encourage a wider conversation between the users of the space. Telling a story about a place and time.

MW Is that because you see your school projects as cities within cities? There's a sort of morphology around how cities work that education projects lend themselves to so naturally.

Nicholas Russo Well, yes. Schools are basically little urban-planned cities in a way. As Brad was touching on, this is particularly relevant to this project. A meeting place for staff and students isn't common in a school, where spaces are usually quite confrontational. The piazza concept removes that level of confrontation so that students who may have special needs, for example, can interact with staff. The softening of the materials and the curves make the Piazza Dell'Ufficio a more welcoming space.

BW That was the other important note, to create a visually curved softness on a really limited budget of 650,000 Australian dollars which is very tight for a project of this size. The cardboard tubes created a holistic feeling to the space and really tied

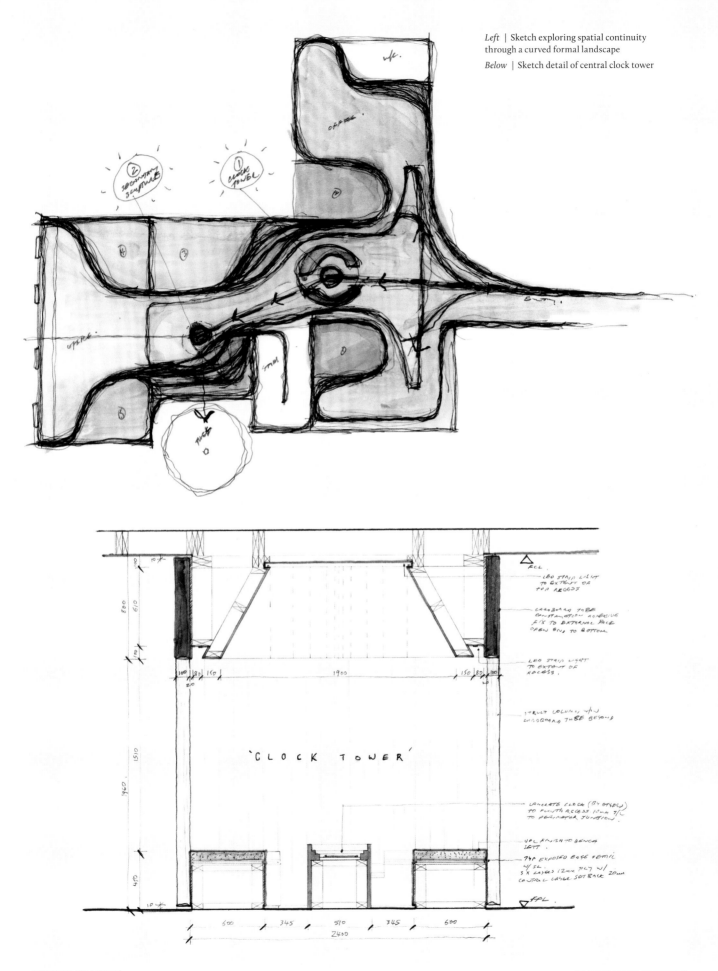

Left | Sketch exploring spatial continuity through a curved formal landscape

Below | Sketch detail of central clock tower

'CLOCK TOWER'

everything together; as with the Pavilion Between Trees, you get these moments of dark and light, and series of quite raw but visually integrated materials. When we choose a material, we always consider how we can best detail it. We don't want it to look in a certain perceived way, as a cardboard tube would typically be. It has to be of a higher quality, and we take that kind of approach with all of our projects within school environments.

For us there is always this process of adding to and elaborating client briefs. A client will come to us and say, "We need this space for staff admin and student welfare." And then we think, "OK, that's great", but instead of just ticking their boxes, how about making more out of that? So we think about it in a more institutional way, and a more civic way, and also consider the measure of the success of the project. When the staff moved into the Piazza Dell'Ufficio, they didn't quite gel with the space – I think because they didn't have their familiar, traditional four-wall plasterboard office. But then six months later, Marco DiCesare, the college principal and our client, confirmed, "They love it now. They've really kind of come to love it. They've understood it. It really does work well. It really breaks down barriers between us and students; it creates much more of a collaborative open working environment." This really felt like a great measure of success for a project. It pushed the boundaries of staff members and made them rethink the notion of what an office environment could be. In a way that's better for us than if they'd loved the space from day one; it reaffirms we have done our job well. We were also lucky that Marco was an amazing leader who saw the value in what we could bring to the school environment and what that means for the students. We always approach these projects from a student perspective.

NR Definitely, and Marco was the very first principal we have worked with who was prepared to sacrifice staff facilities for the greater good of the students.

MW So, the client in this instance sounds just as courageous as you guys are with your design, which is fantastic because you need that support behind you to be able to be innovative both spatially and in terms of materials. Where does this project sit amongst the ten other projects you've designed for the Caroline Chisholm campus? Did you have to get a couple of them under your belt to win Marco's trust, so that you could slowly build a narrative with him over time?

BW Yes, the Flyover Gallery pedestrian bridge was the very first project we did with him. In the early stages of the design, our schemes were quite conservative, but then we realised this was a great opportunity to make a point and change our future trajectory with this client. So we said, "Let's just go all out and turn this open-air breezeway into an art gallery." The school really saw the value in this idea, particularly when it opened, and everything since has just stemmed from there.

MW What's so interesting about your studio, for me, is that you move between residential work, educational projects and those of a more civic nature, but when I look at the photography of this school project there are certain hallmarks – for example the play of light, and material considerations – that are also visible in your house designs, which returns us to the themes of sanctuary and tranquillity. Is the idea here to make your educational buildings more homely? Is your manifesto that any kind of architectural typology should have these qualities?

NR I don't think the typology really matters – by the time we did this project, we had a really clear understanding of what was important to us. As for your point about the qualities of light and space, I don't think that they're exclusive to enhancing the spaces of any particular typology – they're fundamental things in architecture.

BW You're right, and on top of that there's a very simplistic way of looking at it – there's a language and an attempt to bring the home into the school environment because we could see at first hand the positive responses from students; for instance, in 2013 when we did the Pamela Coyne Library at St Monica's College in Epping, Victoria, students were staying after school and coming in out of hours because the space felt like a home away from home.

MW The borrowing of books also increased more than threefold after the library reopened. The client had been about to throw them all away and make it a digital library.

NR More often than not with these types of projects, we're working with an end user who is part of a majority client group that doesn't fully appreciate what good design and thoughtful space can achieve in terms of wellbeing and productivity. We've been fortunate to work with some clients who really resonate with us. But it's still sometimes a battle with some client groups. This in itself has made us steadfast that you're never going to please everyone, so we might as well try to make a space that we're proud of and that is primarily student led and student focused.

BW Another nice thing is the ideas embedded within the projects. We want our projects to be a discovery for students – of ideas that reveal themselves and evolve as they experience the building over time. It's lovely when you hear them referring to your concepts by name: "I'll meet you at the Piazza" or "I'll meet you at the Spanish Steps". The ideas take on a life of their own, which is really rewarding, and it's great to see them resonate with their intended users.

MW Yes, this is very interesting, isn't it? The ideas you started with live on through the terminology they're using, but it goes far beyond the semantics of a name or diagram. I can also see a kind of civic understanding through the scales of how human connections work in spatial relationships – the subtleties and sophistication, in this project particularly. I guess the geometries of the curvatures and the materiality support and further articulate that curvature.

BW The light in this project was really important too – even in the way we just captured the subdued light you get under some of the porticoes and neoclassical buildings in Venice. The little subtleties of something like light might trigger a memory in your mind and take you to beyond the realm of the specific project.

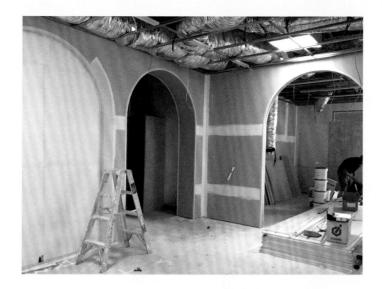

CONSTRUCTION PROGRESS SHOTS

Above | Formal archways

Right | Central space with curved ceilings overhead

Below left | Cardboard tubes were a cost-effective way of creating curves

Below right | Forum amphitheatre with sculpture tower dropped ceiling element being installed

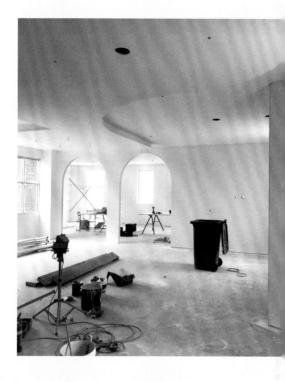

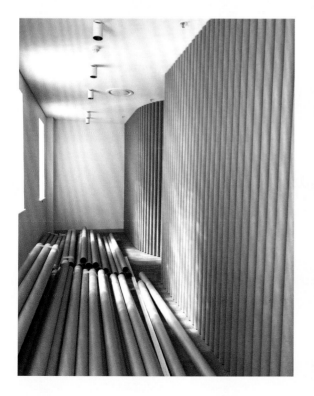

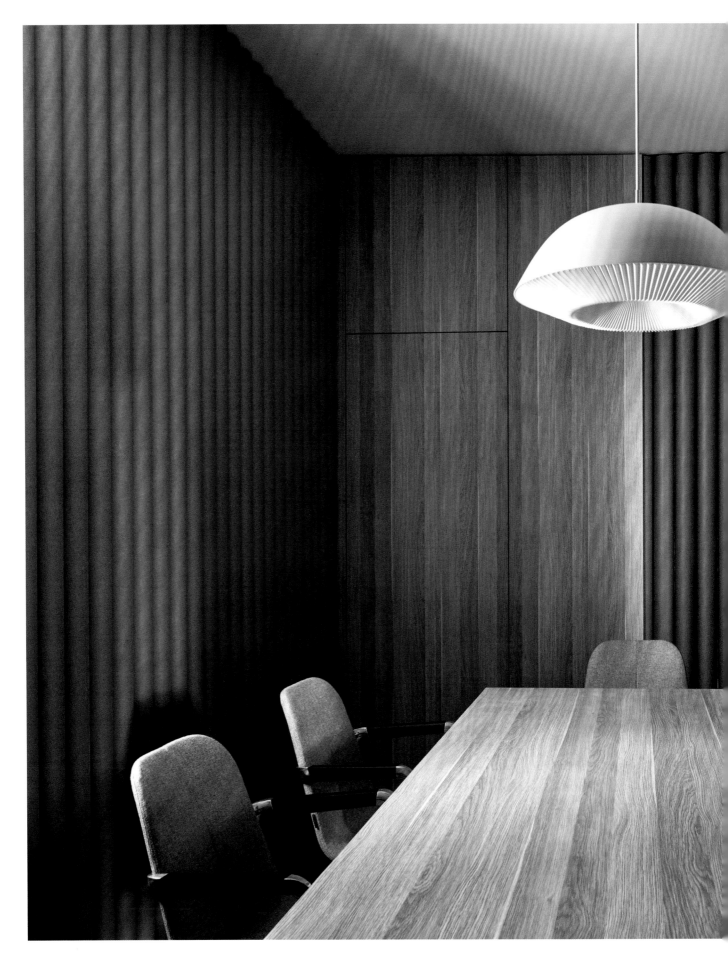

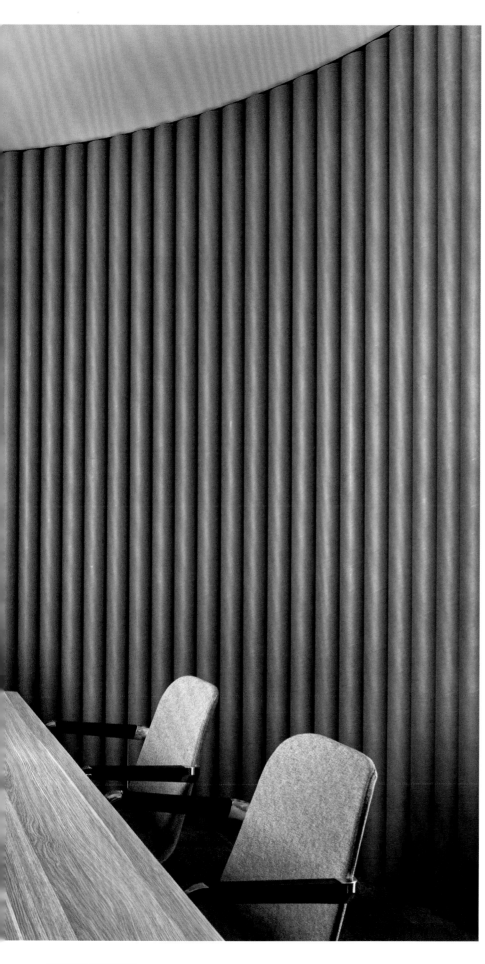

Left | Large meeting room interior

COMPARISONS
/
by Conrad Hamann

Branch Studio consistently engages with architectural history: from pre-industrial architecture, to indigenous people's shelters in inland Australia, to the past that is not even past of recent architectural design.[1] Branch were influenced by Australian and, especially, Melbourne precedents, and this can be seen in the connections their work has with the 1930s to 1950s architecture of Roy Grounds, Robin Boyd, Frederick Romberg, Bill Irwin, Barry Patten, Peter McIntyre and Kevin Borland.[2] Branch Studio link these with Richard Neutra, and with Mies van der Rohe and his major buildings – especially the Farnsworth House in Plano, Illinois (1951), Berlin's Neue Nationalgalerie (1968) and the unbuilt Brick Country House project (1923).

In their Multi-Purpose Hall sports complex for Caroline Chisholm Catholic College in Braybrook (2015–22; see pp 154–67),[3] Branch Studio revisits Melbourne's structurally expressive tradition. The design recalls the "Melbourne Optimism" of the 1950s: the Melbourne Olympic Swimming Stadium (1952–6), the Sidney Myer Music Bowl (1956–61) or Bogle Banfield's grandstand at Sandown Park Racecourse (c 1959–62). Linking these concepts to architecture's more ancient lineages is already a major conceptual task; yet Branch Studio accomplish such a leap in geographical as well as temporal distance, extending even to current trends in architectural thinking. In just ten years Branch Studio have integrated such conceptual leaps in a score of buildings, gaining coverage of their work in both Australia and Europe.

In Europe, architectural modernism has been profoundly shaped by the inheritance of the ETH Zürich and communities of practice such as those in southern Switzerland-Piedmont's Ticino region, and related teaching and work in Spain and Portugal. Brad Wray studied in the Ticino region, at Switzerland's Accademia di Architettura di Mendrisio, where he came in contact with Peter Zumthor and Valerio Olgiati, and was taught by the Portuguese architects Giancarlo Byrne and Francisco and Manuel Aires Mateus. Olgiati's influence is the most apparent in Branch Studio's projects, and it can be seen in the parallels between his Céline Store in Miami (2018) and Branch Studio's Piazza Dell'Ufficio (2018; see pp 52–67) for Caroline Chisholm Catholic College and their Houses to Catch the Sky project (Melbourne, 2022).[4] Both are designed with integrated floor contour changes and embedded furniture. And, as with Olgiati's Ardia Palace proposal (Tirana, Albania, 2008), both use brick-red granular surfaces on "draped" concrete panels with curving lower edges.[5]

Wray and Russo also design furniture and light fittings,[6] and since their renovation and extension to the Pamela Coyne Library at St Monica's College Epping, Melbourne, in 2014,[7] their buildings have been specially concerned with furniture's capacity to gather around walls and restrict space as determined by architectural structure.

LAND, SUBURB AND CENTRAL CITY
Branch Studio's The Urban Sanctuary, a 2020 competition design for Watermans Cove, Sydney (see pp 192–201), sought to create a public building of novel openness within densely urban surroundings. The design itself was based on the concept of a circular meeting centre with a massive, closed triangular external form and large openings. This was a bold approach, as the competition seemed aimed towards reaffirming the concept of a shared landscape, aligning with Sydney's prevailing ideal of Arcadian houses/temples-in-landscape, which has consistently been regarded as a universal urban design solution. Branch Studio's design was perhaps too urban, a major issue for a city that mostly regards its own superb density and congestion – the forced perspectives and stacked-up terracing and bungalows on its hills – as things to be fought against or ignored rather than actively utilised.

Even their more rural designs carry the sense of settler Australians as urban beings, set in and adjusting to new surroundings, however restorative those surroundings may be. Much of their work draws from and flourishes in middle- and especially outer-fringe suburbs and semi-rural beach areas, mostly around Melbourne, a city that plays the role of Australia's officially less-glamourous São Paulo to Sydney's watery Rio.[8] Branch Studio's designs are also distinctive in referencing the Swiss Ticino region's architectural legacy,[9] though that tends to exist primarily in open

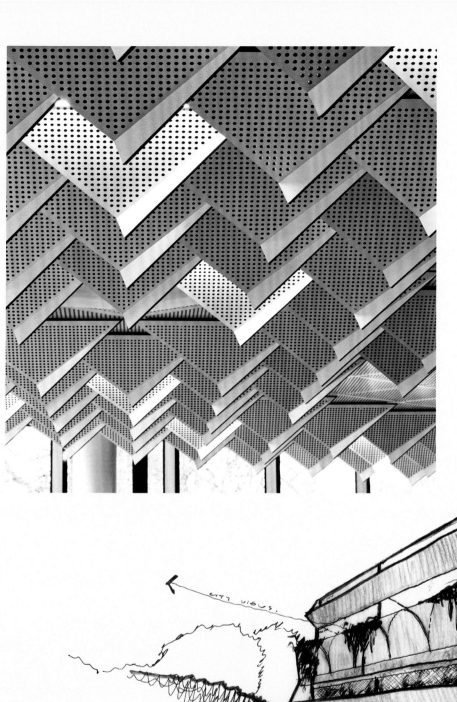

Left | Handmade acoustic panels on mass create a multidimensional ceiling landscape Quaine Library

Below | Houses to catch the sky townhouses

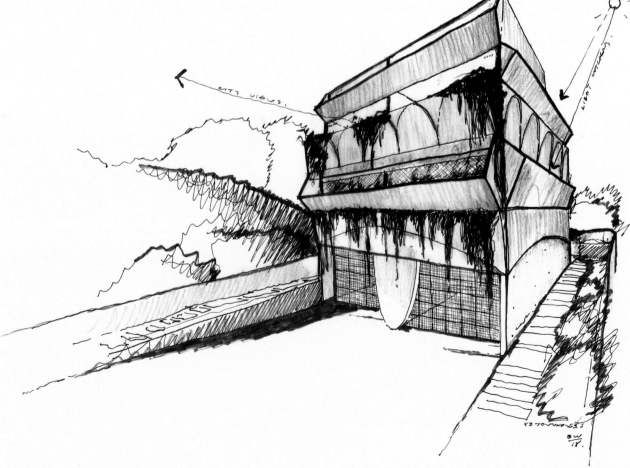

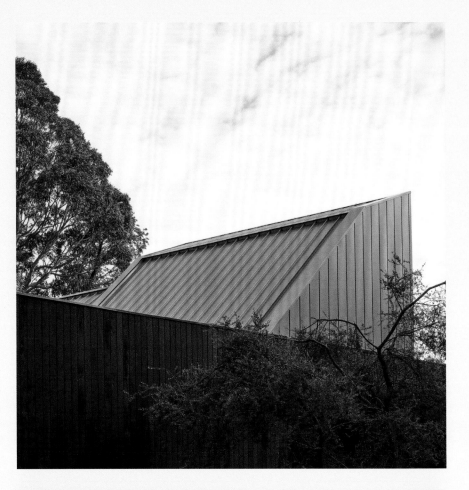

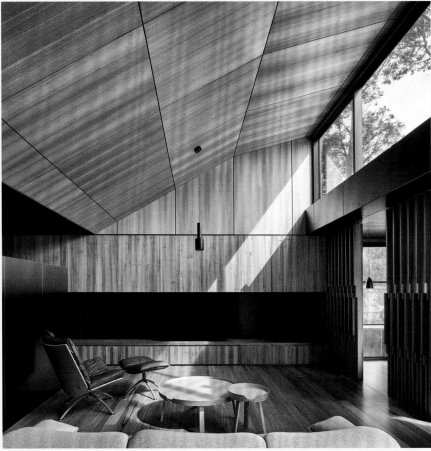

Above | Light-catching roof form Casa X
Right | Light-catcher over living area Casa X

land settings, as with Zumthor's more proximate designs, or in cityscapes of medium-high rather than low density. In contrast, Australian cities are somewhere in-between, and markedly low-density middle-outer suburban[10] in texture.

Ironically, despite Australia's official anti-suburbanism and the anti-suburban thrust in much Australian architectural commentary, Melbourne has become architecturally far more positive towards its everyday suburban life,[11] and its suburbs are to a marked degree the arena and basis of a rich and socially responsive architecture. In part this is a legacy of Hugh Stretton, and then of Peter Corrigan, Wray's teacher at Melbourne's RMIT University. RMIT's history curriculum, taught by Corrigan with Mauro Baracco and others, emphasised the role of wide and often varied architectural cultures – communities of practice – and adaptation to specific circumstance rather than the more common emphasis on examples of a few pivotal masters.[12]

MOVEMENT AND EPISODES

Branch Studio have had two earlier engagements with specific historical architectural ideas. One was an early and marked Expressionist turn in plan shape, of which their Our Lady of the Southern Cross Chapel in Berwick for St Francis Xavier College (2014)[13] and the Arts Epicentre at Caroline Chisholm Catholic College (2014–19; see pp 114–31)[14] are signature examples. Expressionism also shaped several house plans and returned in the design of the Urban Sanctuary Project, which reworks sweeping line patterns seen in Robin Boyd's Dower House (1968), Biltmoderne's Choong House (1985) and Edmond & Corrigan's first designs for St Joseph's Chapel (1976–77),[15] all in Melbourne. Hans Scharoun's Schminke house at Löbau, Germany, 1933) also influenced Branch Studio's transformation of the Arts Epicentre original square plan. For their Our Lady of the Southern Cross Chapel, which served two Catholic schools: St Catherine's Primary and Francis Xavier Secondary, they used a sweeping plan armature with intersecting curves bunched under the quite different geometry of a long, sloping roof. Other Expressionist affinities are doubtless influenced by Peter Corrigan's use of figuration, sparked by the 1950s German Expressionist resurgence in church architecture.[16] In Branch Studio's work, the movement resurfaces primarily in the shifting, often brief sense of encounter with various and distinct materials and moments, and in the sense of diverse origin in formal instants and episodes. The "episode", indeed, has been a recurrent centre of gravity in Australian architecture since its national Federation period in the 1900s, and Branch implement it in several ways described later.

> "In Branch Studio's work, the movement resurfaces primarily in the shifting, often brief sense of encounter with different materials and moments"

Another early point of focus, sustained more distinctly, was the crimped-roof form: folded in long triangles, needing only a light supporting structure such as a space frame. A discarded petrol station canopy of triangulated structural panels, moved and reworked as an unbuilt Canopy House (2012–13)[17] near Robinvale in Victoria's northwest, was Branch Studio's first use of the form, followed by their Casa X, at Philip Island on Victoria's southeast coast (2015–19).[18] The studio carry the concept through into recent institutional projects, such as the House of Technology at Caroline Chisholm Catholic College (2017).[19] Here, the crimping forms a two-layered clerestory set in a long, inclined roof form, as with Silverleaves, but reads as a distinct moment encountered fleetingly, above an expansive, open main floor. In part it recalls the optimism of small and largely everyday 1950s public buildings in Melbourne, and also the grand, open, yet colonnaded spaces of Mies's Berlin gallery.

Architecture is fundamentally stationary, but its capacity to express movement as "glimpsed" is considerable. This characteristic often co-ordinates both the presentation and variety of Branch Studio's referencing and is another recurring theme in their work, often expressed as an episode or moment glimpsed during a panning view. It is seen in the window and screen placements of their Pavilion Between Trees (2016; see pp 22–37), a private residence in Balnarring, also on Victoria's south coast, which parallels the glimpsed quadrant window set in the

elevation of Romaldo Giurgola's National Park Pavilion at Bar Harbor, Maine (1963),[20] where an arch and linear window surrounds seem to rush past at speed. The Quaine Library for senior students at St Monica's College Epping (2017)[21] has a partial arch, cantilevered from one side, and a lunette or semicircular window with a similarly allusive placement and image. The linear patterning and texture in the rammed earth used for Pavilion Between Trees evoke a comparable sensation. On the other hand, the layered pattern in the rammed-earth (pisé) technique presented in the more Expressionist Our Lady of the Southern Cross Chapel stabilises and "pauses" the sweeping walls.

WIDER AFFINITIES

This visual instability, or at least constant change within a single built form, is a time-honoured technique in the wider textures of High Victorian Gothic, as in the "changefulness" that John Ruskin sought in his favoured buildings, and explained so vividly in his famous essay "The Nature of Gothic", in his classic book *The Stones of Venice*. Such movement and energy were crucial to Peter Corrigan, whose coloration and window form were infused with a recast High Victorianism.[22] With Branch Studio, it is manifested in the varied, oscillating scale in the sourcing of architectural imagery and references – both from sources, initial ideas or connections that would traditionally be considered major, and from those that might seem trivial, serendipitous or accidental. The impetus here is thought through and balanced, Wray argues, and appropriate for its specific task or task patterns, and the breadth of sourcing represents a variety, pluralism and realism in imaging that reworks tenets of earlier architectural postmodernism. This is in itself interesting given the intense initial opposition felt between European architecture of the Tendenza and its otherwise related pluralist or inclusive schools in the US, Japan and Australia. In retrospect, their differences, sensed so acutely in critical circles of the late 1970s, may not, after all, have been so very distinct or different.

"Piazza Dell'Ufficio and the closely related Houses to Catch the Sky share the principle of textural monumentality seen in the work of architects from Rafael Moneo to Peter Zumthor"

Branch Studio's work shows other breadths of inspiration. For their Florence Street Studio, which for a time was Branch Studio's office (2017),[23] they turn the incomplete circle of the plans into cut-outs in elevation, hinting at Carlo Scarpa, Louis Kahn or even American Supergraphics of the 1970s. Branch Studio do not regard the changes of application or resited geometries as an issue. As with both major and minor references or ideas, if they serve the design and work on site, that is what matters. The House of Tomorrow competition design[24] sets out arcs, great and small, around jostling smaller spaces that fuse opposites, recalling the plan of Gunnar Asplund's Villa Snellmann (Djursholm, Sweden, 1918) and Robin Boyd's own Bergin House in Brighton, Victoria of 1952. The surprise seat alcoves in Branch's Piazza Dell'Ufficio speak of the dining alcove at Mies's Villa Tugendhat (Brno, Czech Republic, 1930), crucial in High Modernism. Branch Studio note Richard Serra's Arc installation in New York City (1981),[25] and that has a clear affinity, but the chair alcoves and their bundle-walling also evoke Paolo Portoghesi's dancing annuli and circles, as in his Casa Andreis and Casa Papanice in Rome (1964–9), and Church of the Holy Family at Salerno (1974). Portoghesi is famously identified with Neo-Liberty,[26] a pluralist architectural movement based in urban typology and generally regarded as opposed to both the Ticino School and to Iberian Rationalism. But, in retrospect, the process and the results seem similar, which bears out that European Rationalism and what was becoming known as architectural postmodernism are often very close.

This is certainly true of Melbourne's middle and outer suburbs where Branch Studio do much of their work. Piazza Dell'Ufficio and the closely related Houses to Catch the Sky share the principle of textural monumentality seen in the work of architects from Rafael Moneo to Peter Zumthor. Yet one also clearly recognises the forms and textured concrete of Trieste-raised Ermin Smrekar's Veneto Club (Bulleen, 1972), and his other houses and institutional buildings spread throughout suburban Melbourne. The link here is deliberate as well as fortuitous: through immigration

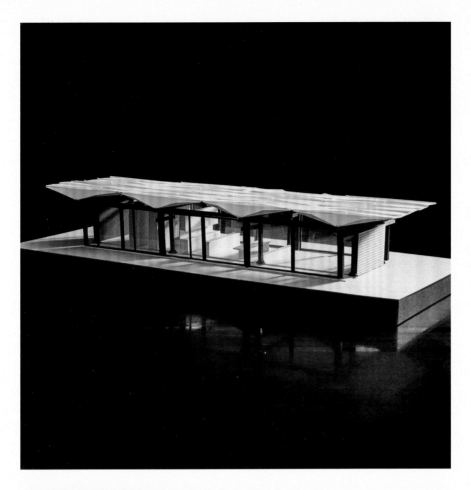

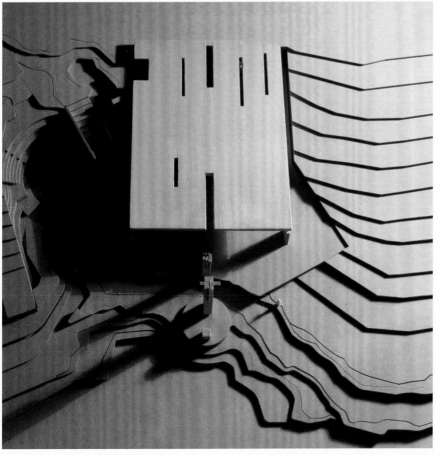

Above | Canopy House – an adaptive re-use project converting an existing petrol station canopy into a house for an artist

Left | Chapel at Salesian College – physical model

Right | Adaption and elaboration of Canopy House into an educational building. House of Technology proposal for Caroline Chisholm Catholic College

Below | House as continuous landscape. Sketch plan for House of Tomorrow design competition

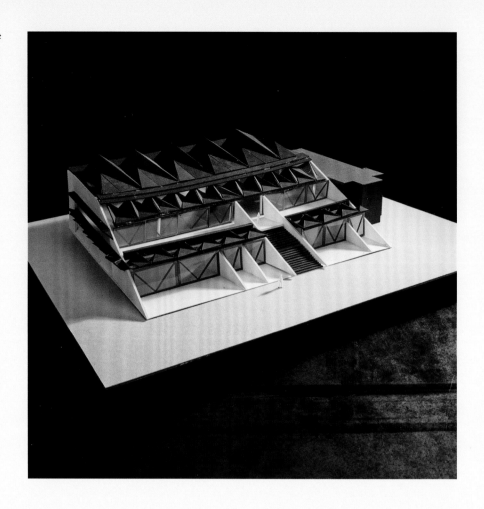

the threads of Melbourne's building culture are linked to those of distant south-central Europe and the Mediterranean. Branch Studio's European affinity is not a civilising mission, as such sourcing has often been in Australia, or a case of architects bringing the design world to the suburbs from some metropolis; their work is about the juxtaposition and frequent fit that popular European forms exhibit in a geographically distant setting. Hence ARCO in St Albans (2018–20; see pp 78–91), which fuses interior and exterior configuration in an enhanced gateway to a primary school in Melbourne's northwest fringe. It, too, has affinities with Mateus's House in Monsaraz[27] and its cantilevered concrete arch, massive and wide. But ARCO is quite different, light and welcoming, drawing visitors in, rather than gazing out at and commanding the landscape. Though drawing on Renaissance arches and colonnade gateways in masonry, Branch Studio's entry space transforms the expected weight and materiality into a screen-like structure of sheet steel that spreads an arriving visitor's gaze left, right and ahead all at once, while casually introducing the school's earlier buildings as a Renaissance gateway might.

ARCO's flipped materiality, and similarly flipped voids – arches, wall scoops and roof holes – show the way Branch Studio work with these elements, treating them as interchangeable between structure and plan, elevation and plan. This is reflected in their use of exploded perspectives in describing projects, as with the Flyover Gallery at Caroline Chisholm College (2014–15; see pp 132–43), which hint at instability in expected elevational and plan forms. This irreverence adds to the surprise and delights one feels when regarding Branch Studio's architecture. Expressionistic plans are tipped on their sides to form sections, as in their Mr. Boutique project of 2012, then revisited in the interior of the Flyover Gallery, where an amoeba-like section was formed to include integral seating and art display spaces.[28] This attitude is of a piece with their unorthodox approach to the value of their sources and references, ranging from nods to the Renaissance in ARCO's referencing, to the serendipitous use of weathered, galvanised steel sheets in ad-hoc cladding for the Orchard Studio in Officer, Victoria (2012).[29] The decorative flashes of hollow brick and wallpaper patterning often seen in European immigrant housing – widely regarded as suspect for years by "orthodox" Australian architectural commentators – are not only kept but accentuated in the architects' refurbishment of the modernist Writers House (2016)[30] built by prominent architectural designer Michael Feldhagen in 1968, in the Melbourne suburb of Caulfield South.

> "Branch Studio's European affinity is not a civilising mission, as such sourcing has often been in Australia, or a case of architects bringing the design world to the suburbs"

IMPACT REVERBERATION

The Expressionist plan form, seen in several early house plans and Our Lady of the Southern Cross Chapel, recurs as a shifting section inside the Flyover Gallery. Its bends and indentations are fitted to form seating and art display spaces, and although it draws on the bridge-gallery tradition of Florence's Ponte Vecchio, its exterior is a red-brown, steel-surfaced bridge reworking, in elevations this time, of the crimped-roof form the architects had previously used as a canopy. The red-brown envelope and the irregular core section also speak of the red ochre used in First Nations cave painting. At the Flyover Gallery, the bridge-corridor joins a festive circle of buildings around a quadrangle, with an answering Juliet's Tower (2016)[31] drawn in a gabled-house outline, in part-rusted galvanised steel sheeting, directly opposite the gallery walkway's span. Here the outline, presented as a screen, inverts Mateus's use of void house outlines in two institutional buildings, as do the monumentalising curve-sided panels used in Piazza Dell'Ufficio and Houses that Catch the Sky.

The General Purpose Flexible Learning Area (GPFLA; see pp 168–81), also at St Francis Xavier College (2015–19),[32] came straight on the back of the Flyover Gallery and exhibits a similar bridge sense. Its form also has connections with Frederick Romberg's heterogeneous and stepped-front apartment designs in 1940s Melbourne,[33] and with the German Expressionist tradition, as in the terraced fronts

leading up to Gottfried Böhm's Mary, Queen of Peace pilgrimage church at Neviges, Germany (1968), and Hans Scharoun's placement of classrooms as terraced housing in his postwar schools (1951–68). Branch Studio represent each class area by a step in elevation outside, set against diverse open areas behind in ways that recall the spatial variance created by fragmentation in Alvar Aalto's 1949 Baker House dormitory at the Massachusetts Institute of Technology (MIT), where a curved, undulating road front was answered by a splitting, fragmented side facing MIT's lawn at the rear.

Branch Studio's school projects, all on tight budgets, gained them recurring work. One that was immediately awarded in this manner was the Pamela Coyne Library. The clumped furniture problem in the hall and institutional building was solved by using stepped contours and stage-like divisions to create central spaces that are both filled yet flexible, while more specific articles of furniture – tables, chairs, carrels – were assigned ribbon-areas. The library itself has an internal sense of a landscape or town square, functioning like the convergence points in Scharoun's schools or the instant stage-spaces in Edmond & Corrigan's Melbourne architecture (1976–2001). As Peter Blundell-Jones has observed,[34] this relates to Expressionism but also to New Building as articulated by Hugo Häring; a current of architectural realism that runs counter to architectural modernism's more general pursuit of abstraction. This is realism in Charles Baudelaire's sense of the "heroism of modern life",[35] and in a variety of places – Italy, Scandinavia, the US, Germany and Australia – it has led architecture towards pluralism and simultaneity in different or divergent references and meanings, enhanced when leavened by abstraction or essentialism in moments or episodes. Australian architecture is well placed here, given it has a history – only now being realised – of urban and suburban-based architecture that argues in episodes, fragments and glimpses, and builds these up in various combinations. Wray and Russo themselves argue that their architecture is layered and collagist in formation, and they welcome the divergence implicit in added art episodes such as installed murals.

"Branch Studio stress narrative: through palimpsest, traces of wear, transformation, references to contexts and their mystique, and the shaping of light and reflection on materials"

In more inclusive regions of its architectural culture, Australian design has of necessity balanced this episodic form with an answer to Robert Venturi's "obligation toward the greater whole."[36] In Australia, this is often a strongly stated narrative in architectural form.[37] Branch Studio stress narrative: through palimpsest, traces of wear, transformation, references to contexts and their mystique, and the shaping of light and reflection on materials.[38] Transformation, for example, is both recall and a source of project individuation for Branch Studio. Mies's Neue Nationalgalerie in Berlin, which Wray and Russo so admire, has a modernised coffered ceiling, firmly in harness with Mies's brand of neoclassicism. Branch Studio transformed the coffered ceiling's legacy, first at the Quaine Library by reshaping an acoustic tiled ceiling with projecting triangular fins, casting a varied shadow pattern. This transformation is revisited for the Rupertswood Chapel at Salesian College in Sunbury, Melbourne (2022).[39] Here the Miesian frame is reasserted, but set against a tramping texture of ceiling ridges, the coffering rising and falling, transformed into panels below an earthen roof.

The Rupertswood Chapel design stands out from, yet is embedded within, the school's spectacular and calm rural site, but its inheritance from the Neue Nationalgalerie in Berlin's Kulturzentrum is deeply urban, just as the Flyover Gallery evokes Australia's red centre as much as central Florence or an Expressionist space from 1920s Berlin. This last raises another aspect of Branch Studio's design work: the way it addresses the rural-urban divide, which for various reasons is fraught territory in Australian architectural culture. Branch Studio straddle the rift almost gleefully, with Melbourne's suburbs as the meeting ground. They do so with ease, and their designs never have the narrowness of built essays as Robin Boyd's so often do. Boyd argued[40] that architecture had to focus on a single idea, where Branch Studio would argue that single idea could just as easily be read in multiples. And that belief reaches into every aspect of their architecture.

ENDNOTES

1. William Faulkner, "The past is never dead. It's not even past", in *Requiem for a Nun*, Random House (New York), 1951, p 49.

2. *Branch Studio Architects: Proemial*, Branch Studio Architects (Melbourne), 2017, p 40.

3. *Ibid*, pp 298–307, 358. Caroline Chisholm (1808–77), a Catholic convert, established immigration services, shelters and the first labour exchanges for women and families in New South Wales and Victoria.

4. http://branchstudioarchitects.com/houses-to-catch-the-sky.

5. See http://archdaily.com/468287/residential-building-zug-schleife-valerio-olgiati.

6. *Proemial*, p 69.

7. *Ibid*, pp 144–57, 355; http://branchstudioarchitects.com/pamela-coyne-library.

8. This is partly due to Australia's long-standing ruralist requirement that a "great city" should have "spectacular landscape" or expansive "sparkling water".

9. The Rationalist movement in Italian architecture emerged in the late 1960s to mid-1970s and was associated primarily with Aldo Rossi, Carlo Aymonimo, Giorgio Grassi, Franco Purini and Laura Thermes. It shared the same typological basis as Neo-Liberty but was far more reductive, generalising and abstract in final form, and governed by a Marxist alignment that rejected as populism contemporary American linkages of typology to overt commercial imagery. The Ticino school was an offshoot, as were contemporary rationalisms in Austria, Germany and France. See Andrew Peckham and Torsten Schniedeknecht (eds), *The Rationalist Reader: Architecture and Rationalism in Western Europe 1920–1940/1960–1990*, Routledge (London), 2013.

10. That is, dominated by detached houses and at relatively low population density and, in Australia, spreading in what resembles sprawl but is usually a fairly controlled pattern where five or six tributary suburbs spread round a series of commercial and transport nodes that develop from rural townships or replicate when need arises. See Ian Nazareth, Conrad Hamann and Rosemary Heyworth, "A Hundred Local Cities: How Nodal Suburbs Shaped the Most Radical Change in Melbourne's Suburban Development, 1859–1980", *Proceedings of the Society of Architectural Historians, Australia and New Zealand (SAHANZ) 38 Ultra: Positions and Polarities Beyond Crisis*, SAHANZ, 2022, pp 285–97.

11. Sydney, significantly, has seldom queried Australian anti-suburbanism, and its dominant homestead-in-landscape ideology for Australian architecture generally has reinforced that attitude in its own architectural culture. Robin Boyd's depiction of "the Australian suburb" in his *Australia's Home*, Melbourne University Press (Melbourne), 1952, pp 2–4, was the pivotal formulation for Australian architecture, hinging on just two pages of vignettes and assertion, and then diffusing into instances of perceived cultural stasis. Few Australian architects have ever explored suburban morphology further. American critiques linking suburbs with universal conformity, as in David Riesman et al's *The Lonely Crowd*, Yale University Press (New Haven, CT), 1950 or William Whyte's *The Organization Man*, Simon & Schuster (New York), 1956, probably solidified Boyd's stance and constructs for his *The Australian Ugliness*, Cheshire (Melbourne), 1960. Hugh Stretton was the earliest Australian revisor in his *Ideas for Australian Cities*, Sun Books (Melbourne), 1975,

augmented by Alan Gilbert, "The Roots of Anti-Suburbanism in Australia", in SL Goldberg and FB Smith, *Australian Cultural History*, Cambridge University Press (Melbourne), 1988, pp 33–49, and Graeme Davison et al, *The Cream-Brick Frontier: Histories of Australian Suburbia*, Monash University Press (Melbourne), 1995. Recent overviews include Alister Greig, "Review: The Way We Live", *Griffith Review: Dreams of Land*, Summer 2003, pp 50–54, and Gary Kinnane, "Shopping at Last! History, Fiction and the Anti-Suburban Tradition", *Australian Literary Studies*, vol 18, no 4, 1998.

12. See Conrad Hamann et al, *Cities of Hope: Australian Architecture and Design by Peter Corrigan and Maggie Edmond, 1962–1992*, Oxford University Press (Melbourne), 1993, revised as *Cities of Hope Remembered/Rehearsed*, Thames & Hudson (Melbourne), 2012.

13. *Proemial*, pp 206–19, 357; http://branchstudioarchitects.com/our-lady-of-the-southern-cross-chapel.

14. *Ibid*, pp 276–85, 360. See also http://branchstudioarchitects.com, where Brad Wray gives a short talk on the building.

15. Shown in Robin Boyd, *Living in Australia*, Pergamon Press (Melbourne), 1970; Vanessa Moroney, "Revisited: Choong House", *Architecture AU*, 22 September 2017, via https://architectureau.com/articles/130-136-ah116_revisited_choong, and Hamann et al, *Cities of Hope*, pp 16, 78–82.

16. *Cities of Hope*, pp 10–11. The German movement dominated postwar rebuilding, and was marked by architects such as Rudolf Schwarz and Gottfried Böhm, arguably influenced by the theologian Romano Guardini. Summarised in Hugo Schnell, *Twentieth Century Church Architecture in Germany*, Schnell & Steiner (Munich), 1974. Peter Corrigan lectured on Schnell and Schwarz's ideas in the early 1960s.

17. *Proemial*, pp 344–53, 355. Branch Studio relate that the design was originally built for Mobil by a group led by Gordon Nicholson (p 344). The canopy and its enclosed undercroft, clearly separate visually, linked in principle to Robin Boyd's Pelican house (1956), now demolished, at Mount Eliza, to Melbourne's south. See "Chronological, List of Works by Robin Boyd", *Transition*, 38, 1992, p 208.

18. *Proemial*, pp 264–75, 360; http://branchstudioarchitects.com/casax.

19. http://branchstudioarchitects.com/technology-building.

20. Romaldo Giurgola, "Reflections on Buildings and the City: The Realism of the Partial Vision", *Perspecta*, 9/10, 1965, pp 107–30.

21. *Proemial*, pp 186–205, 360; http://branchstudioarchitects.com/quaine-library.

22. See Hamann et al, *Cities of Hope*, pp 146–7.

23. *Proemial*, p 361.

24. *Ibid*, p 357.

25. *Ibid*, p 64.

26. Earlier critiques are in Reyner Banham, "Neoliberty: The Italian Retreat from Modern Architecture", *Architectural Review*, 747, April 1959, pp 231–5, and Vittorio Gregotti, "Striving for Reality", in his *New Directions in Italian Architecture*, George Braziller (New York), 1968, p 47. Portoghesi outlines much in the movement in his *After Modern Architecture*, Rizzoli (New York), 1981, and Alan Colquhoun summarises the movement well in his *Modern Architecture*, Oxford University Press (Oxford), 2002.

27. Matheus Pereira, "House in Monsaraz/Aires Mateus"; http://www.archdaily.com/918263/house-in-monsaraz-aires-mateus.

28. *Proemial*, pp 355, 94–5, 106–07.

29. *Proemial*, pp 132–43, 354; http://branchstudioarchitects.com/orchard-studio.

30. *Proemial*, pp 108–31, esp 122–3, 128–9, 358; http://branchstudioarchitects.com/writershouse.

31. *Proemial*, p 105, 358; http://branchstudioarchitects.com/juliets-tower.

32. Francis Xavier (1506–52), among the first Jesuits, is an important saint in Australia, being patron to East Asia and the Pacific.

33. These stemmed from Romberg's admiration of what he called Melbourne's veranda row housing (terraces), and show in his Newburn (1939–41), Yarrabee (1940) and Stanhill (1943–51) apartments, all in inner Melbourne suburbs.

34. Peter Blundell-Jones, *Hugo Häring: The Organic Versus the Geometric*, Edition Axel Mendes (Fellbach), 2002.

35. Charles Baudelaire, "The Salon of 1846: On the Heroism of Modern Life", in Francis Frascina and Charles Harrison (eds), *Modern Art and Modernism: A Critical Anthology*, Westview (New York), 1982, pp 17–18.

36. Robert Venturi, *Complexity and Contradiction in Architecture*, MIT Press (New York), 1966, pp 88–105.

37. I argued this in "Patterns, Translations, Narratives: Australian Architecture-Themes in a Diverse Culture", in Neil Durbach et al, *Abundant/Australia: 11th International Architecture Exhibition*, Venice, 2008, pp 10–37.

38. *Proemial*, p 59.

39. http://branchstudioarchitects.com/rupertswood-chapel.

40. Boyd reiterates the idea throughout his *Puzzle of Architecture*, Cambridge University Press (Cambridge), 1965.

Project	ARCO
Type	Educational
Location	St Albans, Victoria, Australia
Project duration	2018–20

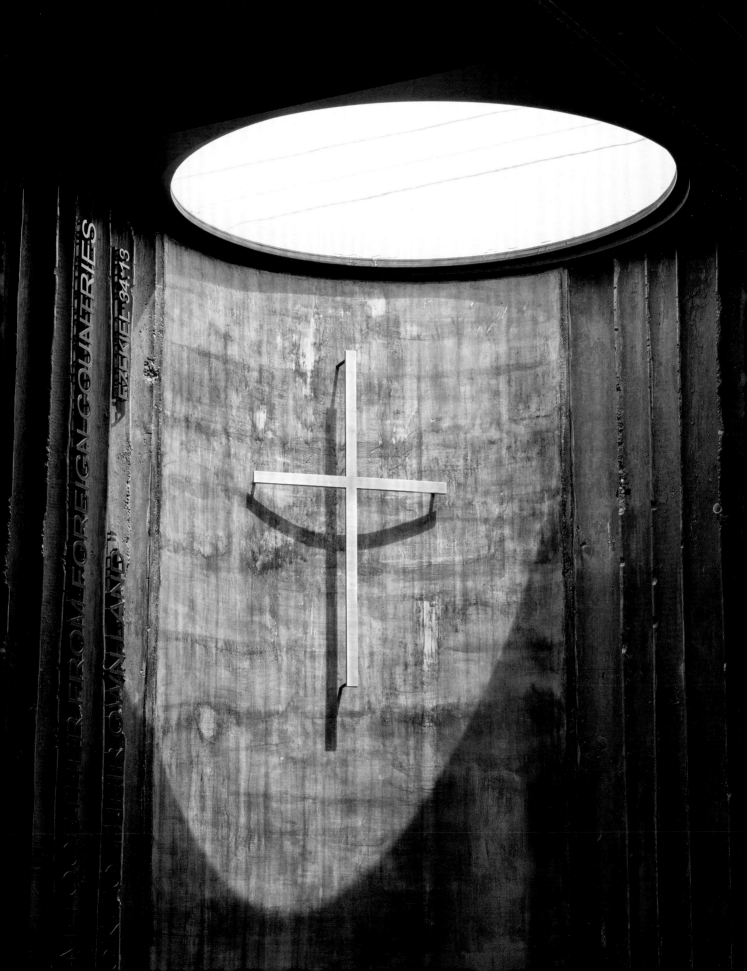

In 2018, Branch Studio Architects were invited to design a formal entrance space and identity for Sacred Heart Catholic Primary School following an extensive rebuild by another architect. They conceptualised and elaborated upon the brief to create a solution consisting of four main elements: an entrance canopy, signage, a gate and a new landscape interface.

The canopy is intended to protect against the elements during student pick-up and drop-off. Its main elevation to the street was conceived as a formal archway similar to those seen in Roman ruins, and used to inform the canopy's planimetric and elevational logic. The result is a series of distinct spaces within the courtyard created using a single form. Formed of steel plate with no columns or beams, the structure's rigidity and integrity are maintained by a web-like steel plate on the underside.

The primary structural support consists of a single curved, black-oxide concrete wall poured in-situ that also encloses a small chapel space for reflection – an addition to the clients' brief, proposed by the architects – which also houses liturgical scriptures and a cast brass cross. Pine poles were used in the formwork to produce a scalloped and ribbed internal texture within, resulting in a tactility that invites users to physically connect with the architecture. Two circular cut-outs in the canopy roof allow light to permeate the chapel and "play" along its walls throughout the day.

The new signage was rationalised as a scalloped concrete pole incorporating the school's name in cast brass letters, creating an element of presence through formal mass. Deliberate control of scale maintained approachability in relation to the primary school's students.

School security was one of the brief's priorities, with the proviso that the building was "not to look like a jail". The architects conceived of the new motorised gate as an event – a pleated-steel stage curtain, transparent from the inside and opaque from the outside – which opens to unveil the school to the community.

The existing, barren concrete slab of the entrance area was partially retained, cut and given various floor treatments to establish flowing patterns and spaces inspired by the work of the Brazilian landscape designer Roberto Burle Marx. Timber benches around the perimeter in conjunction with soft landscaping offer practical places to sit and wait, while adding a material softness and counterpoint to the black canopy and chapel.

Previous pages left | Ribbed profiled concrete takes on the proportion of a child's hand as an act of provoking physical interaction and tactility

Previous pages right | Sacred light. A circular skylight permits changeable light play across the wall during the day

Opposite top | Entry interface with customised signage tower and draped mesh security gates

Opposite bottom | Internal canopy view with webbed steel underside and formal arched opening looking back towards entry gates

Overleaf | Internal canopy view with reflective chapel space looking back towards entry gates

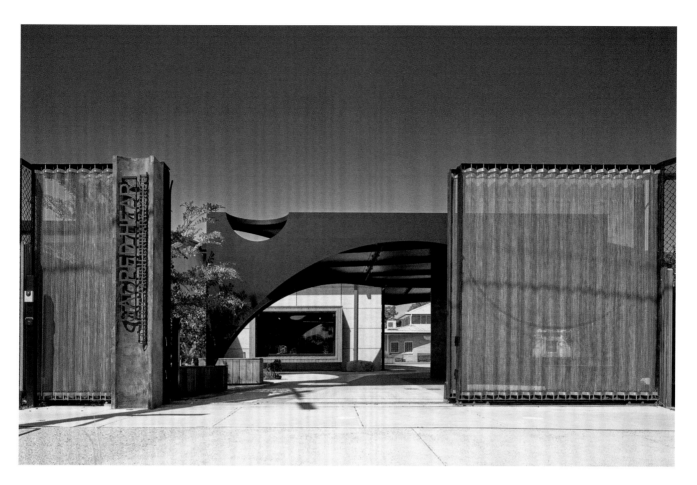

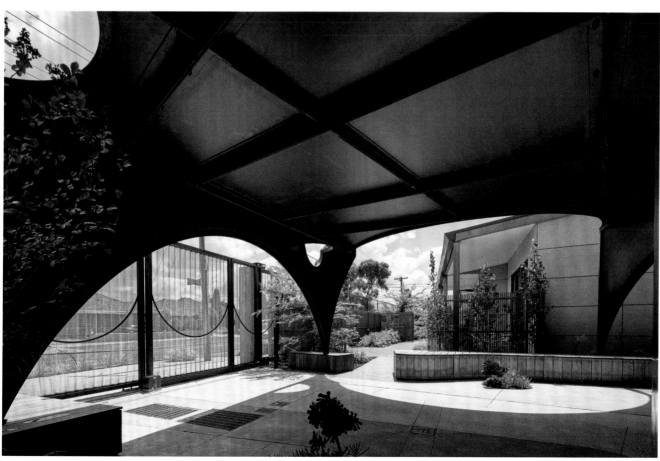

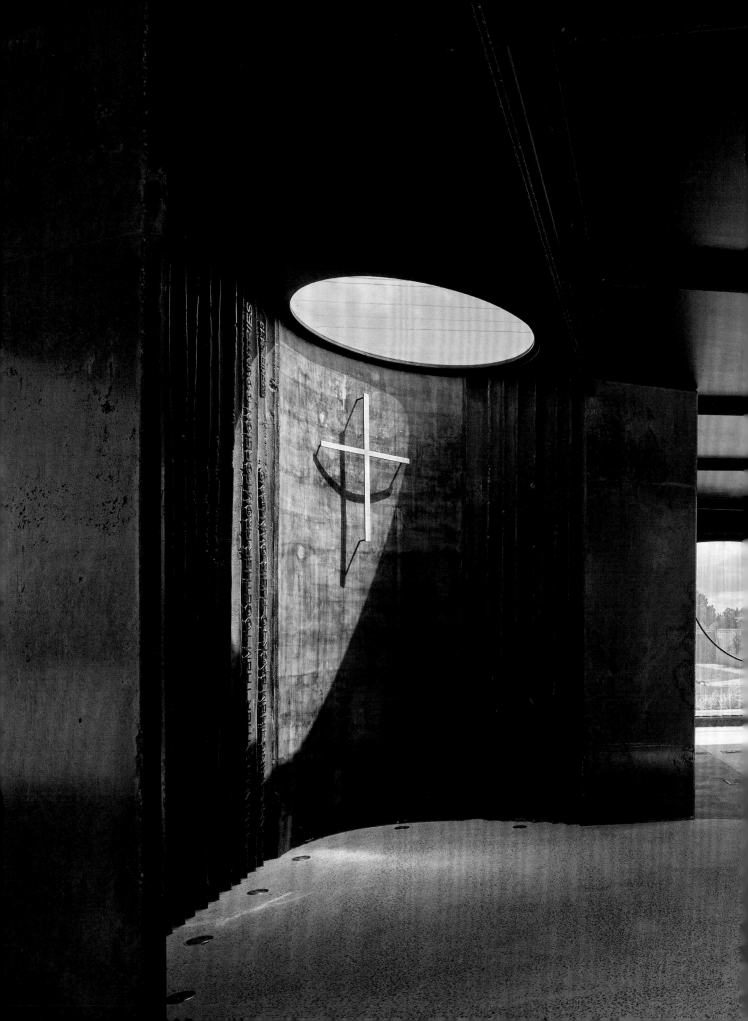

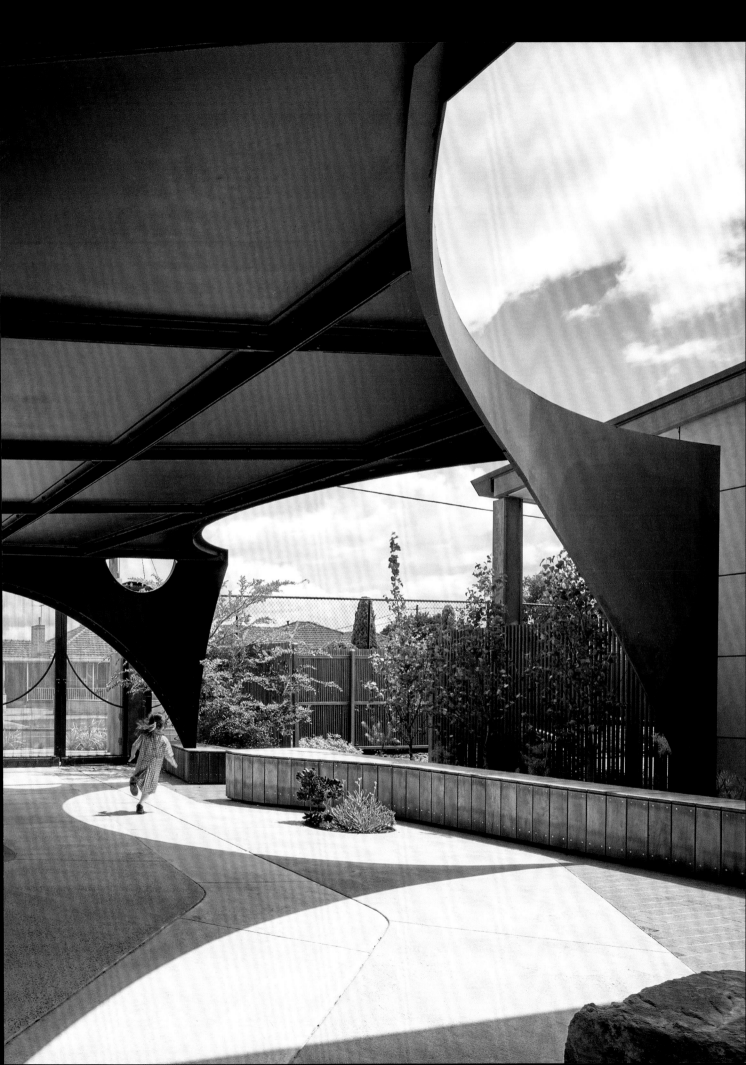

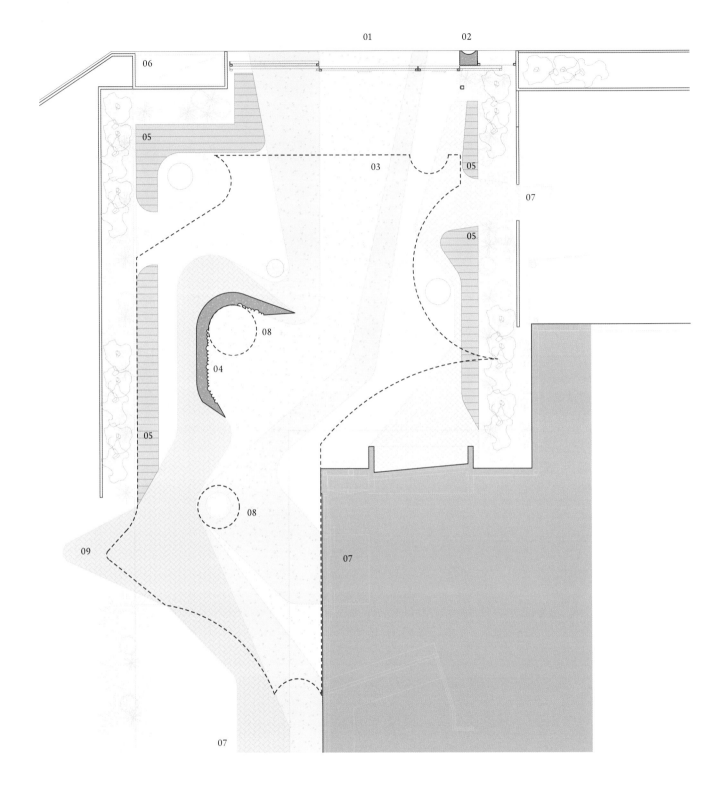

GROUND FLOOR PLAN 1:100
01. Street entry gate
02. Signage
03. Archway
04. Chapel
05. Bench seat
06. Existing fire panel
07. Office entry
08. Skylight
09. Future Kinder

Opposite | Physical model

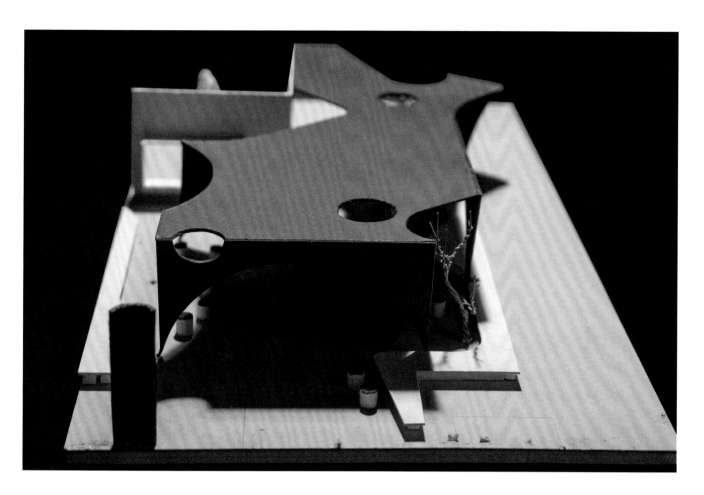

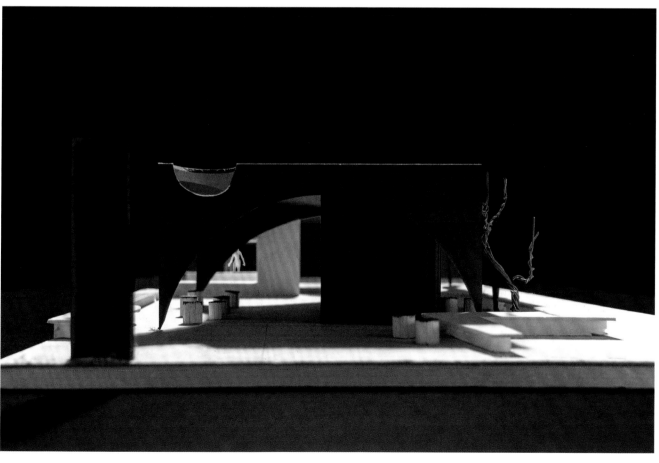

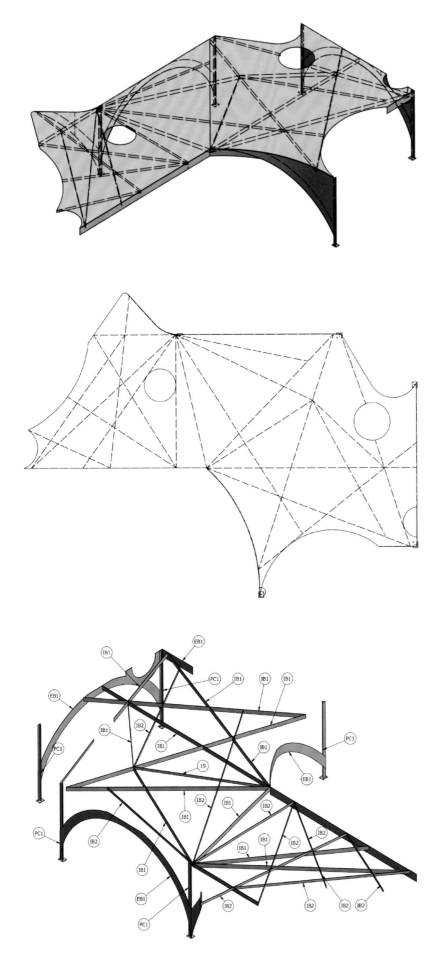

Left | Structural isometric – canopy is made entirely from steel plate with no traditional columns and beams

Opposite | Roof form in site context with existing buildings

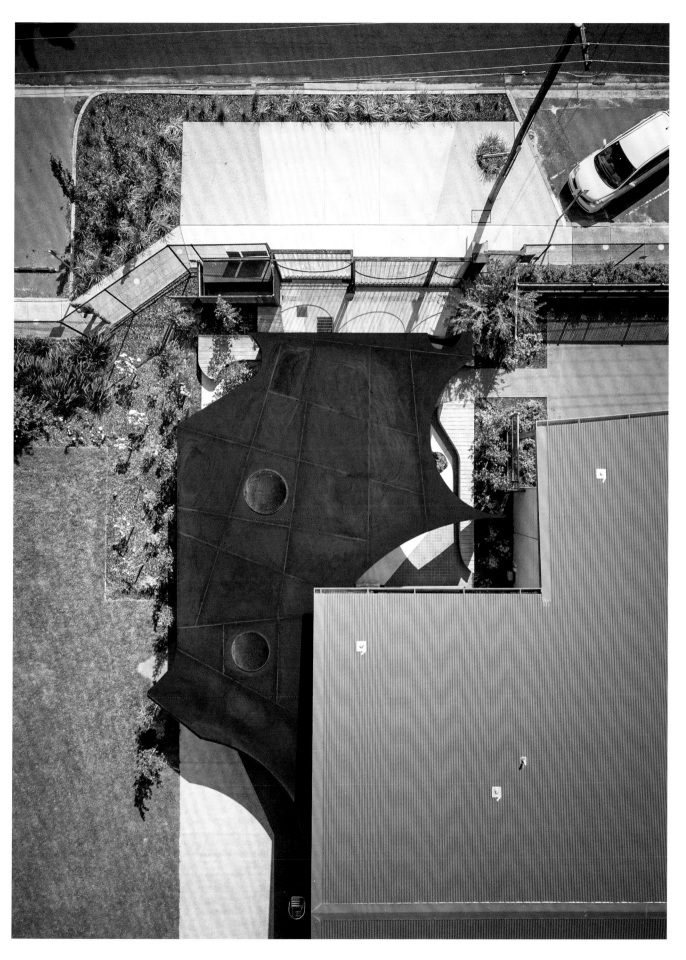

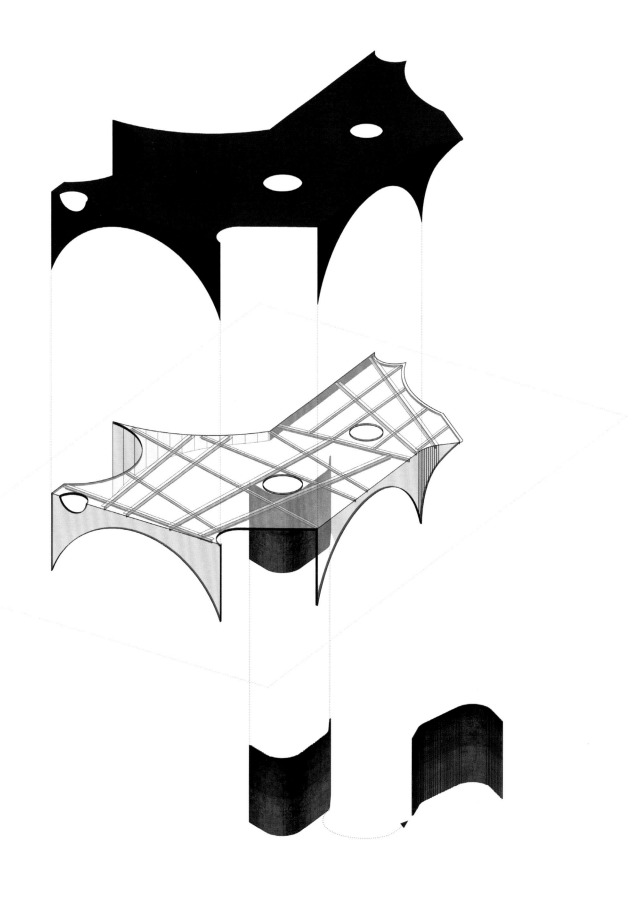

Opposite | Sketch plan – composition of canopy and landscape as a layered continuity

Above | Exploded isometric – form, canopy structure and chapel

Overleaf | Entry interface – canopy and landscape

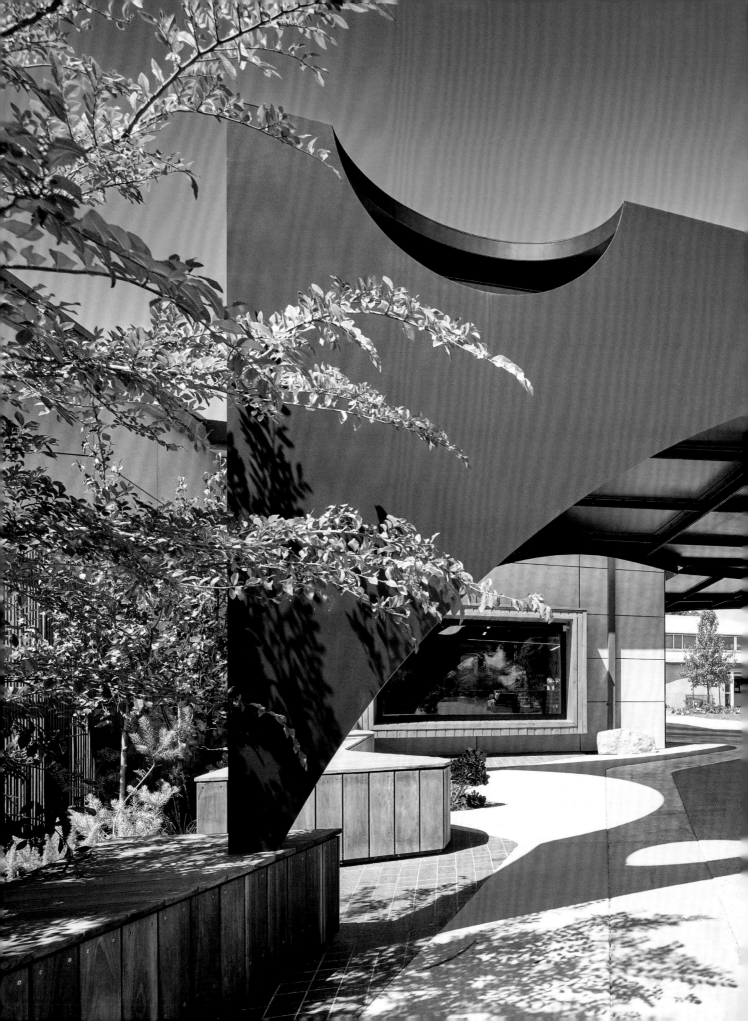

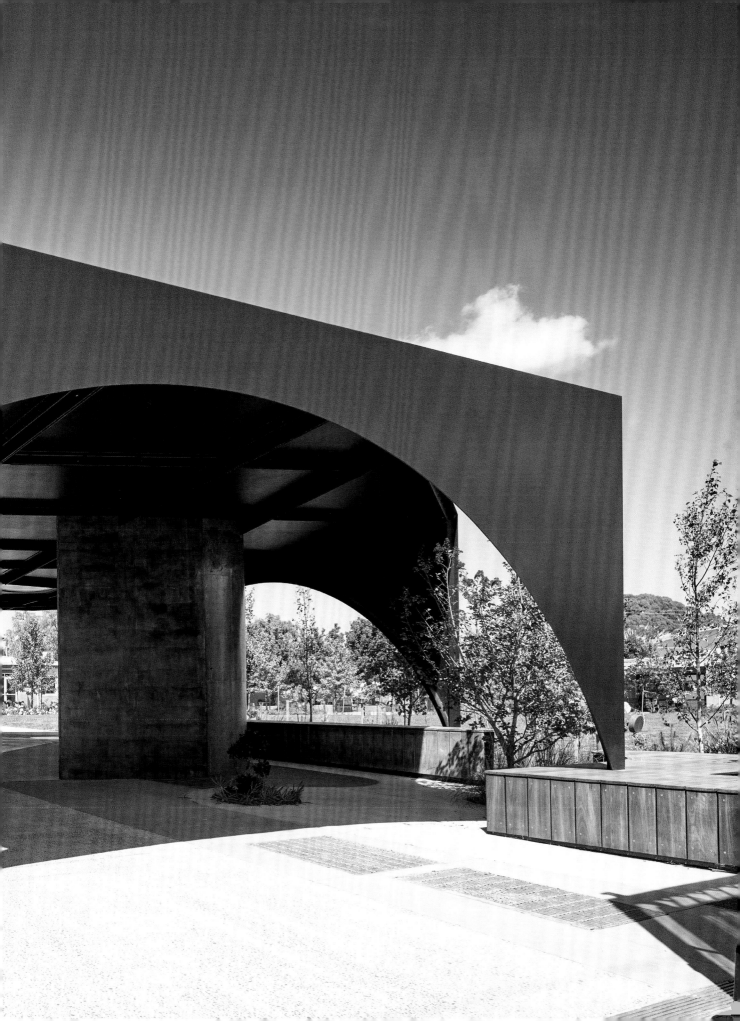

Project	CASA BOBBANARRING
Type	Residential
Location	Mornington Peninsula, Victoria, Australia
Project duration	2017–21

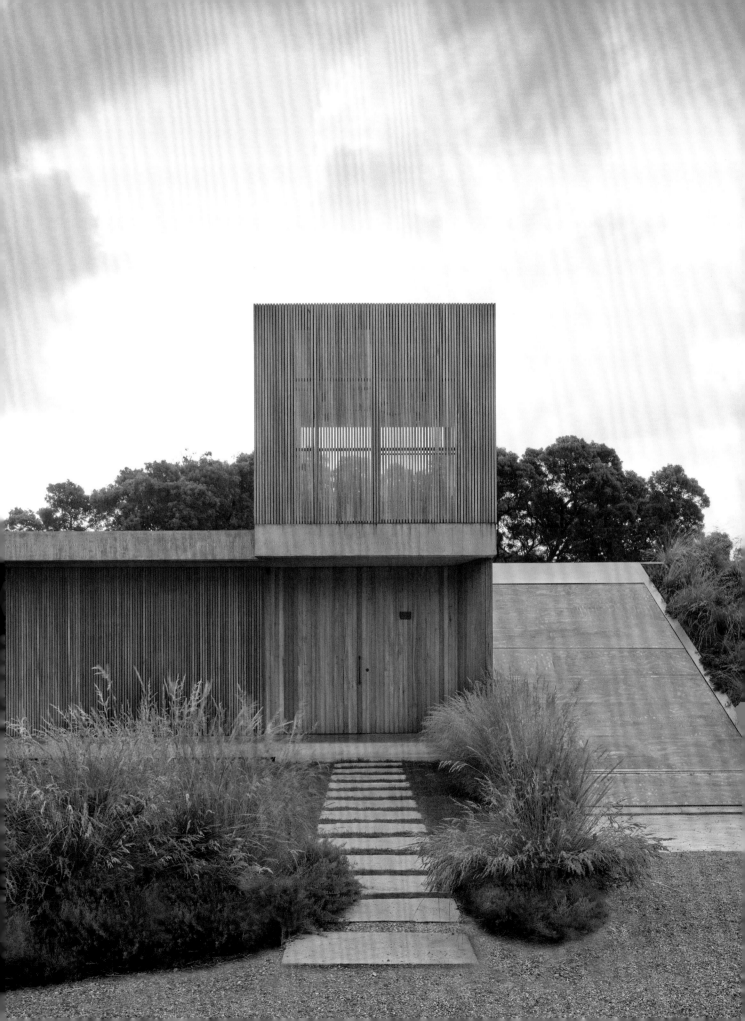

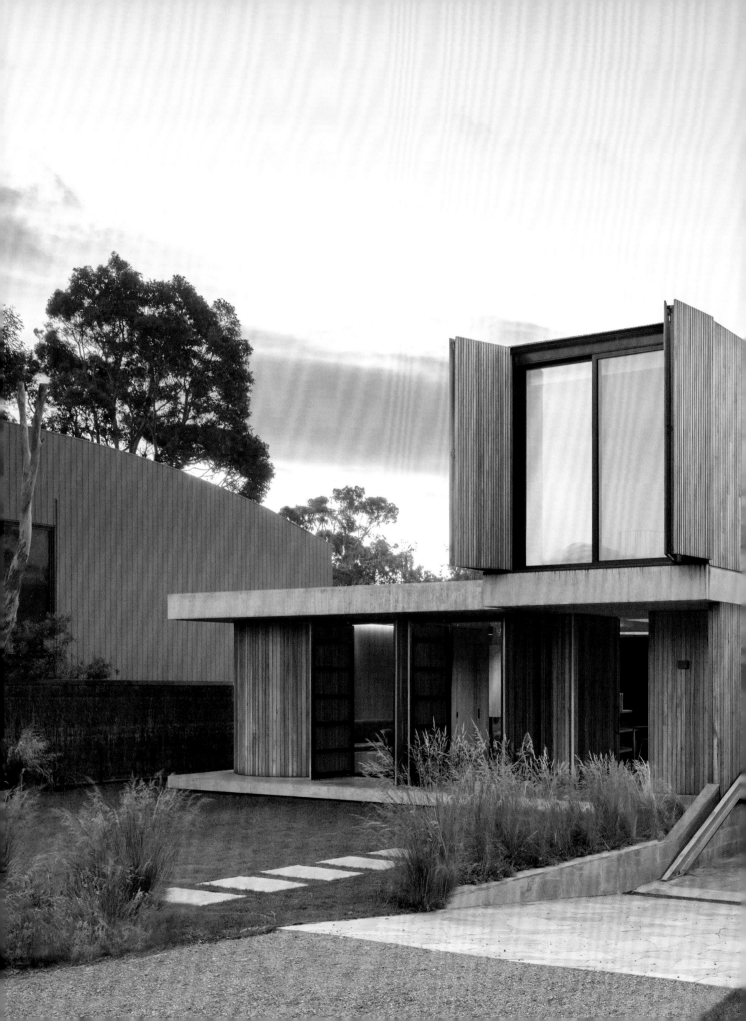

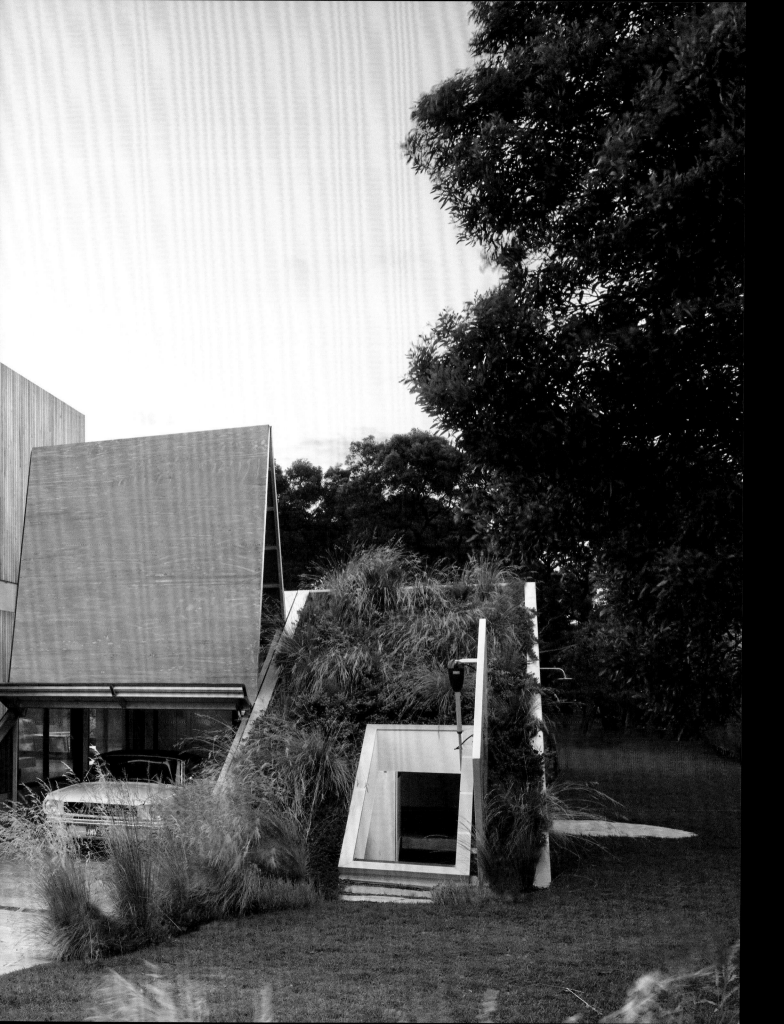

The house is located on the promenade frontage, opposite the boat club at Point Leo in Victoria, southeast of Melbourne. Called Bobbanarring after the Aboriginal (indigenous) name for the Point Leo area, it is set back from the street and foreshore to the south behind a large open grassy area, and looks into a vividly contrasting green sanctuary space, dotted with large, dark-trunked blackwood trees, to the north. The clients approached Branch Studio with an initial idea informed by Brazilian modernist concrete architecture from the 1950s. The architects used Oscar Niemeyer's own house, Casa das Canoas (1951), as a starting reference, given its strong relationship to its Rio de Janeiro jungle site and expressive flowing concrete canopy that created a seamless transition between inside and outside.

Casa Bobbanarring's concrete roof seems to hover over its lower concrete slab, which is elevated approximately 25 centimetres to distinguish it from the ground plane and allow low native vegetation to flow freely under and around the house. The house seemingly floats within its site. The limited material palette of native Australian timber both inside and out, and black aluminium windows, as per the client's brief, are in harmony with the context, and establish visual cohesion and spatial clarity.

The house opens to the north through a formal concave curve in the roof profile, allowing natural light to penetrate deep into the open-plan and continuous kitchen, living and dining spaces within. A series of apertures in the roof also let in light, which celebrates and formally highlights important areas such as the main dining area. A central circular pool with incorporated spa provides a strong datum for the courtyard. Pool balustrades are visually light and open to provide a continuity beyond the courtyard with the wooded sanctuary space to the rear of the building.

Bedrooms are placed around the perimeter of the building to the north, facing into the central courtyard and the forest-scape beyond. The extension of the roof form visually increases the feeling of size and connection to place. These more intimate residential spaces are deliberately secluded from the street to the south. Bathrooms and wet-room areas are treated as darker residual areas, but all have their own visual link to the courtyard and captured landscape within.

The garage/gallery space, study, pantry, laundry, front entrance and "jewel box" – an area designed to house surfboards – are all pragmatically placed towards the southern end of the site facing the street. The roof of the garage/gallery offers a theatrical moment as it opens diagonally and then folds back over on itself to reveal its contents. Similarly, access to the jewel box is controlled by means of a motorised flap, which opens to expose the interior of the landscaped hill. A small multipurpose room on the upper floor captures the only possible ocean view through a break in the trees on the nearby foreshore.

The frontage of this single private residence is designed as a pair of conceptual hills or dunes, creating a formal continuity with the surrounding landscape and partial concealment from the street. Native grasses and shrubs cover part of the elevation to bunker the house within its site and context. Operable, vertically slatted timber shutters form a visual continuation of the exterior cladding of the building's east and west walls, allowing the house to be closed down and opened up at specific times of the day, resulting in a highly adaptable living space that can be very open and public or very private.

Previous pages opener left | Detail of ground floor operable timber screens

Previous pages opener right | Entry sequence in closed configuration providing a glimpse of the landscape beyond

Previous pages | View from driveway with house in open configuration

Opposite top | View from front yard with house in closed configuration

Opposite bottom | View from south-eastern boundary. Continuity with landscape – house as dune

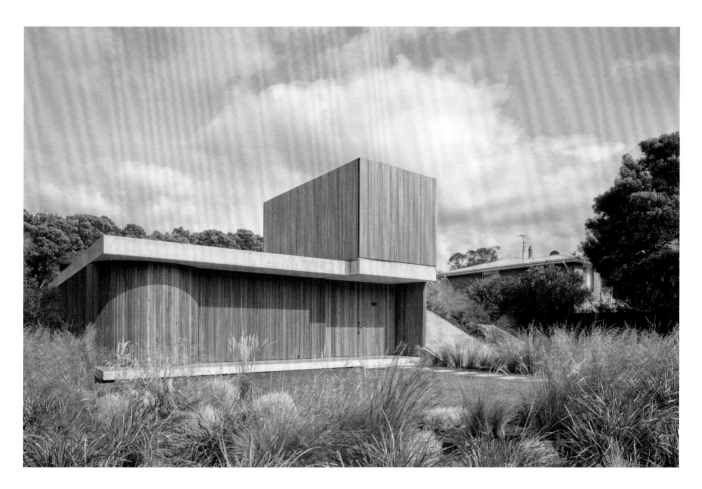

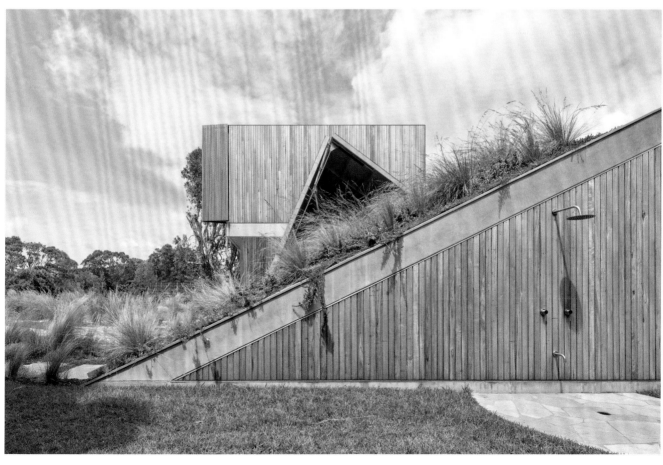

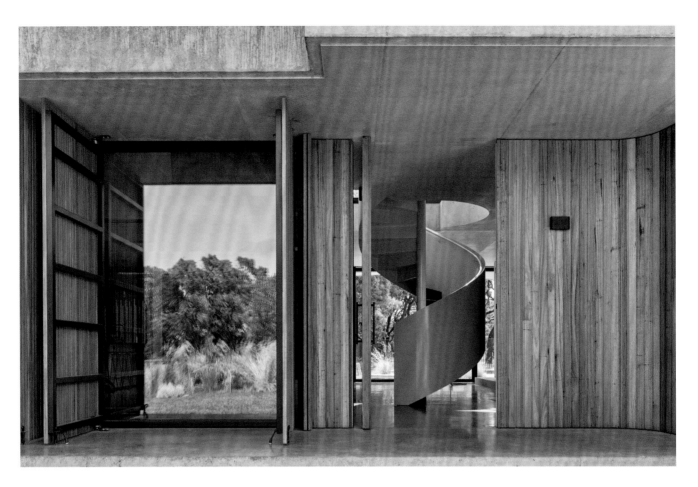

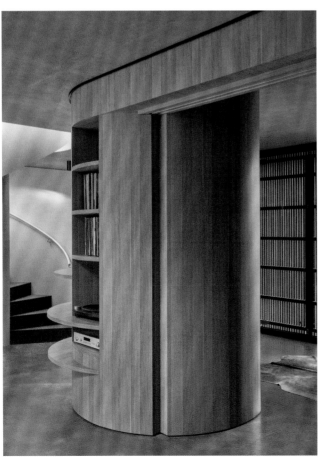

Above | Front door entry sequence

Left | Internal multifunctional and multidimensional joinery unit

Opposite | Entry sequence looking back towards front door in closed configuration for privacy

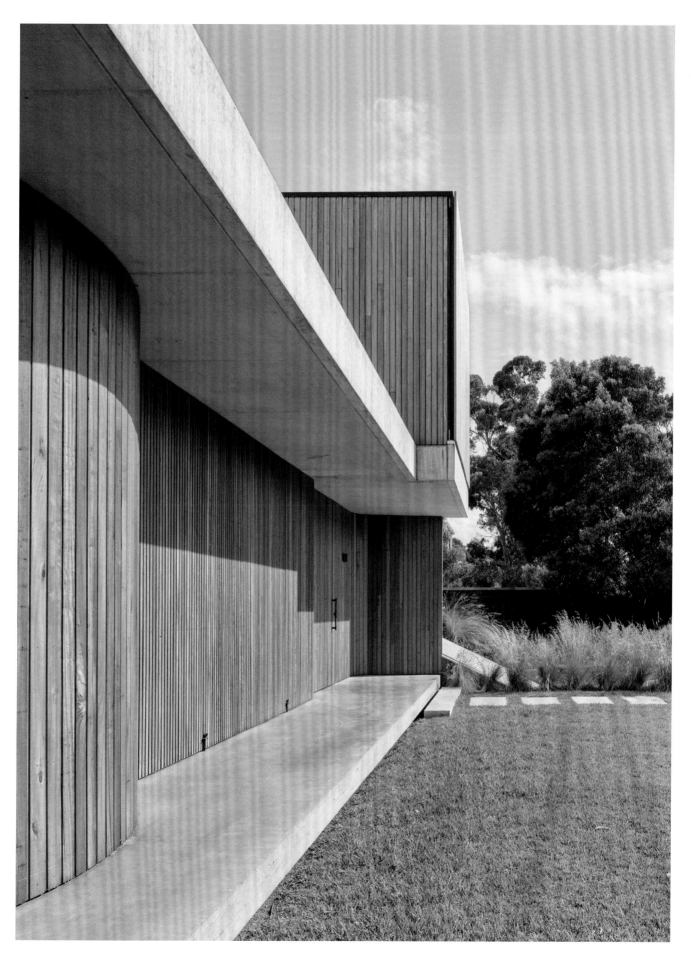

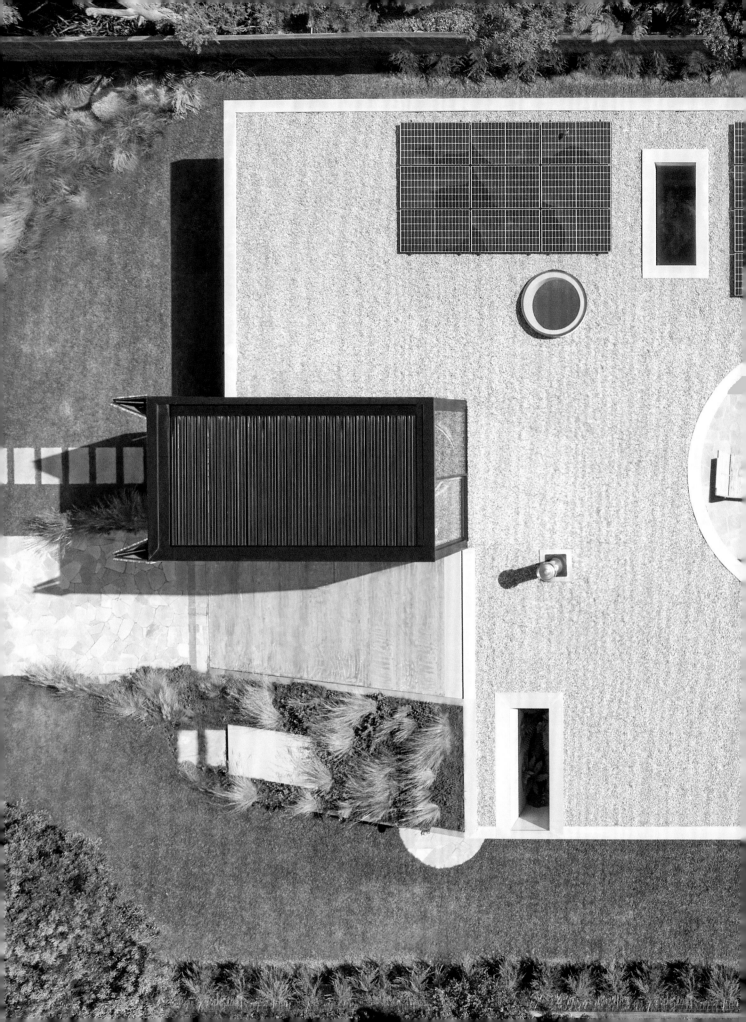

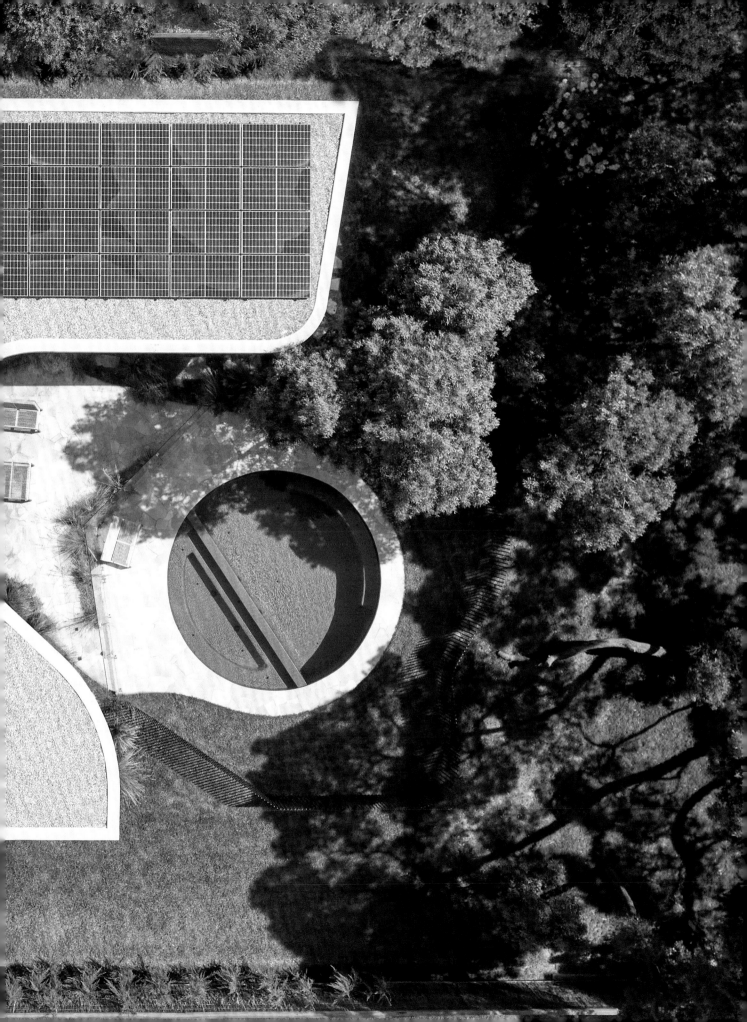

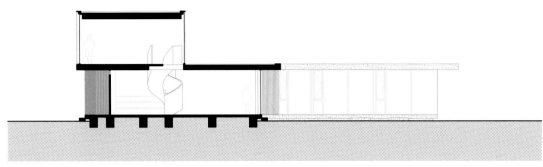

SECTION A

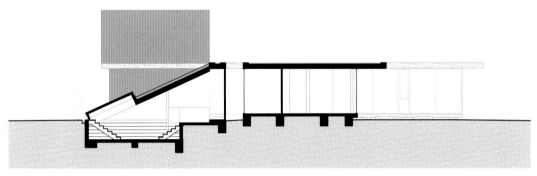

SECTION B

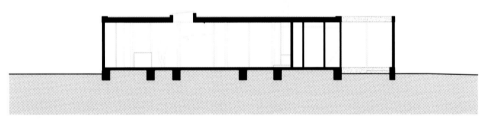

SECTION C

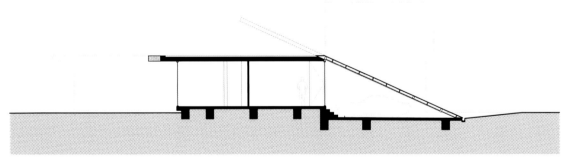

SECTION D

Previous page | Aerial perspective within site context

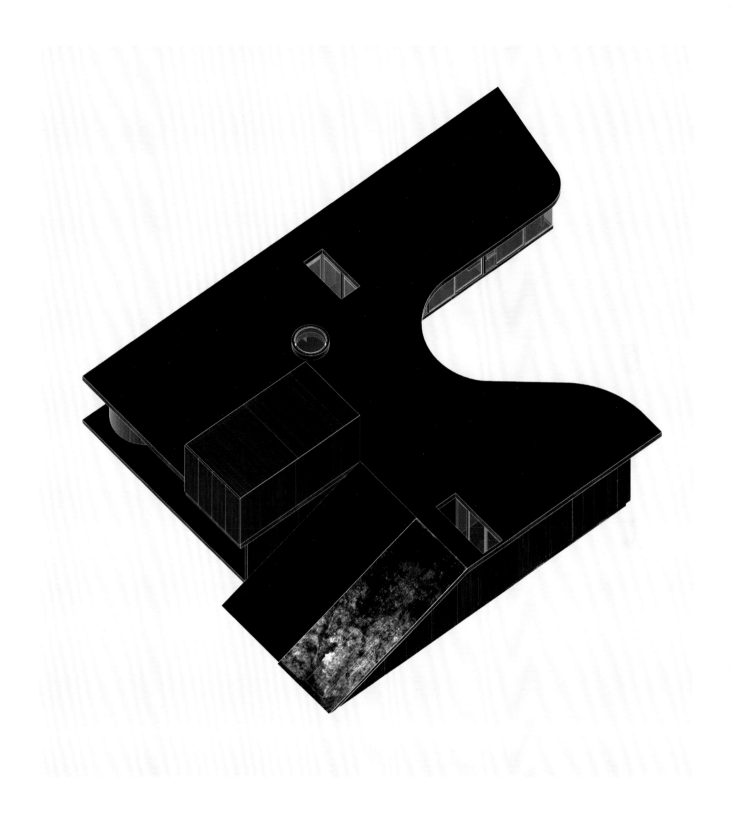

CONSOLIDATION

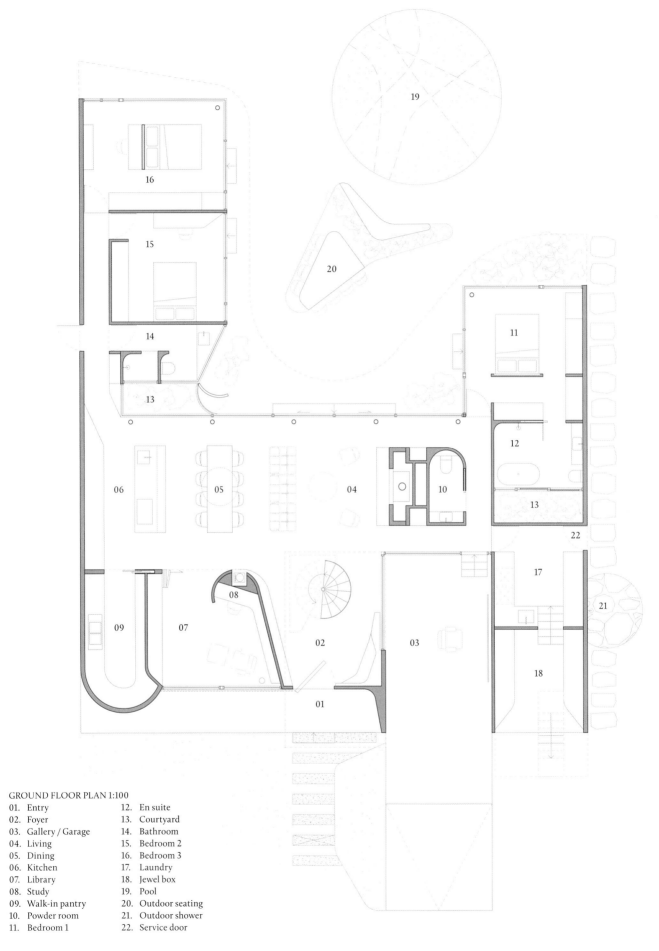

GROUND FLOOR PLAN 1:100

01. Entry
02. Foyer
03. Gallery / Garage
04. Living
05. Dining
06. Kitchen
07. Library
08. Study
09. Walk-in pantry
10. Powder room
11. Bedroom 1

12. En suite
13. Courtyard
14. Bathroom
15. Bedroom 2
16. Bedroom 3
17. Laundry
18. Jewel box
19. Pool
20. Outdoor seating
21. Outdoor shower
22. Service door

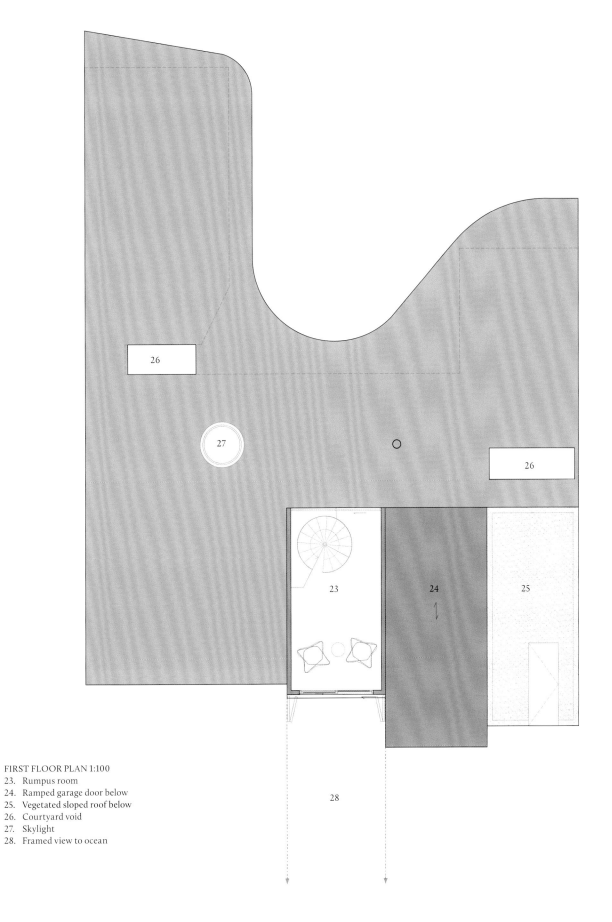

FIRST FLOOR PLAN 1:100
23. Rumpus room
24. Ramped garage door below
25. Vegetated sloped roof below
26. Courtyard void
27. Skylight
28. Framed view to ocean

CASA BOBBANARRING
IN CONVERSATION
/
Michael White
/
Nicholas Russo
/
Brad Wray

Michael White Let's begin by talking about the location of Casa Bobbanarring.

Brad Wray It's on the promenade at Point Leo in Victoria, about 70 kilometres southeast of Melbourne. Bobbanarring is the indigenous name for the area. It's an interesting site as you are basically on the foreshore, but – given there is quite a setback from the houses to the main road that runs through the area – you are actually somewhat removed from it in the traditional sense, though the frontage is quite exposed.

At the rear of the site is a beautiful, vivid-green, small-forest-like space, which is heavily contrasted with the black, almost charred-looking trunks of surrounding trees. The rear yard is one of my favourite spaces, a real sanctuary in the middle of quite closely knit houses.

MW How did the client and project come to be?

BW Our clients saw another of our projects in a magazine and liked our work. They had a passion for Brazilian modernism and wanted a concrete house, which was something we'd been wanting to do for a long time. We also love that era of Brazilian architecture, so that was a good start.

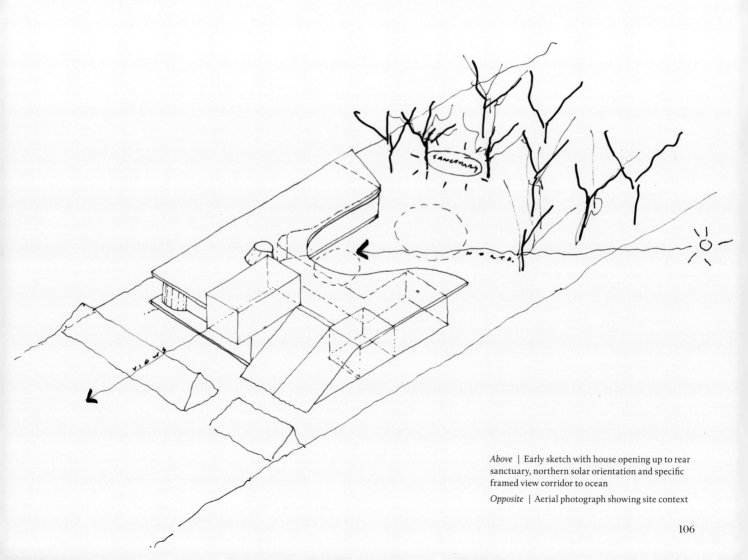

Above | Early sketch with house opening up to rear sanctuary, northern solar orientation and specific framed view corridor to ocean

Opposite | Aerial photograph showing site context

However, it wasn't about re-creating a project from more than 50 years ago, but rather something in the "spirit of history" that could evolve into a scheme that was quintessentially us.

The inspiration was a house in the context of a forest. Oscar Niemeyer's Casa das Canoas (1951) was the starting point, especially given the elasticity of the concrete form and the house's connection to its environment and context. There is equilibrium and a seamlessness of site and building in Niemeyer's house, not in the sense of mimicking its environment, but co-existing with it.

The Casa Bobbanarring plan centres around the notion of a sanctuary space to the rear, which is also the northern orientation. It was therefore developed from rear yard to front yard, whereas in most situations the street façade is arguably seen as visually most important. There are neighbours on both sides, and so the house is quite pinned in from the east and west orientations. We started with a block which was carved out and opened up to the north to allow light to come into the central living, kitchen and dining areas with the bedrooms to both sides around the rear-central open courtyard. We wanted every part of the house to have a view of and connection with the landscape. The curved concrete roof created a sense of spatial freedom

from the surrounding properties, opening up the house and establishing a powerful relationship with the forest space.

MW Yeah, and become more internalised here, and kind of framing out to the lovely description of how that kind of natural form contains and creates the courtyard. Now I'm starting to see through some of the education projects, maybe it's more the Art & Technology building where you set up a condition, that's a modifier, then you really rely on a relationship to something else opposite.

Nicholas Russo I think by extension it is a response to the opportunities the context presents. So often you see opportunities lost or no consideration as to what can be gained from embracing a site rather than designing despite it.

BW The garage, study, pantry, entrance and "jewel box" are all pragmatically situated at the southern end of the site towards the street, with the sleeping and living spaces kept private from it. The garage and jewel box were conceived as "hills" or "dunes". We wanted the front of the house to embed itself within its site through a series of physical landscaped elements. The concept then developed to the point where the house itself became the hill, which is why you get the formal ramping to the street frontage.

A small, multipurpose room on the upper floor captures the only view of the ocean through a fortuitous clearing in the bush along the foreshore. This box, at the top of the house, was added later as we saw the opportunity and brought it to our clients' attention. It disrupts the purity of the lower, curved form, but on a practical level it adds another space to the house, and simultaneously reinforces the sense of connection to place.

MW I know what you mean. It seems a shame to interrupt the natural form with a concrete shell, but doing so extends the project beyond the starting point of Niemeyer's house; it creates an interesting tension between wonderment and curiosity, perhaps similar to that in your Arts & Technology building, but at a different scale.

BW And fundamentally it makes the building highly site-specific – if you move it across a bit, it doesn't work anymore.

NR The whole façade is controlled with screening, so you can enjoy intimate, private moments and/or open yourself up to the street. It's about regulating the light and the nature of the space. Sometimes our clients have all the screens closed, which creates a solid form, and at other times they have them all open so that the property becomes almost transparent and like a totally different house. It's fantastic.

MW Tell me more about the jewel box.

BW It's a special place for surfboards. Our clients are really into surfing, and the main breakers in the area are literally straight across the road from the house.

But the other part to the jewel box is the garage, or studio as I like to refer to it. The clients have an old Mustang, which they wanted as a showpiece in the house. Although we rejected that idea, we did make this space that can be used to showcase their car or – more importantly as we saw it – can become a space for art.

It's opened and closed by an automatic sliding door that retracts up and folds over on itself. Our goal was to avoid the typical box garage scenario of most residential houses in the area, so we rationalised the garage/studio volume and jewel box as a hill which opens up. It's all very Batcave-esque, but it retains our original concept of the house essentially being a landscape of sorts.

MW That's really interesting. What was the design process for the garage?

NR There was a lot of research and development. A provisional sum was included in the contract, as nobody could price it. We had worked on other projects with a steel/engineering contractor who had a passion for architecture and who we thought would be perfect for this one. Together we went

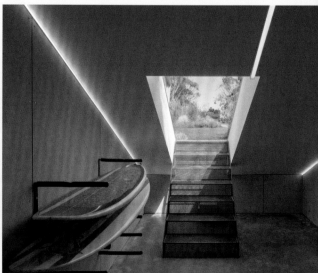

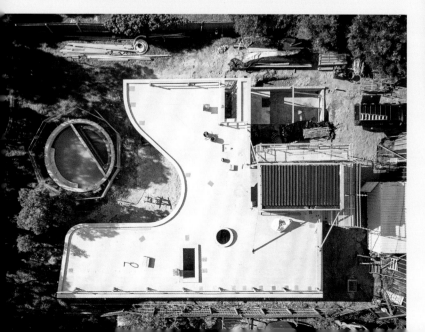

Above left | Construction progress shot showing voids and light

Above right | View inside the Jewel Box with external access stair

Left | Construction progress shot – aerial

Opposite | View of house in context from rear sanctuary space

back and forth, exploring numerous options with hinge and hydraulic systems before eventually deciding on the sliding option.

MW Tell me a little more about the landscaping. How does it interact with the house?

BW The landscape is an integral element of all of our houses. With Casa Bobbanarring it was imperative that the landscape be quite natural and act as a gradient that radiates out to the forest at low height, and also immerses itself into the courtyard and around the house. We needed to celebrate the existing trees in the sanctuary space at the rear. But the front is where the landscape literally encompasses the house, for example on the jewel box lid where native grasses and plants grow up the façade and further enhance our idea of bunkering the residence into its site.

MW Beautiful. So you are insulating the roof with rocks?

NR Yes, it consists of a membrane, insulation and ballast, which are rocks.

BW The roof area in a way becomes a third landscape of its own. You get a real sense of the curve encapsulating the rear garden from that perspective.

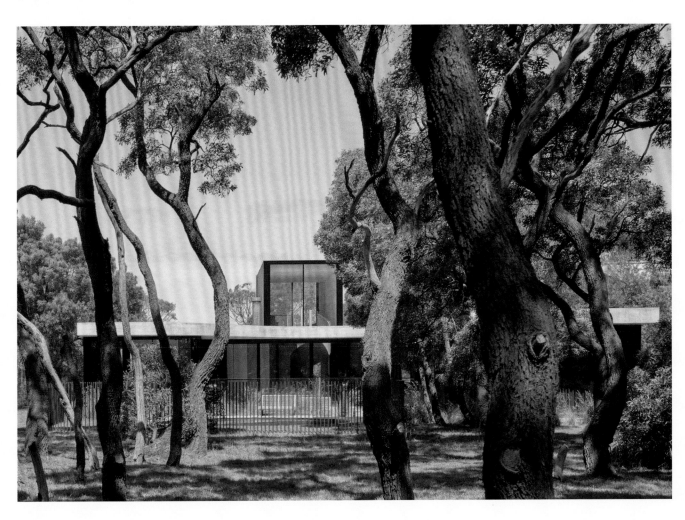

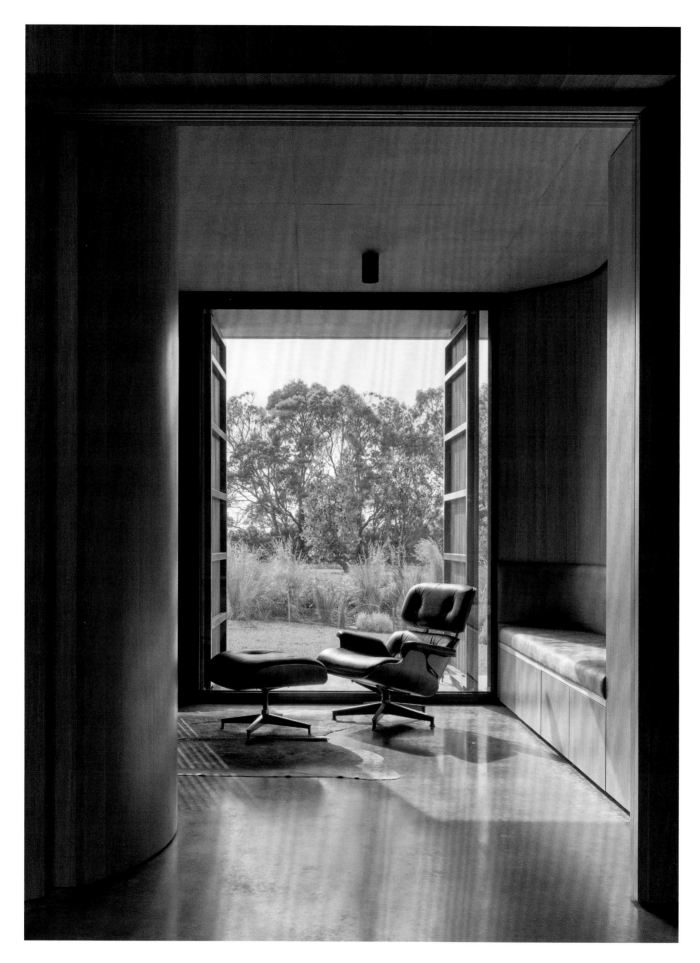

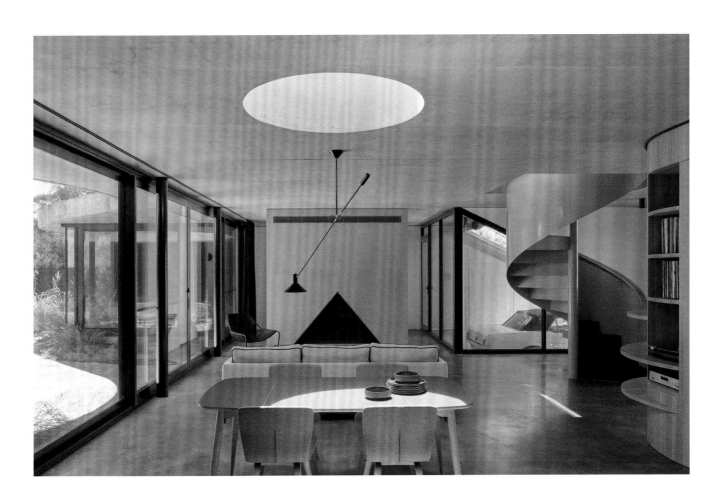

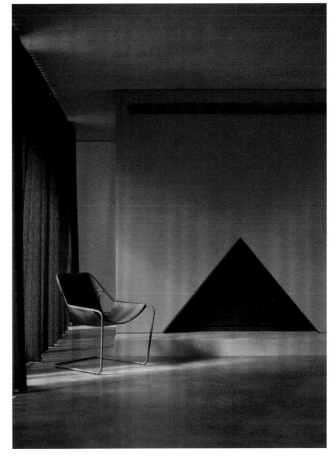

Opposite | View into library with strong visual connection to external landscape in open screen configuration

Above | View from kitchen to dining and living spaces

Right | Triangular fireplace

Overleaf | Central rear outdoor space with native planted landscape designed to create a continuity with internal spaces

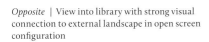

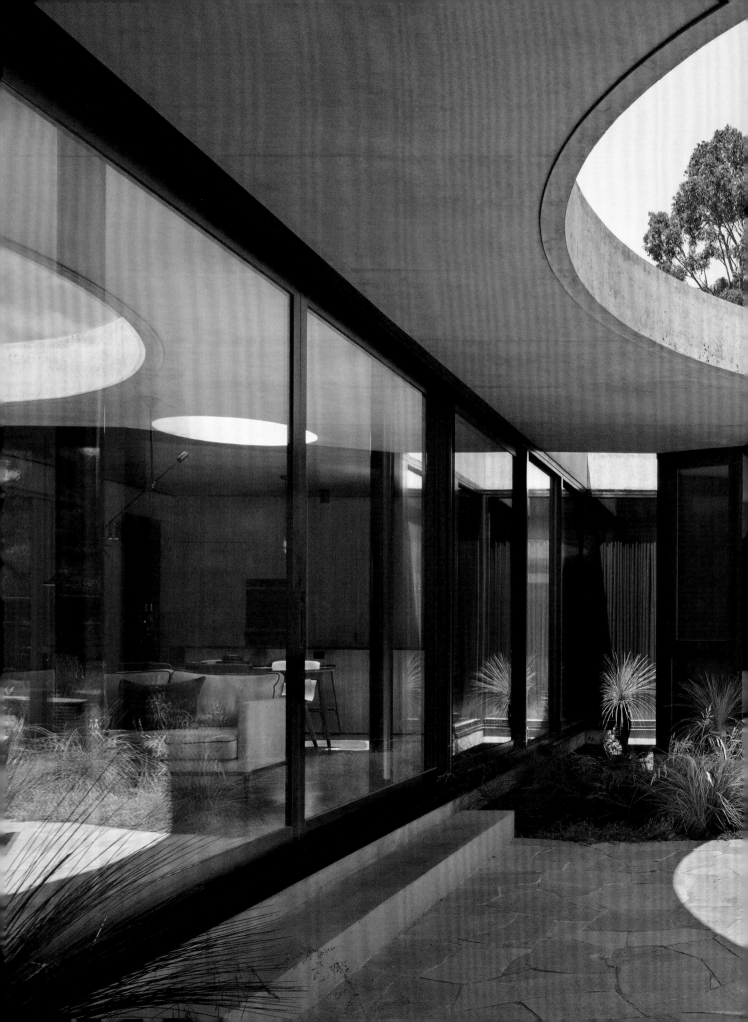

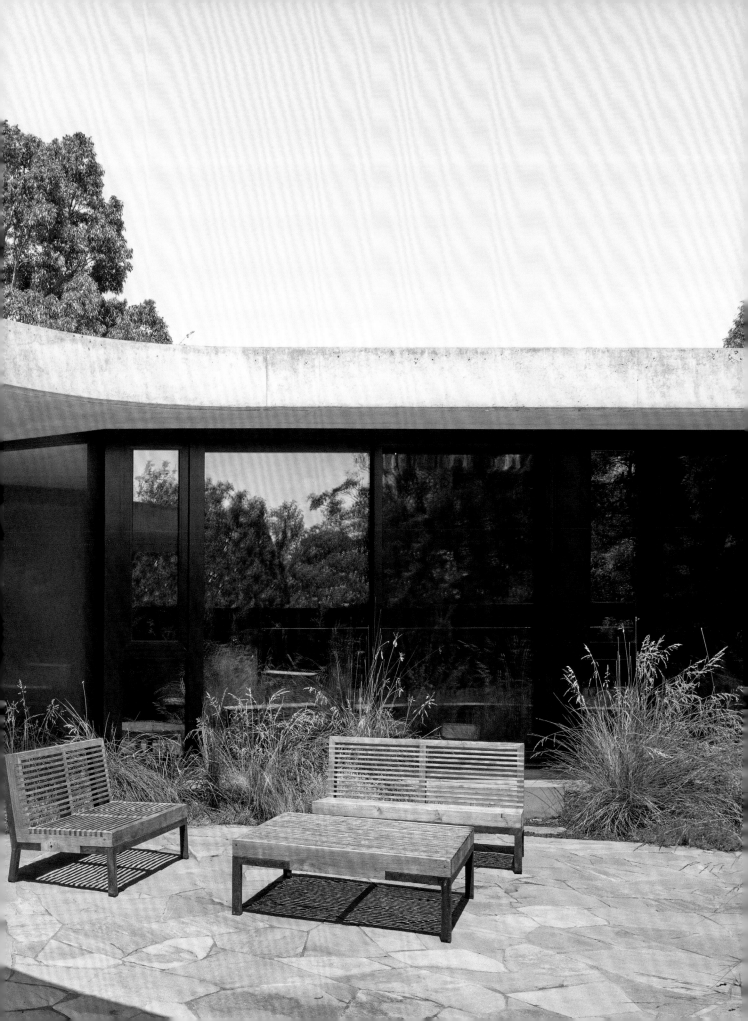

Project	ARTS EPICENTRE
Type	Educational
Location	Braybrook, Victoria, Australia
Project duration	2014–19

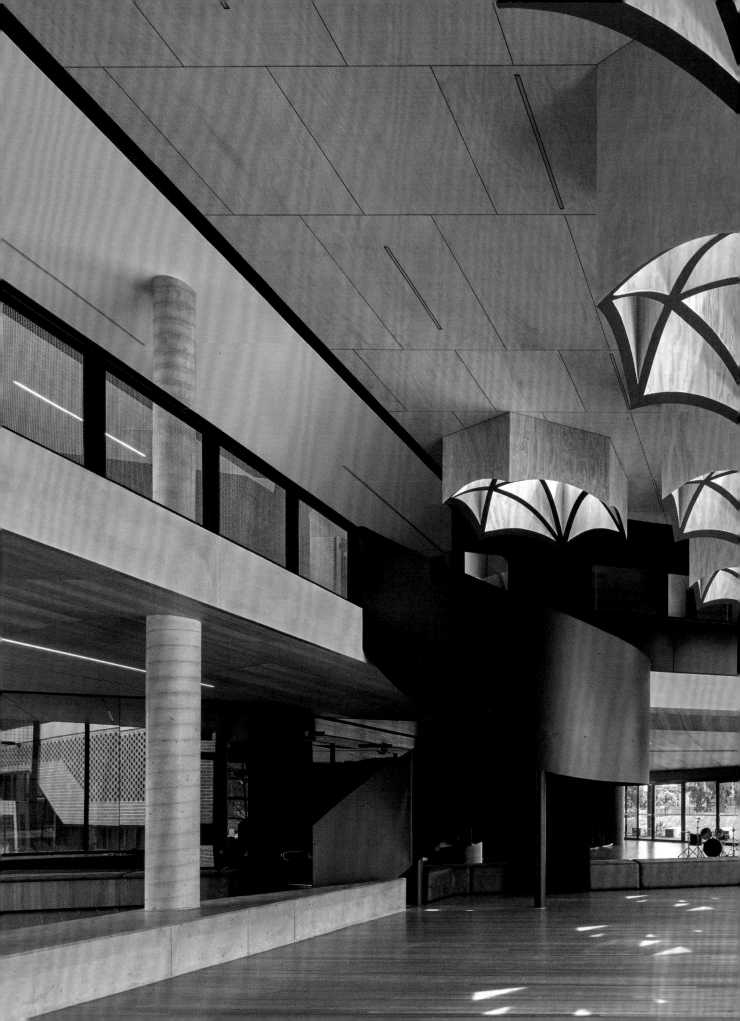

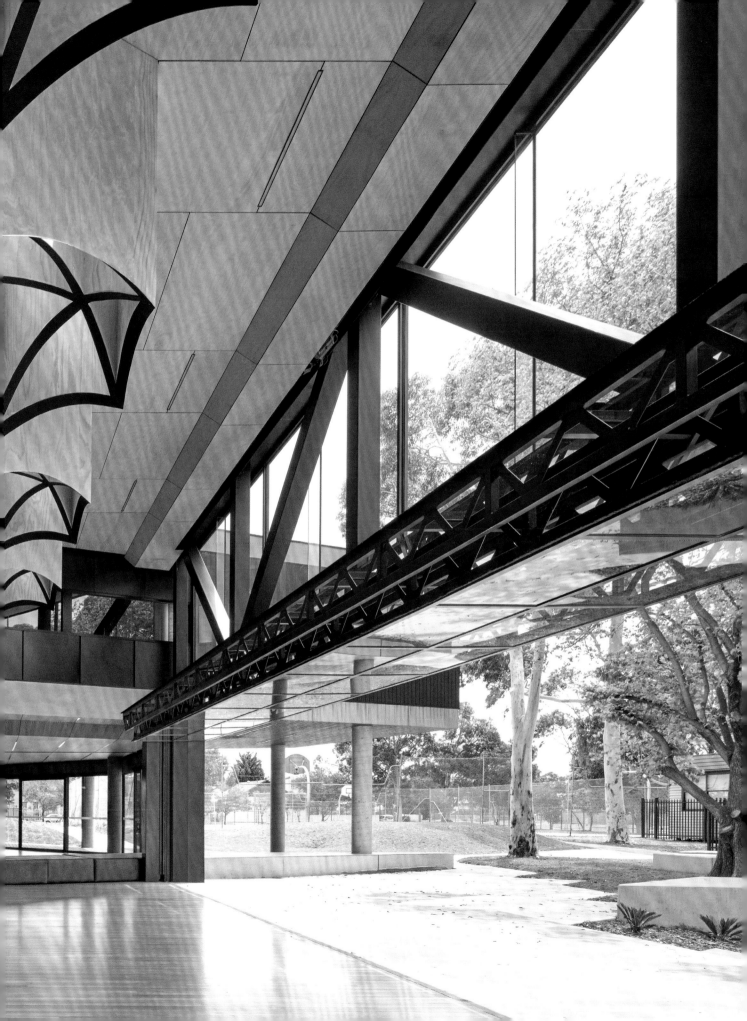

The Arts Epicentre is Caroline Chisholm Catholic College's new creative hub. It replaces a former 1960s convent on the site, which had been inadequate for the purpose. The new building, which encompasses approximately 1,800 square metres of floor area across two levels, formalises a fresh identity for the Churchill Avenue Girls Campus, and functions as a landmark for the campus and the college as a whole.

From its inception, the building was designed as a public performing-arts centre rather than a mere addition to the college campus. It caters for a wide range of creative programmes, including drama, theatre, music and fine arts, and its flexible spaces are also able to accommodate large gatherings and performances. An impromptu performance in an open practice-space off the foyer of the Victorian College of the Arts Drama School building in Melbourne, designed in 2004 by the late Peter Corrigan of Edmond and Corrigan, was one of the main design drivers for the project.

The design of the Arts Epicentre was developed from a series of key architectural decisions that respond directly to the site, context and culture of place. A large central atrium forms its heart, acting as an adaptable performance space where all the disciplines housed within the building are able to come together. A central black-steel spiral staircase, which also functions as an informal stage, allows the building's users to become part of an overall "performance" while going about their daily business. This idea of audience and performance mirroring one another informed the internal arrangement of flexible, easily configurable spaces. A series of small practice spaces can be combined to make one large performance area; performance spaces can become audience spaces; and vice versa. Their dimensions are controlled by a series of operable stage curtains that also transform into a clean, slate-black backdrop when required.

The relationship between the internal and external parts of the building is also flexible. An impressive 15-metre-wide by 3-metre-high steel-and-glass folding door opens the atrium towards the adjacent outside courtyard, expanding the floor plate to create an indoor/outdoor performance space. Four ply-clad light-catchers appear suspended from the ceiling, their form inspired by a combination of design elements from the convent originally on the site.

The upper level of the building to the west and south elevations is consolidated by an extended, ribbon-shaped, perforated-aluminium sunscreen. The pattern derives from a pianola roll of the music for"Singing in the Rain", composed by Nacio Herb Brown in 1929. The screen reduces solar gain from the hot afternoon sun, particularly on the west elevation, while celebrating and reflecting the interior programmes to the college and wider community.

As part of the project, the central external courtyard has also been reconfigured and overhauled. Soft plantings of native and locally sourced vegetation contrast with timber and concrete elements to establish a series of outdoor viewing and smaller performance spaces. The courtyard now also links an existing community chapel to the front of the campus, engaging local people and offering potential for various neighbourhood groups to make use of the building outside of school hours.

Previous pages opener left | Detail of black-steel spiral stair

Previous pages opener right | Perimeter stair with veiled mesh screen looking into central forum chamber performance space

Previous pages | Central performance space with operable glass folding door and light-catchers above

Opposite top | Perimeter foyer space looking towards central forum chamber performance space

Opposite bottom | Black-steel stair material composition

Overleaf | Exterior courtyard acts as a flexible overflow space to central forum chamber performance space within

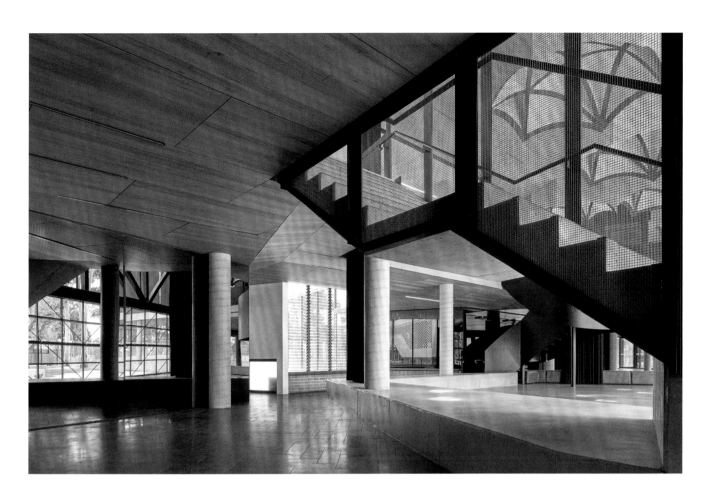

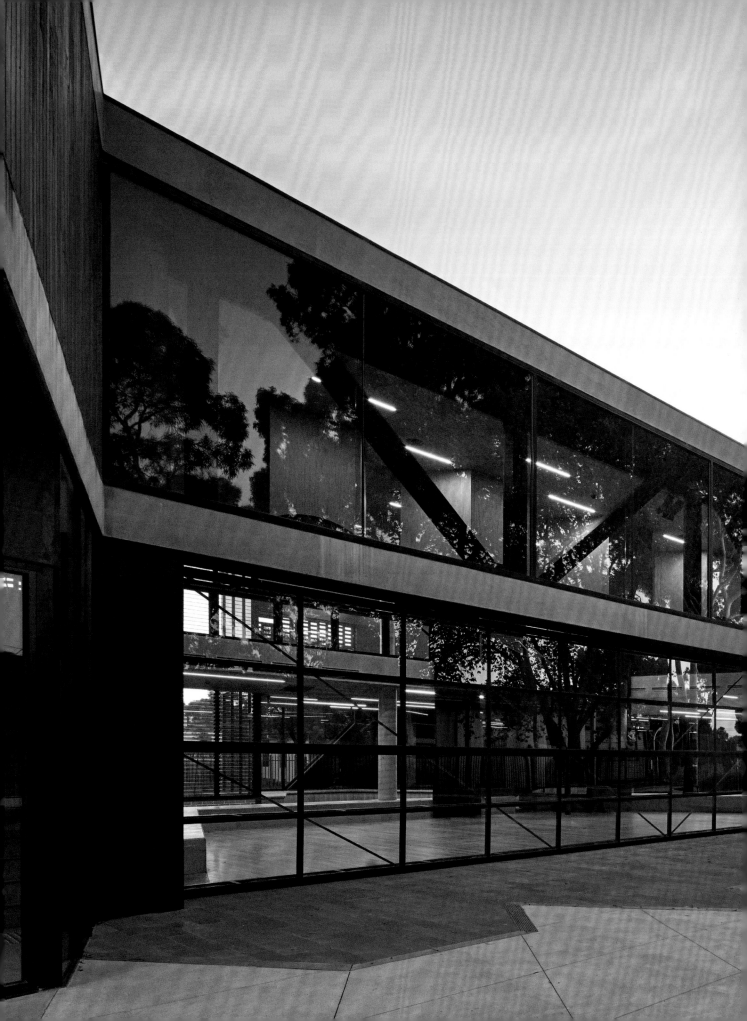

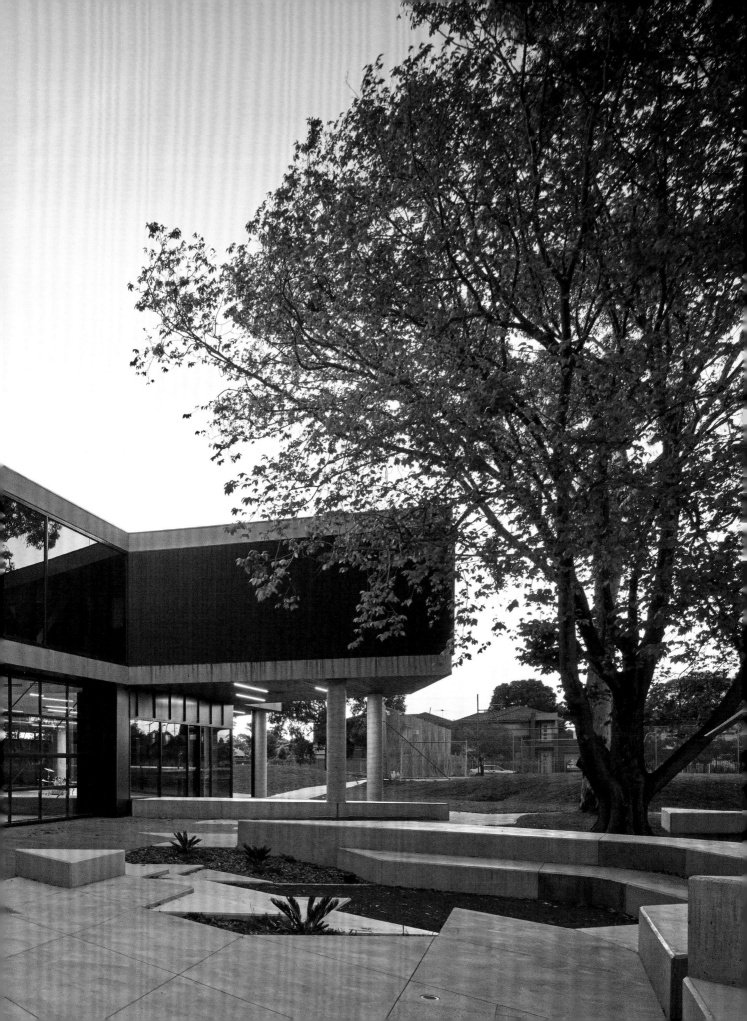

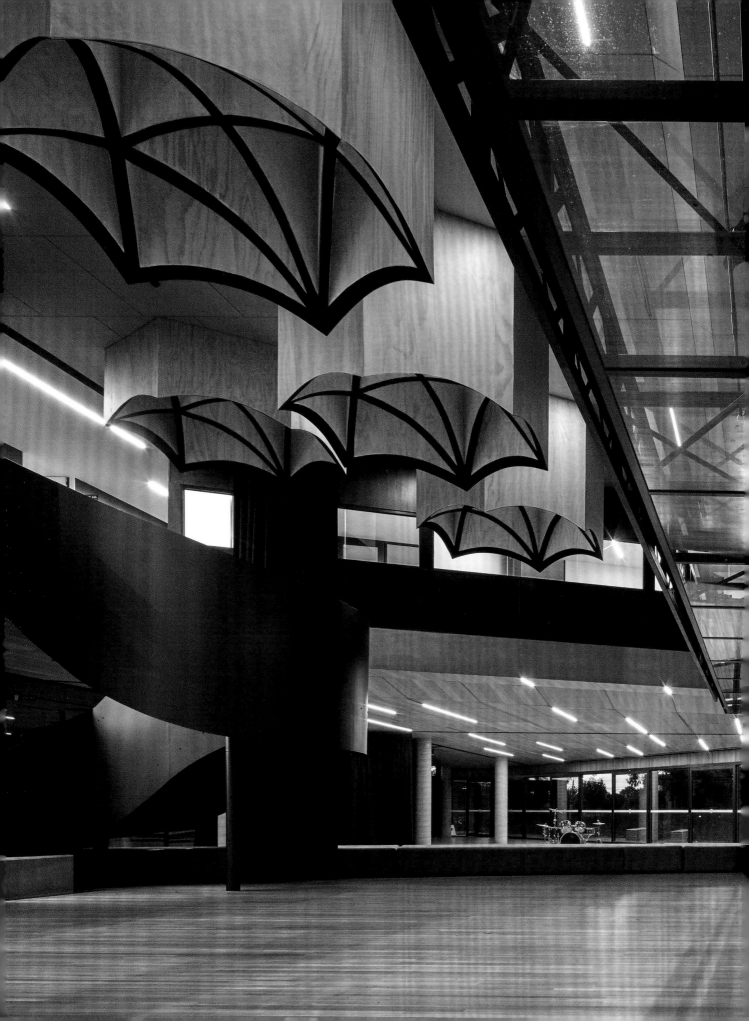

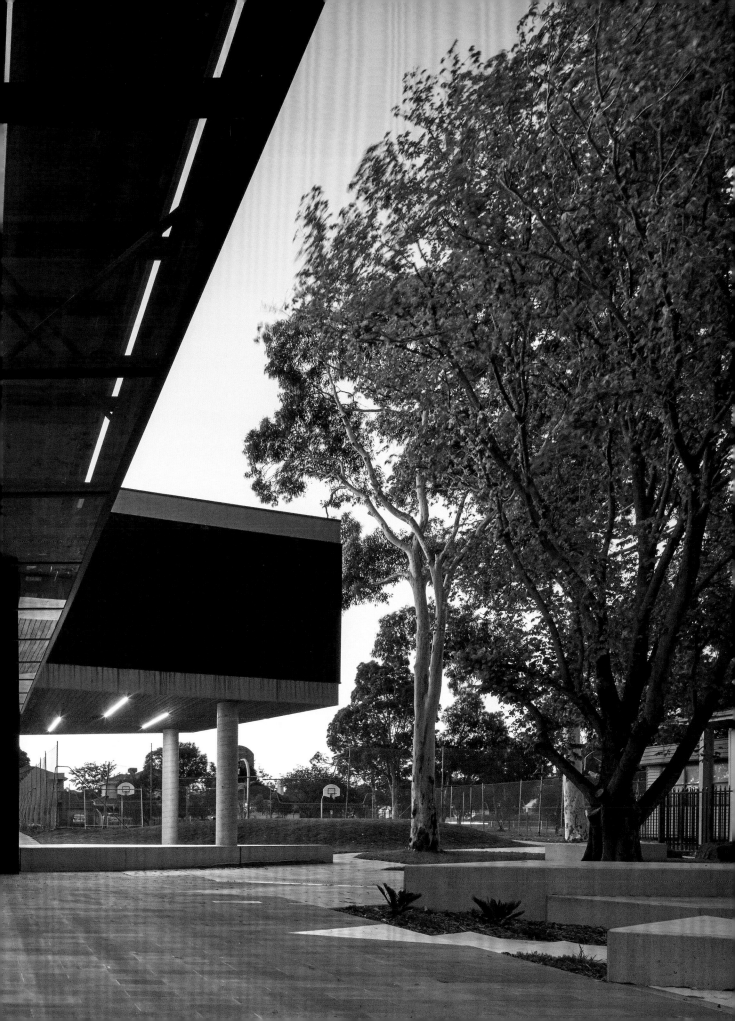

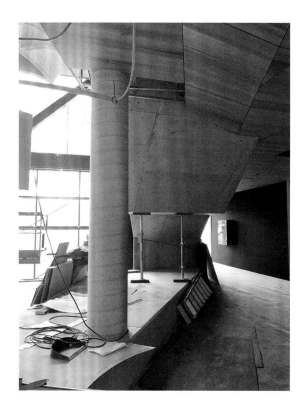

Previous pages | Continuity of interior to exterior from central forum chamber performance space

Above | Patterned brick façade along Margaret Crescent

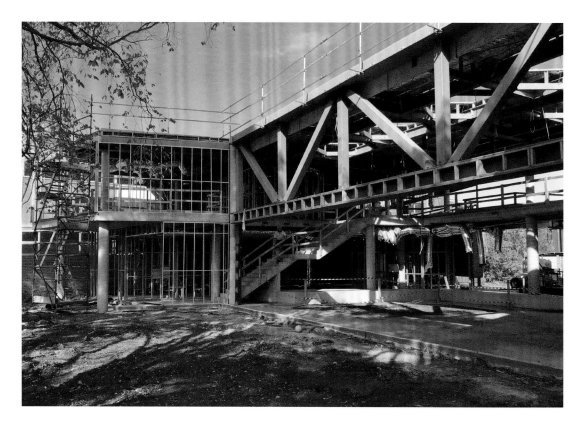

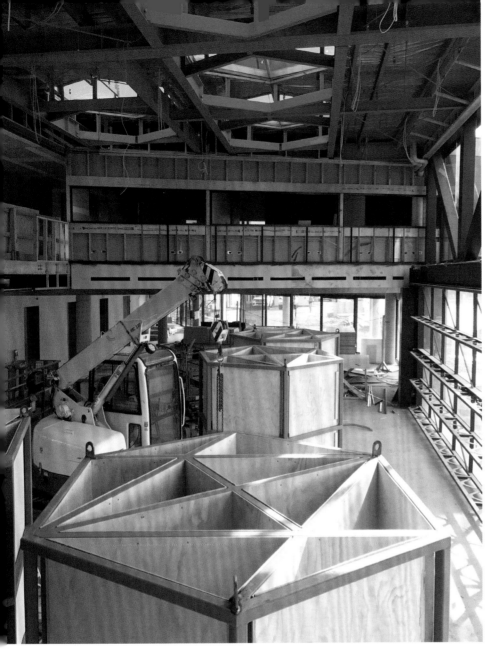

CONSTRUCTION PROGRESS SHOTS

Opposite far left | Concrete perimeter stair

Opposite bottom | Looking towards central forum chamber performance space from external courtyard

Left | Light catchers awaiting to be craned into ceiling voids above

Below | First floor slab being prepared

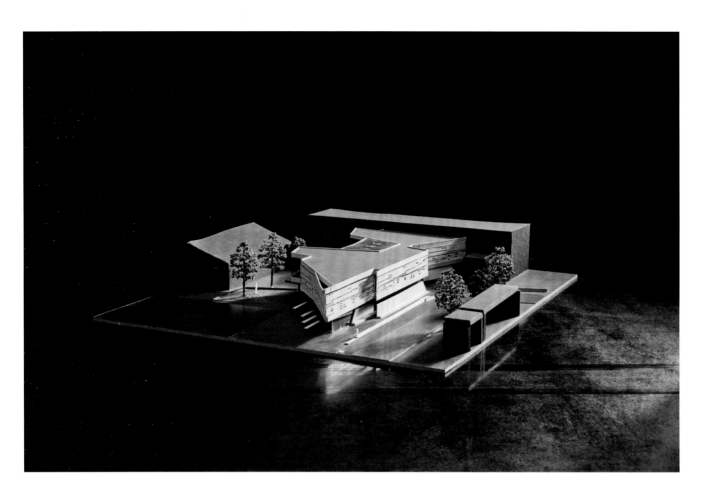

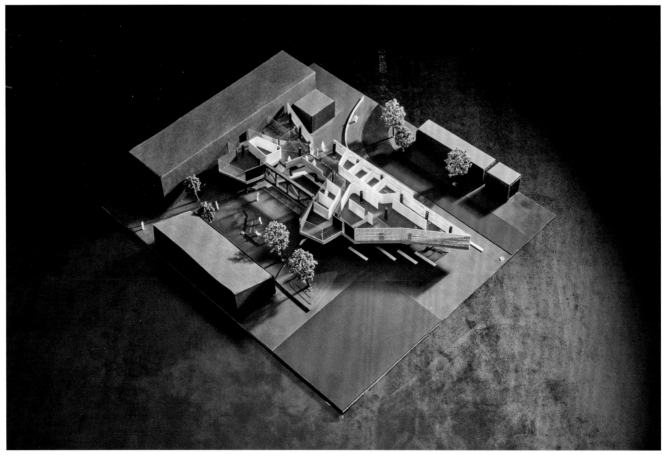

SECTION A

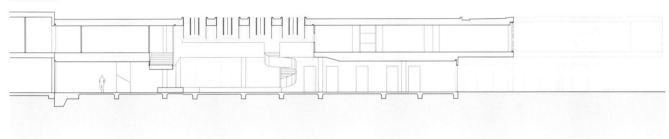

SECTION B

SECTION C

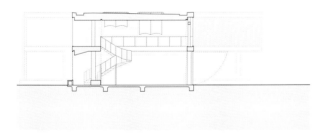
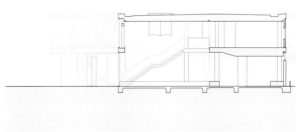

Above top | Sectional perspective drawing of central forum chamber performance space

Above bottom | Sections

Opposite | Physical model

FIRST FLOOR PLAN 1:400
01. Forum chamber below
02. Stair access to below
03. Instrument store
04. Music practice studio
05. Multipurpose classroom
06. Flexible space
07. Guitar studio
08. Keyboard studio
09. Staff office
10. Art studio
11. Kiln room and wash
12. Gallery and art storage space
13. Light and sound control room
14. Existing school corridor

GROUND FLOOR PLAN 1:400
01. Entry
02. Foyer
03. Kitchenette
04. Forum chamber
05. W/C and change
06. Store
07. Practice studio
08. Multipurpose classroom
09. Art box
10. Breakout space
11. Existing campus library
12. External courtyard
13. External amphitheatre
14. School ovals
15. Basketball courts
16. Existing church
17. Margaret Crescent

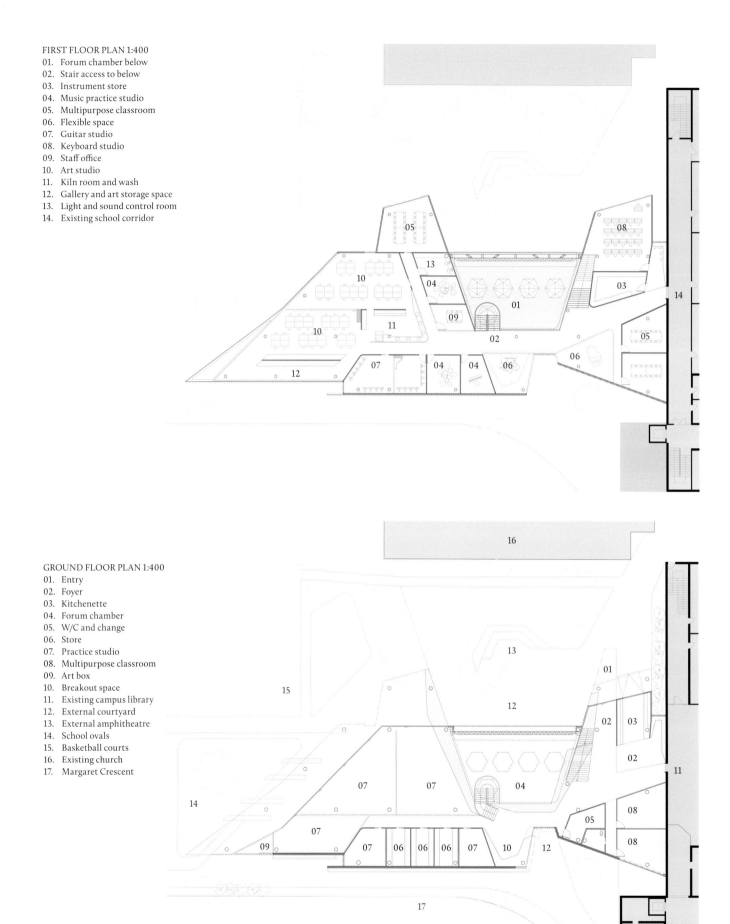

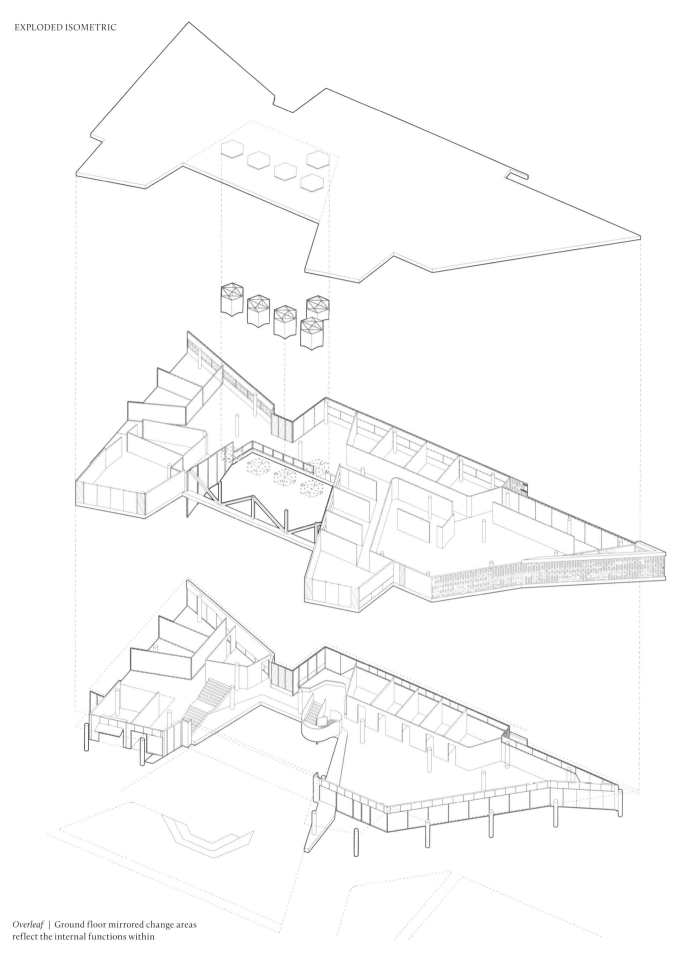

Overleaf | Ground floor mirrored change areas
reflect the internal functions within

CONSOLIDATION

ARTS EPICENTRE

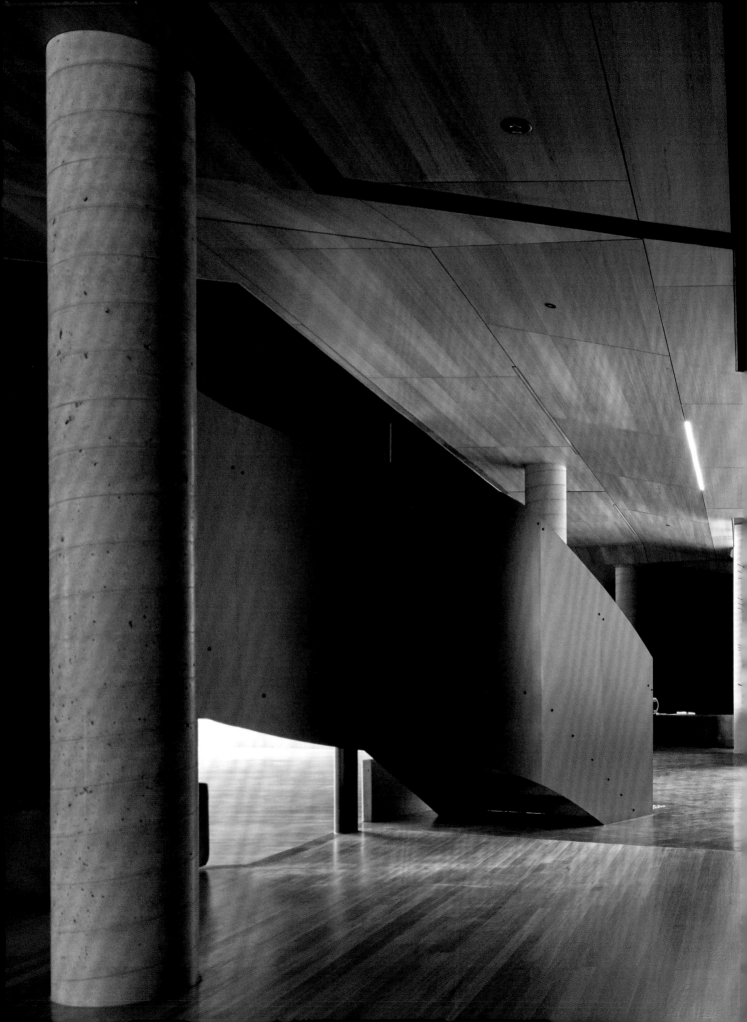

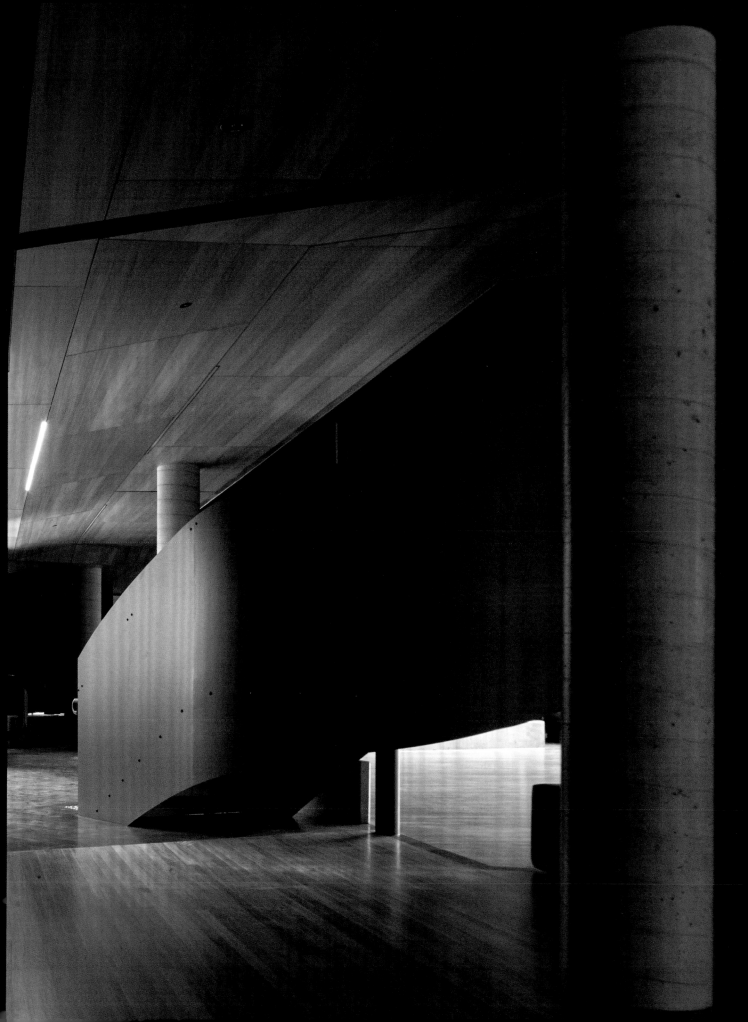

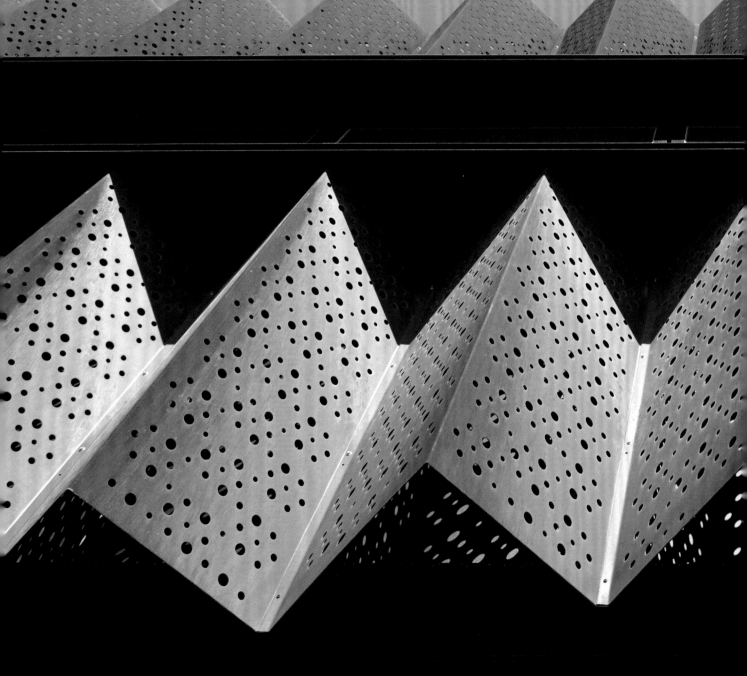

Project	FLYOVER GALLERY
Type	Educational
Location	Braybrook, Victoria, Australia
Project duration	2014–15

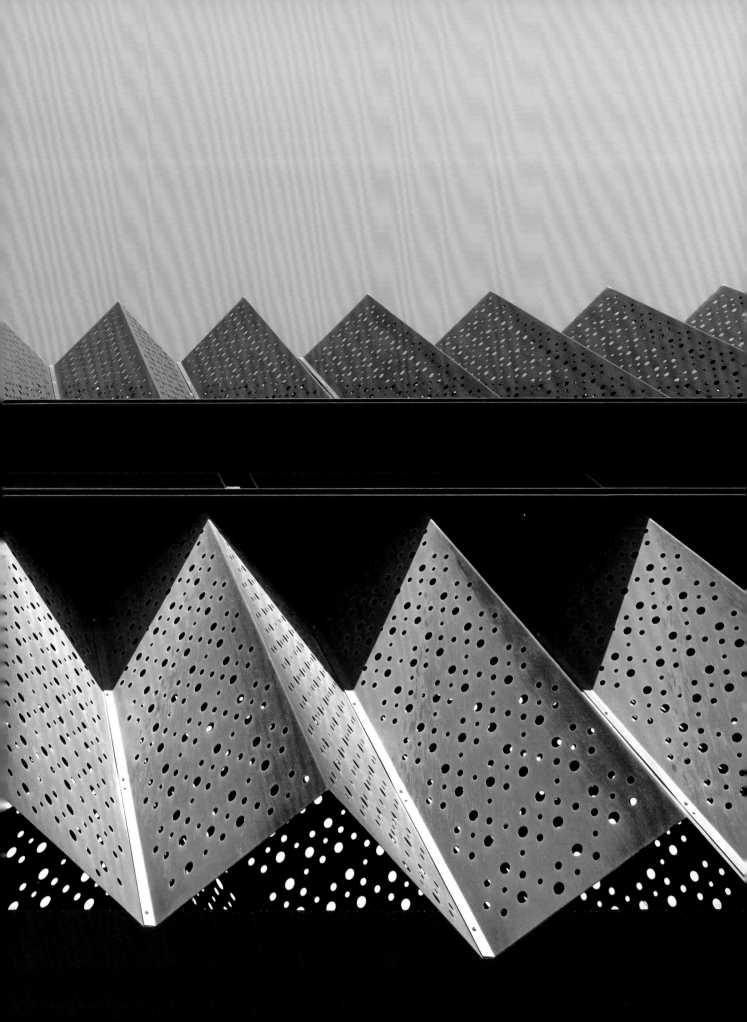

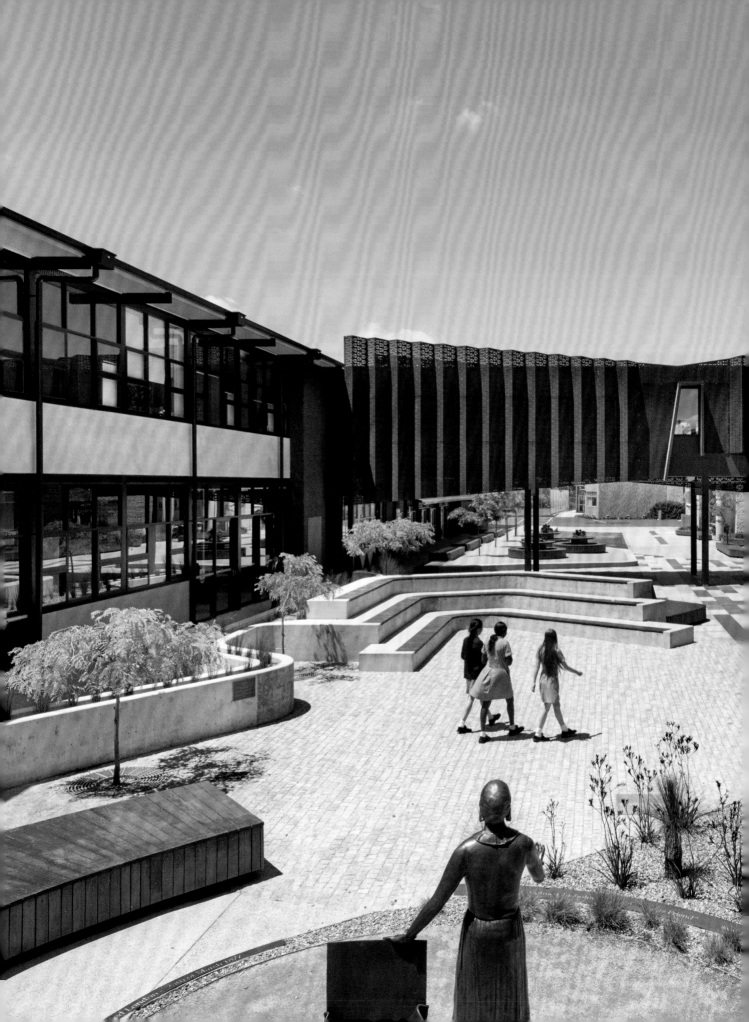

The Flyover Gallery is a pedestrian bridge some 21 metres long linking the Arts and Science wings of Caroline Chisholm Catholic College. The minimal brief – to make the existing structure "look good" – seemed to underestimate the potential of such a project. The architects therefore decided to begin by conceiving of the flyover as the centrepiece of a renovated quadrangle within the heart of the school campus, and started their design investigation by asking themselves how to create a space that would connect art and science both conceptually and physically.

Recent trips to Europe, prior to accepting the commission, inspired a series of ideas and conceptual references that drove the conceptually "layered" outcome of the project. These included the Ponte Vecchio in Florence, encompassing both space and programme, and memories of cavernous ice glaciers and rich contrasting geological landscapes in Iceland. The indigenous rock art of ancient Australian caves was a more local reference, sparking the idea of activating the interior space of the bridge with artworks.

The architectural functions of extrusion and subtraction are used as primary generators to establish a "carved" quality within the interior space, which is largely developed from the section. Five recessed art boxes along one side display students' artworks in various media including drawing, paintings and textiles to construct the narrative. A central lookout point, inspired by the Prince's Balcony of the Doge's Palace in Venice, is a place to reflect on the art displayed within the space, and also creates a visual relationship with the adjacent Juliet's Tower, and with liturgical and other icons of the school's ethos such as the statue of Caroline Chisholm.

The carved internal geometry blurs the notion of walls, ceiling and floor, and afforded opportunities for a continuous lighting pelmet, a long skylight to admit natural lighting, and an extended seat that allows groups of students to gather and classes to be held within the space. Along one side, a generously proportioned, extended horizontal strip window referencing an Icelandic bathhouse offers a continuous view to the courtyard below.

Layers of contrasting materials, transparencies and textures form the gallery's external fabric. An underlayer of black-painted fibre-cement sheeting is shrouded by a zig-zag pleated outer layer of perforated Cor-Ten steel cladding. The pattern takes its inspiration from the pierced marble tracery on the Bridge of Sighs in Venice, and is derived from prints by the American artist Christopher Wool, yielding a middle ground between representations of scientific diagrams and of dot art to visually link the two academic disciplines. To connect interior and exterior, the pattern was repeated in the glass skylight in the form of fritting, its shadows and reflections becoming an artwork in themselves.

Previous page opener | Perforated external façade detail

Previous page | Flyover within the context of the larger quadrangle landscape

Opposite top | Flyover in its quadrangle context

Opposite bottom | Internal gallery spaces embedded into walls

Below | Sequence of space through short sections

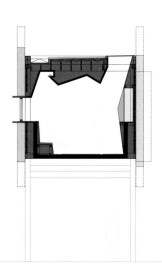
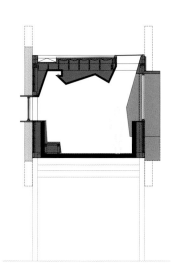

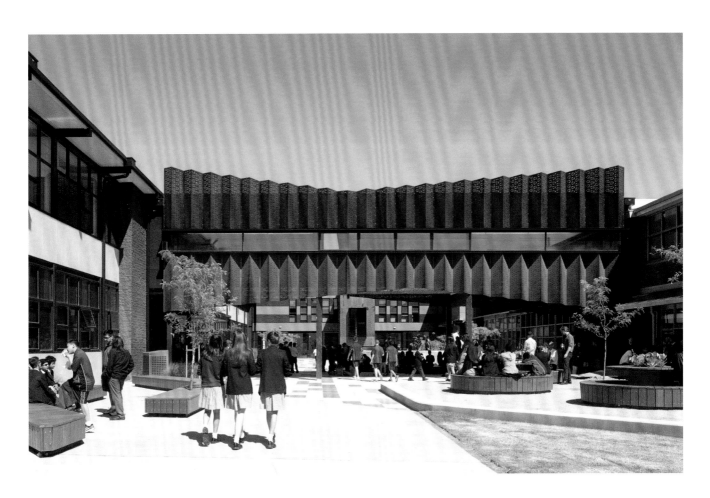

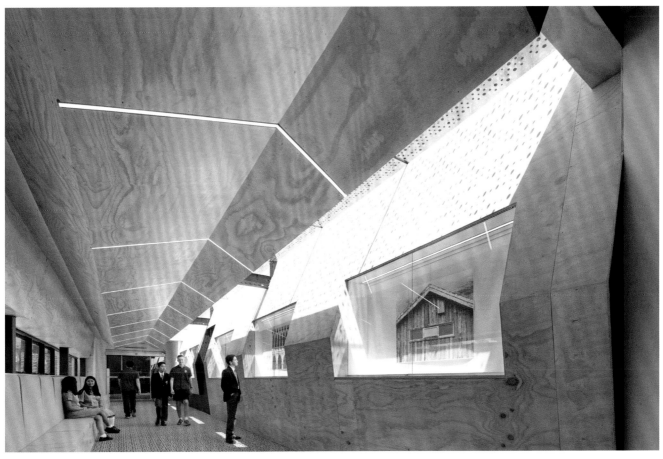

FLYOVER GALLERY
IN CONVERSATION
/
Michael White
/
Nicholas Russo
/
Brad Wray

Brad Wray The Flyover is an important project for us – it's a built discussion about our holistic approach to educational design. I think this project in particular outlines our design manifesto for the educational sector. We feel good design should be for everyone. Many schools we work in, including Caroline Chisholm Catholic College, are located in quite low socioeconomic and developing areas, where the limited budgets always seem to be an excuse for the production of soulless architecture. For us, budget should never be an excuse for a bad building. In this case we built the Flyover for 450,000 Australian dollars.

Nicholas Russo Yes, I think this is a really good example of a point we've touched on: challenging and extending the brief and exploring what else we can provide beyond the formalities of a specific programme.

Michael White So you take a multifaceted approach to your work and to the client's brief?

NR Yes, to make a building also do something else for them. The Flyover Gallery was our first exploration into this. It became an art gallery as intended, but also a bookable teaching space for the college. They even have events like parent information sessions in the space, which is essentially a nondescript existing overpass.

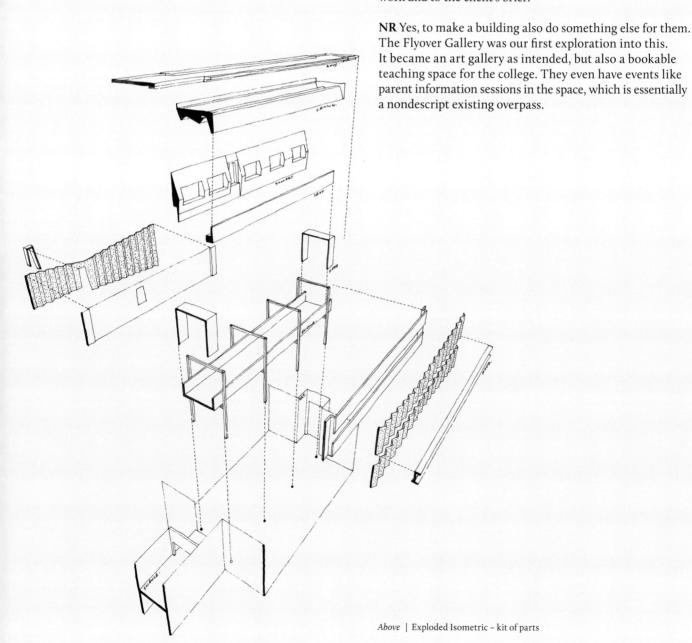

Above | Exploded Isometric – kit of parts

BW When Marco DeCesare, the college principal and our client, came to us at the start and said, "The kids are getting wet; you need to do something to fix it", it made us think about the project more broadly and less specifically about pragmatics.

At the time, my wife and I had just been to Venice and Iceland, and our travels were some of the key references for the Flyover project: the various bridges in Venice, and others such as the Ponte Vecchio in Florence, where the programme is embedded within the structure, were the inspiration for the linkway between the Art and Science departments, and the architectural nature of the Nordic ice caves influenced our vision for an internal cavernous space, a geological cave with art embedded into it. The school blew up some of the photos I took on our trip and exhibited them in the art boxes at the project opening so that students could understand the ideas.

MW And do these display boxes represent a kind of tension between the departments? Are they a coming together of science and otherworldliness?

BW In some ways, yes. And I think we tried to do that with the façade as well.

NR It was also more specifically the idea of geology [science] and cave painting [art] – that link between the two.

BW In the 1980s and 1990s, the American artist Christopher Wool did these amazing prints with dots and a kind of molecular structure to them. They're quite graphic, but also scientific in a sense. We were really interested in how we could bring these two elements together as a visual language for the project that can be read on the façade through perforations, internally through frit patterns on the glass, and then reflected throughout. The layers bind art and architecture together.

MW Aside from your manifesto that good design should be for everyone, is "fine art meets architecture" a manifestation of that idea, in that if you present the students with something intriguing, they can better engage with the space?

BW Absolutely, and on that same trajectory we like to provide cues to moments of history and see how these might relate to and translate into a contemporary environment.

NR Some students at the school have probably never previously walked through an architectural space or experienced fine art, so it's just an extension of that idea.

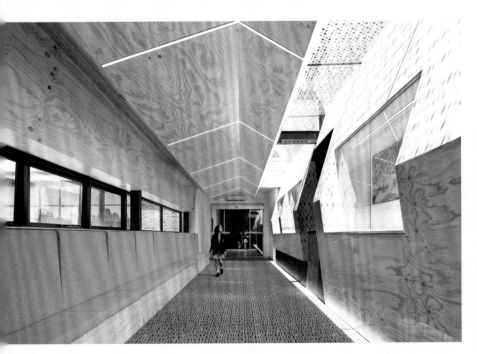

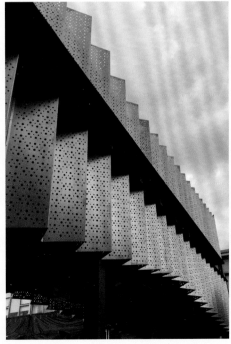

Above left | Interior space with continuous informal bench seat and linear skylight

Right | Initial material condition during construction – pre-weathering

MW It's spatially exciting as well. Going back to some of your houses, there's a subdued quality and areas for moments of reflection. And here you have responded to the needs of the students, heightening their awareness and exposing them to an elevated kind of thinking.

This project, which had budget limitations, efficiently and effectively punches above its weight, with materials carefully chosen for their earthiness and textural quality, and according to how light interacts with the interior. If you were winning commissions for bigger projects with much larger budgets, do you think you would still try to be as efficient as possible and to maintain efficiency as a form of innovation?

NR Absolutely. No matter how much money we've got, I feel like we're always trimming to just get under the mark, because the philosophy is push it to its limits. Good design doesn't have to cost a lot, but sometimes you have to assume you can do anything to come up with a good one. We often talk about the elements of what a good design is. With the Flyover, it's not about the materials, but the section and spatial quality. So, whether it's fully cast-in-situ concrete – or plywood in this case – the spatial quality, the idea of space, is always present.

BW With our buildings, even if you lose the material or you can't afford this or that, there's still always the integrity

of the idea. If the idea is solid, it's about that space, and it doesn't cost anything.

MW I know there's this strong gesture of natural life breaching the two discrete education departments on either side of the bridge. But then there's this lovely pause moment somewhere in the middle. Is it one of your buildings?

BW Yes, it's called Juliet's Tower, which is based on the Prince's Balcony at the Doge's Palace in Piazza San Marco, Venice, onto which the prince could come out and talk to the people down below. Something else that appeals to us are the breakout spaces in between gallery spaces – like at the National Gallery – where you can pause and reflect on what you have just viewed. These are typically framed with a view of a river or tree. With the Flyover Gallery we've tried to capture a central moment of reflection and pause between the artworks in the displays.

MW Cor-Ten steel is used to clad both the Flyover and Juliet's Tower. Is this materiality deliberate?

BW Yes. We wanted to enable these two fragments to converse across the courtyard. The practical function of Juliet's Tower is so that the Principal or a senior staff member can open the doors and talk to a large crowd of

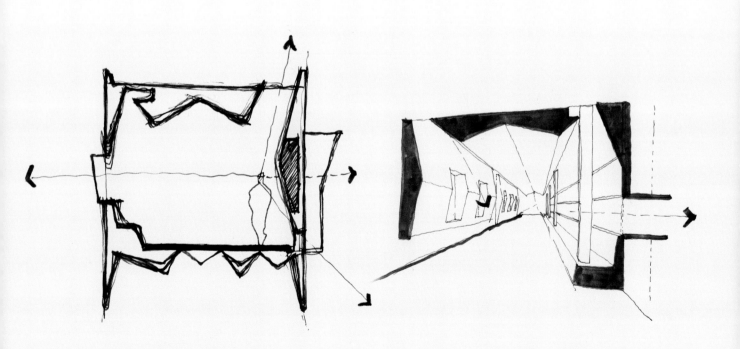

Above | Early sectional sketch exploring spatial continuity and potential view connections

Above | Perspective sketch – extrusion of the section to form interior spaces

students. We've witnessed this on a couple of occasions, and the sense of playfulness and fantasy really appeals to the students. The notion of history – as when great leaders would speak to the masses from designated focal points, as at the Doge's Palace.

MW Was there a point when you realised you were going to be doing multiple projects at one school, and would be able to establish relationships between them, like that of a clock tower viewed from a piazza? The existing architecture seems not to have much design thinking behind it. Are you trying to somehow make it legible with these little campus jewels?

BW In some ways it happened organically, but in others it was a conscious decision. There were discussions about piazzas and these kind of moments in time during all of our presentation work related to this particular school. Marco is Italian, so we often joked about the number of Italian references. But, most importantly, there's an overall narrative that inherently provides a rich framework for many of the projects.

Below | Construction progress shot. Flyover in quadrangle context pre-weathering. Our client witnessed the transformation of the flyover from shiny to rust-weathered

Below bottom | Physical model exploring formal shadow-play in façade

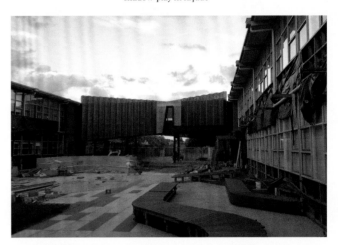

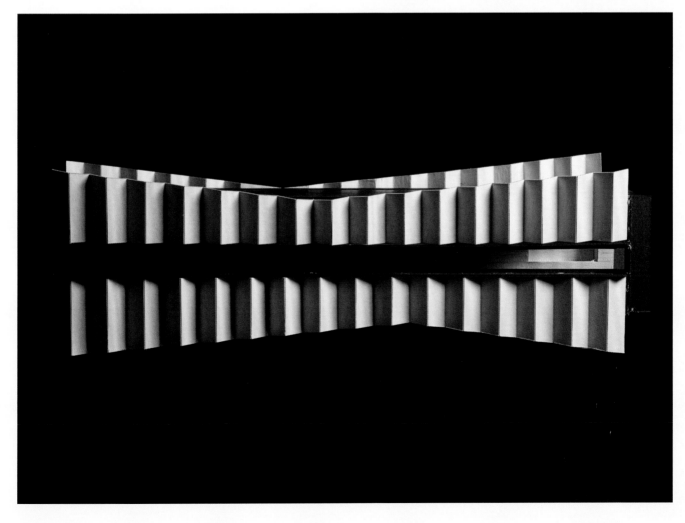

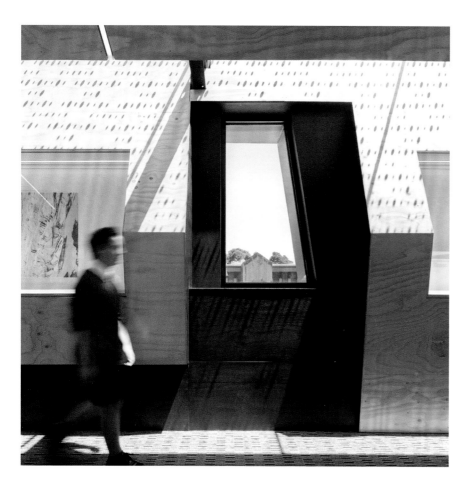

Left | Prince's Balcony lookout to Juliet's Tower and formal visual pause in the sequence of the space

Below | Visually derivative of the section – interior space

Opposite | Linear strip window with perforated and folded façade composition on existing column and beam structure

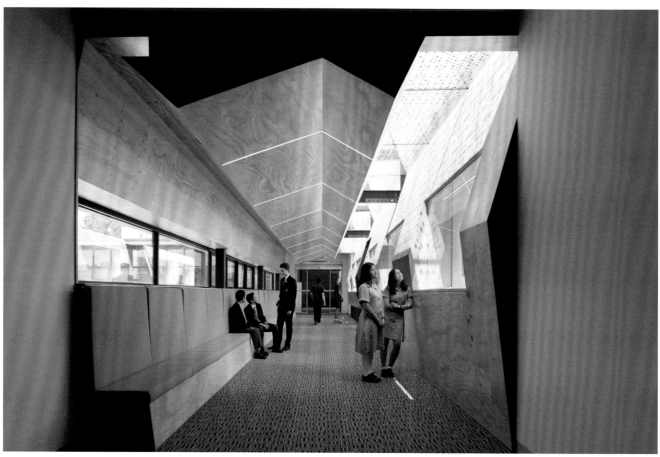

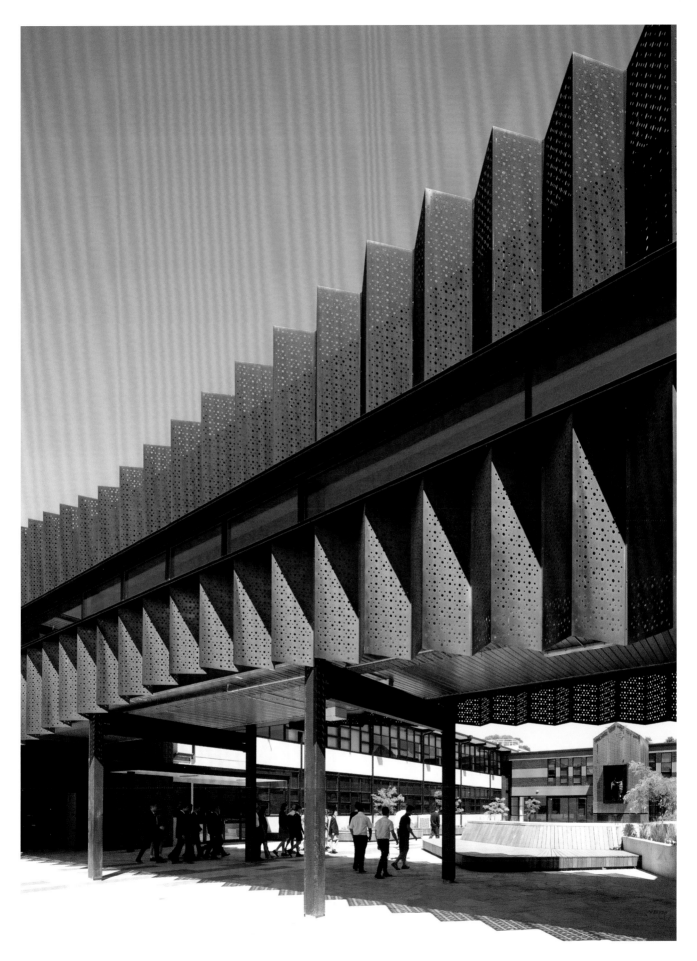

IN CONVERSATION
WITH PETER CLARKE
/
Peter Clarke
/
Brad Wray
/
Nicholas Russo

Brad Wray Let's begin with the first project we all worked on together, which was the Flyover Gallery at Caroline Chisholm Catholic College.

Peter Clarke When we started looking at that project and reflecting about how to do it, it became more of a conversation.

From my outside perspective, architectural photography can sometimes become a matter of ticking boxes – "It's been done and here are some nice photos moving on." But not every photographer and architect thinks that way. In our case, you could say it was like a meeting of minds; it was as if, "Well, hang on a minute. We started to talk about the architecture. And then talked about how we did it."

I've often said that you guys need to develop a style or a strategy for the photographs of your buildings that you think is reflective of your practice. I've said this to many people, but I don't know if it's necessarily something agreed upon or whether it's just determined that the architect should have a greater input.

How to photograph a building should always be a discussion, much like you have a discussion with the client, so that the photography is consistent. What is the desired outcome of a job? Because you're actually meeting other creative people and asking "Okay, how do we get a result that we think is a good reflection of what we've done?"

I mean, documenting architecture is often hard because a photographer comes in with a preconceived idea about the way they want to photograph, but then it's a matter of trying to interpret the building or the built form in the way that he or she thinks is appropriate, and then reflecting that back to the creator, who is the architect.

Below | Peter Clarke working during Placidus Student Welfare Spaces shoot 2023

This is a conversation we've had before. Architectural photographers get hung up on shooting wide-angle shots all the time, and in the end that's not a good representation of the building's form. It never truly represents the building, because you go up to it thinking, "Oh, I didn't realise it was actually flat – I thought it was pointy." Because that's the way buildings are usually documented. But photographers develop a style, much like you as architects will develop a style and believe it's also reflective of you as creative people.

See, what's interesting is that I can come and take a photo in an instant of something that you guys have spent years thinking about and then building. And that building then takes on the form of its representation, which is an image that may not actually be true to what the building is.

Nicholas Russo Or it may also not be true to what you intended people to experience in that space. I remember these discussions early on in our collaboration and I think you're right. It's not that we were unhappy with the way things were being represented, but I don't think we'd really thought about it to that level of depth, where the photos or the photography of buildings have so many purposes. Initially, when we started the practice, the sole purpose of our photography was to get more work. So it was, "Let's get some photos, and get them published so we can get more work." As you know, that kind of commercial aspect of anything so often totally compromises the artistic integrity of the outcome. So, once the pressure of "getting more work" became less relevant, you came in at that point to talk to us about how we wanted to represent ourselves.

PC I think what I've experienced over the years is that people can get too hung up on brand name architects, brand name photographers. But in the end, are they delivering the result that you are happy with? I think that the discussion, the documenting side of things, is me trying to understand the architecture so that the photography is not

Below | The flyover from Caroline Chisholm Catholic College was the first of many projects shoots with Branch

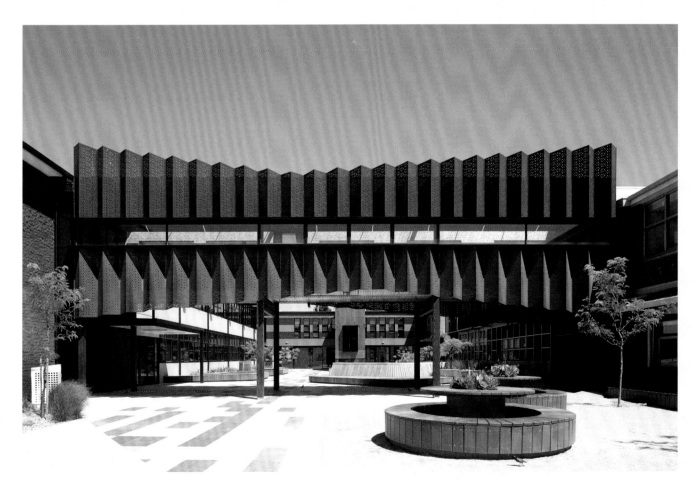

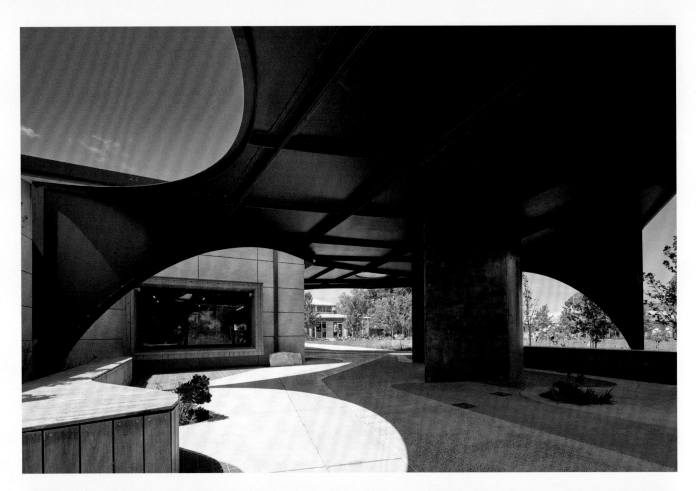

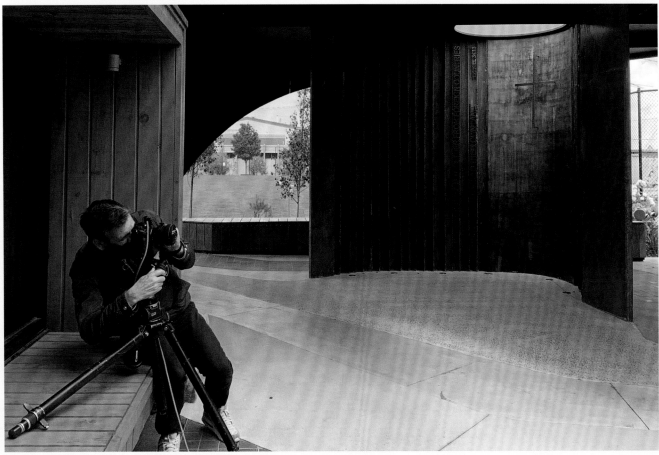

coming from a person who is not an architect and who just documents spaces. I can add my influences, but that still has to be done not just with the consent, but also with the understanding of the creators, if that makes sense.

BW Yeah, that makes absolute sense. It's similar to the way that we approach the design of a building. We don't design a big thing and then kind of put in all these little moments. We design the humanistic moment/s, similar to how we like to capture the moments in your photography, and for me that's something that's become very clear over the course of this journey.

PC This is much like that conversation we had earlier about the photographs of Peter Zumthor's work done by Hélène Binet. What happens is that architects sometimes like the way certain people interpret their buildings. I think that's the strength of someone like Hélène Binet. She finds the moments that celebrate the architecture. And as architects that's probably rewarding because, as you've just said, you design the building from inside out; you don't just sort of go "Plop, here it is." The countless hours spent thinking about where that junction must be to make the light come in there, and in what way, and about how the other materials should be this or that because the result reflects a certain sort of mood that you're after. Those are the sorts of intangible things that are hard to capture in a photo, but it's up to the photographer to try and find that, to try and reflect the intent of the design.

I think that's very difficult because, unfortunately, in photography there's a tendency to want to reduce a building down to the one "hero shot". I don't think that's fair, because the building is always so much more. And just because you get one great shot of the outside of the building doesn't mean you've actually told the story. And I often talk about it as a story, and it was often expressed to me very early on in my photographic career that you are telling the story. You have to take people on a photographic journey through the building to experience it, because the reality is that most people won't get to your buildings. So, what we're trying to do in the photographs is tell the story so that people can understand the light, the space, the materials, the forms – all those sorts of things.

> "We can never see a building the way that someone else sees it for the first time ever, because when in a sense you've lived in it for years, it's impossible to understand how people are experiencing that for the first time, as with any piece of art"

BW That's absolutely right. When I think of the work of Hélène Binet, it's more often than not a quite zoomed-in moment – like a moment capturing shadows on a wall – and you can instantly get a sense of the mood and the feeling of that building. And I think, how incredible that is. There is so much greater depth in a photograph like that than the prevailing hero image.

NR I agree. And it's interesting what you were saying before about that critical level of thinking about how a building is represented, that then becomes the circle that gets completed. Because working with one person who's thinking critically about your building, and talking to you about it, then makes you think more critically about how it is going to be experienced when you're designing the next one. I feel that's an almost cyclical thing, as what we learned on a previous project is then reflected in the next project and so on. And the discussions are about things like styling and taking away decoration, and the light and shadows. It's via those discussions and conversations, and those moments shooting and learning how other people interact with and see your buildings, that as designers we get better. We can never see a building the way that someone else sees it for the first time ever, because when in a sense you've lived in it for years, it's impossible to understand how people are experiencing that for the first time, as with any piece of art.

PC Just reflecting on what you're saying, what the discussions have done is added another thought process to how you've designed your buildings. You're not

Opposite | Peter working during ARCO shoot in late 2020

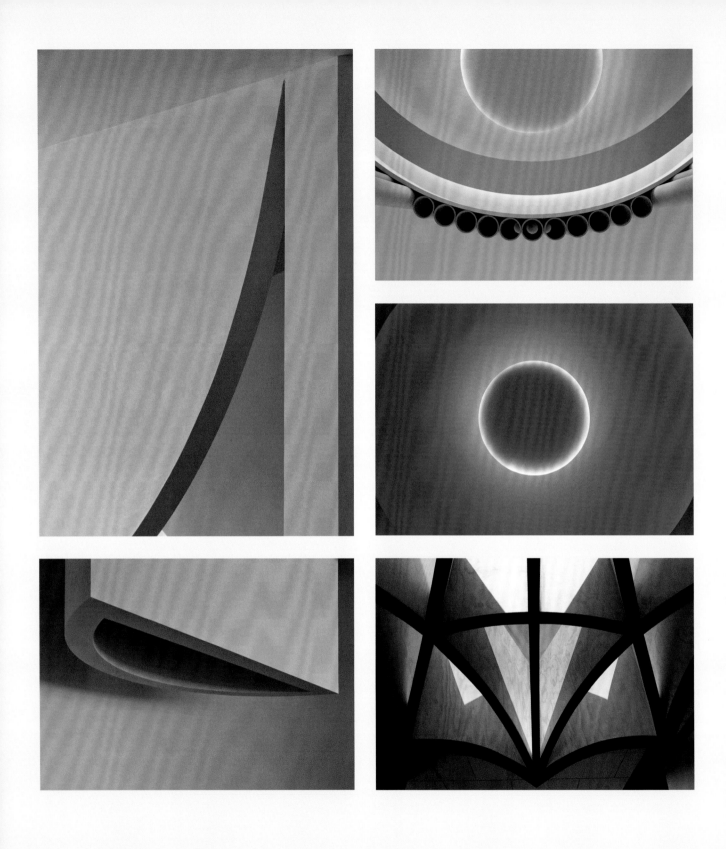

DETAIL STUDIES
Above top | The chapel from Placidus Student Welfare Spaces

Above | The ceiling over booth seat from Placidus Student Welfare Spaces

Above top and middle | The ceiling in the clock tower from Piazza Dell'Ufficio

Above | Light-catcher from Arts Epicentre

Above top | Ribbed concrete in the reflective chapel space from ARCO

Above | Black-steel stair from Arts Epicentre

Above top | Curved ceiling from Piazza Dell'Ufficio

Above middle | Profiled acoustic ceiling panels from Quaine Library

Above | Ceiling in the Chapel from Placidus Student Welfare Spaces

necessarily thinking about how we will photograph the building you're designing, but you are thinking about how, in the end, the building is going to be experienced. And it can get you starting to actually visualise, in the design phase, how it'll be photographed. You are going to think "Oh, this is actually going to be a great visual", and it's interesting because you see the visual strength of the building, apart from the materiality and its functionality. You can actually see the way it is rolling out from its inception, which is really weird as a vision of a building.

BW I think it's more about the clarity of the idea. I don't believe we're thinking "Oh, this is going to be the photo." It's definitely not about the photo in itself, but more like when you take a photo of something, and someone else comes along and says, "Hey, let's just take a photo of this thing with a shadow on it." And all of a sudden as a designer, as an architect, you say to yourself, "Well, we don't actually need a lot of stuff to make this space be what it needs to be." So yes, it's all about that process of reduction or refining, of distilling the concept.

PC Yeah, I can see that as architects you're at the mercy of budgets, and budgets drive the process because of the materials and such things. You remember that in the early days, because of budget constraints, you were doing beach houses out of plywood. You had to use ply out of necessity, but that didn't mean you couldn't celebrate it for what it's good for. But I think that as you guys have become more experimental, as well with the off-form concrete being more deconstructed, you're finding it's interesting. Because in some ways the ARCO canopy is saying, "Here is this little sculptural form, but its beauty is in its moments, in these little moments of the deconstruction", and you're saying "You can find the beauty in its smaller elements." So, that's fascinating because I think you know what we've been talking about with your architecture and with trying to find a way to express it. We often talk about photography as a visual language, and you always talk about your architecture having a language, because that's your way of speaking. It's you guys talking as architects that I think about at the end of the day, and what I also find rewarding as a photographer is that when we talk about it, we end up agreeing.

And so, in the end, what happens is that the process becomes enjoyable because we can all work towards something and go "Oh, this is great because we're going to get this and this and this." It's funny, isn't it, because we've reflected on the building process and we talk about the pain of building, which is so fraught with angst and anxiety because clients, builders and architects often don't agree. If you like, you almost need a psychologist, because ultimately, for everyone, it's like marriage counselling because, at some point, someone is not going to be happy in the relationship. And circling back, that's the thing about photography. I find that photography is often something where the architect picks up the phone and says, "Hi, I'd like you to come and document my building." The photographer turns up and photographs the building. Lovely photos done. Game over. "Thank you very much. I'll see you at the next one." Whereas I think I have tried to engage myself with the designers, because I want to get to know the building; I like to enjoy the buildings; I like to understand the buildings, because I appreciate architecture and built form. What I believe I'm trying to say is that it's through this understanding that I can help, or find something to give back to you, if that makes sense. And so, I want to be part of the process.

I think that the way we talk about how we capture your projects has actually reinforced your resolve about who you are as architects.

BW That's a really interesting point because I feel like we want to be more like artist-architects than the kind of commercial, magazine-type architects. They finish a project, get a stylist, get the photos of a project. And it's mostly not architecture. It's quite contrived. The spaces are basically just filled with

"We often talk about photography as a visual language, and you always talk about your architecture having a language, because that's your way of speaking"

stuff and the photographs say nothing about the architecture. That should be at the forefront – light, space and all that good stuff.

PC Well, these things don't come to everyone, shall we say. But when you look beyond that, I think there's a reward in developing strong relationships with people, whether they be professional or personal. In this regard, we've sort of got to know each other both personally and professionally, and it's rewarding to experience doing the work together.

BW During the journey, over the years, we've really begun to push and push and become far more abstract. And we love it. It's in the way we often talk about it: let's go more moody, let's go black and white, and pushing some boundaries too.

PC Which is interesting because if you think about the CTK science labs, you approached them with a completely different vision. You said, "Pete, let's go harder", and that conviction, that was a brave decision. The funny thing is, there's no right or wrong, because there will be people who appreciate what you do. And you know the thing about being creative is that not everyone will like what you do. That's just an unfortunate thing about life. But as you're saying, all along this journey of photographing your projects has been about "Oh, let's try this. Let's do this. Let's go harder. Let's do this."

"We have really wanted to push against what the mainstream sees architecture as being, and what a finished project should 'look' like. We design architecture as spaces and experiences"

BW I think that's because we have really wanted to push against what the mainstream sees architecture as being, and what a finished project should "look" like. We design architecture as spaces and experiences. Again, I come back to this idea or notion of architects as artists and not as home lifestyle commodity providers.

PC Unfortunately, I think that architects begin to second-guess themselves and they start asking "Oh, should we do this? And should we do that?" And what happens then, is that you're just trying to please a certain market. That's transitory; that's on-trend for the moment. Whereas in ten years' time, if we go back to what that person has done in glass, say, you'll be thinking, "That just looks a bit clichéd." Well, if you pare it back to the basics, you then think "this should be enough". That's a case in point. But, unfortunately, architects then start talking about "Oh, but we need to style, we need that because we need to get into magazines." Then I say, "Who's your audience?" If you're doing domestic architecture, we probably need to recognise these things are important. But if they become the driving forces, then what are we saying? That the architects are not good enough? That we need to actually add things to it to actually support the architecture? Well, surely the architecture should be enough.

Someone like Chipperfield or Zumthor would never put a chair or a glass in the photos of their architecture because it would just be jarring to them. Could you imagine if you said to either of them, "I think you need to style it?" I mean, that's funny, isn't it? We would have discussions in the office about the fact that the pure architects, the ones that we seem to celebrate and refer to the most, seem to have almost nothing in their images. But what's also interesting about those architects is there's a consistency in the people they work with. So, if we look at Chipperfield, or if we go back to Jesús Granada who does photography for the magazine *El Croquis*, there's a consistency in who's looking at and photographing their buildings. Not that I don't think there's merit in other people seeing your buildings and rephotographing them, but there's also something to be said about people who know you, know your work. And through an ongoing relationship, they can actually respond in a way that you know will always generate photographs you're happy with. You build up those relationships over years. But that doesn't mean to say that we, as other creatives, can't say "How about if we go in another direction?"

For example, with the science labs, when you said "Pete, let's go even more abstract today", I would always say, "Yeah, OK, I'm up for that." But then, as creative minds we can also get together and through our skillsets explore those other directions and then actually go there. But that's a conversation where I think we circle back to our original thing.

BW Yes. And there are lots of ways to do that, and there are practices that will have a different photographer on almost every job, and they seem to cycle through half a dozen photographers and that might work for them, but I just can't see how that would work for consistency. So, it comes back to what you're saying about Chipperfield, Zumthor, John Pawson and similar architects of that stature. The way their work is represented is always kind of consistent, and I think that's what we have built or are trying to build.

NR Well, I think that this is another point that speaks to the fact that you can't be completely true to the idea you have in your head and put on paper. The built reality in the actual world is going to be different, because you're dealing with so many outside factors and limitations, natural events and synthetic constraints that we're never going to be 100 per cent happy with everything. It's impossible, but you know, it's good if you're happy with the way that you've represented your idea.

"You can't be completely true to the idea you have in your head and put on paper. The built reality in the actual world is going to be different [...] you're dealing with so many outside factors and limitations, natural events and synthetic constraints"

When you are true to yourself, and you're not trying to please anybody else, the irony in that situation is that you actually get more of that recognition you want, and maybe that repeat work. Because it's a clear, concise visual product. Whereas by compromising and representing your work in a way that you think other people wanted to see it, you may have just got by. You know, the work of a compromised artist always has something a little bit tacky about it. Like you never really want to engage with that as a consumer. Whereas artists like Brad and me, we believe that our conviction will, in the end, survive all the fashion trends and throwaway frills around the edges, and we will hope to create a body of work that we can reflect on down the line, and be happy with what we have achieved.

PC That's why I often tell people that I work until I'm satisfied. Which is, I think, why you guys push through your work, through the pain of your clients, with the conviction to see your vision through, for example with the crazy garage door, which has caused you pain. For me personally, I don't look at the money side of things, because I know that I'm well catered for at the end of the day. I'll go back and reshoot because I need to be proud of what I'm doing. I need to be comforted by the fact that I did a good job, which is why I say I'll keep going until I'm happy. And I believe that as architects you do the same, despite everything that is put in your way.

Opposite | Interiors of the Junior Girls Science Department for Caroline Chisholm Catholic College, 2021

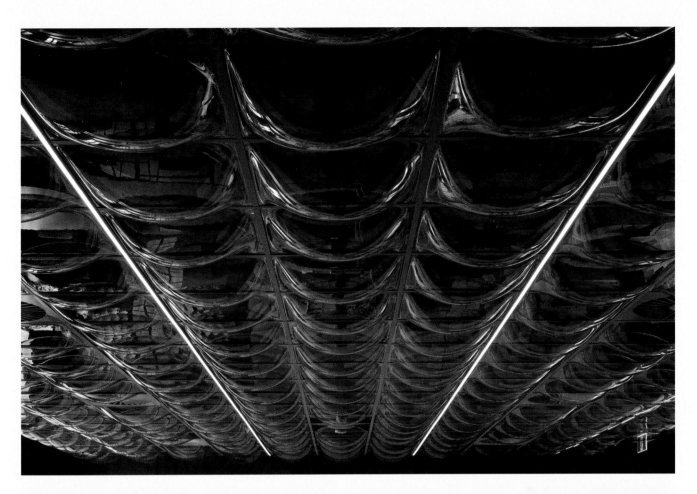

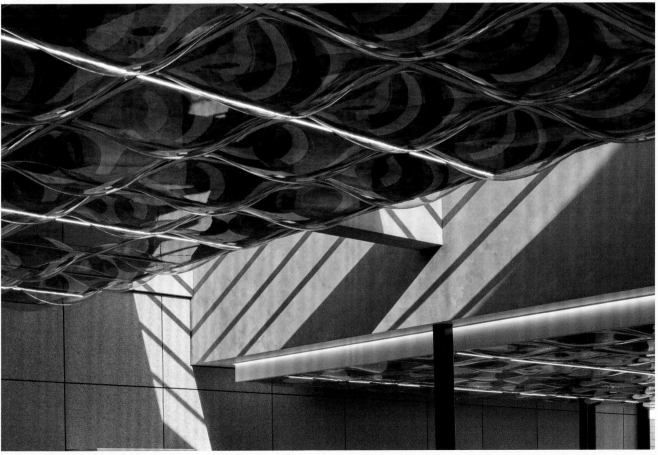

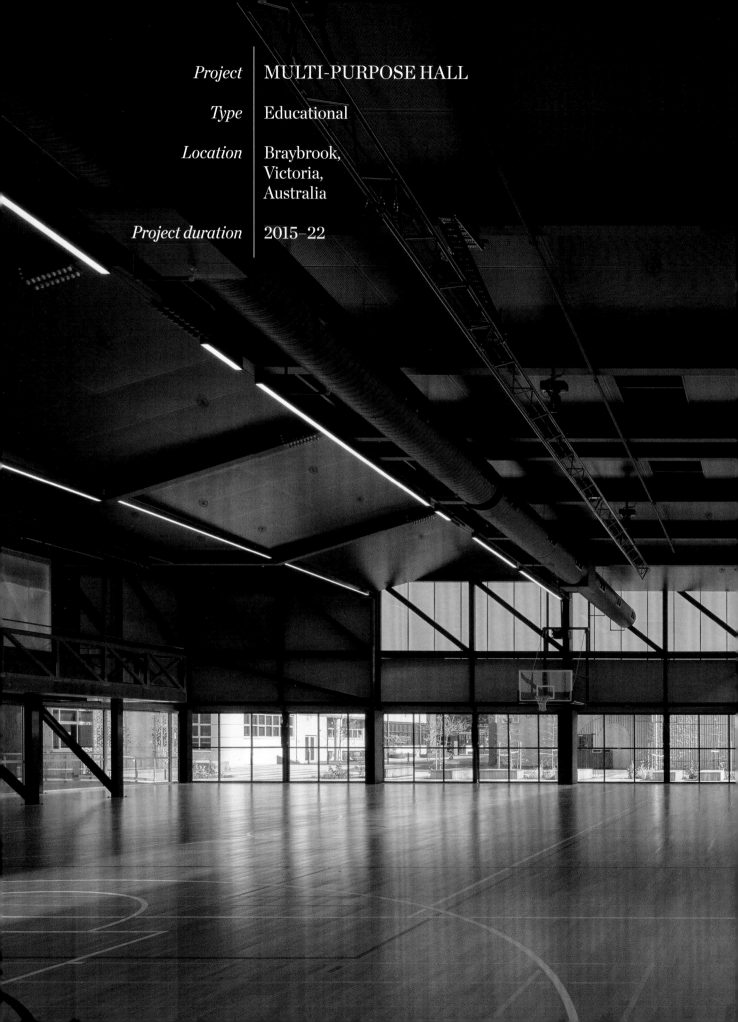

Project	MULTI-PURPOSE HALL
Type	Educational
Location	Braybrook, Victoria, Australia
Project duration	2015–22

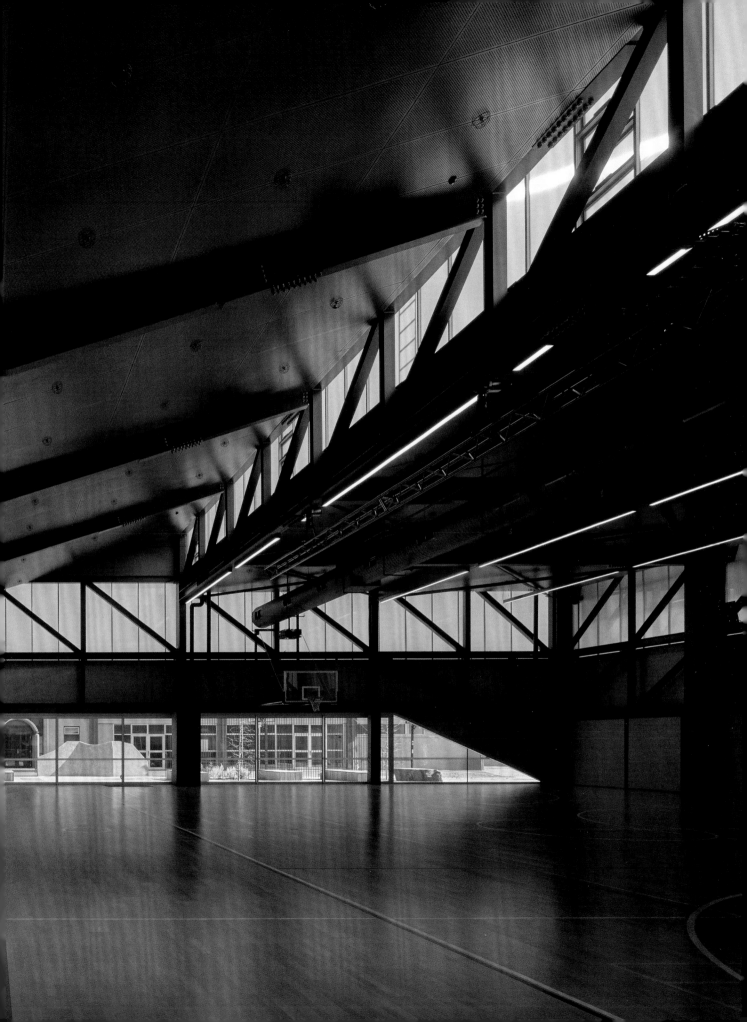

The new multipurpose sports complex is a much needed addition to the Caroline Chisholm Catholic College campus, providing a setting for students and staff to come together for assemblies, celebrations, mass, and sporting activities. The architectural approach to the brief responds to the industrial history of the local Braybrook environment, and celebrates the rich traditions of the expressive Structuralist architectural movement prominent in Melbourne from the 1950s onwards.

With no similar amenity in the school's grounds, the flexible floor plate of the hall can accommodate up to 2,100 seated students. A series of operable glass fire-station doors allows the building to open to the surrounding ovals, quadrangle and school playgrounds to accommodate even more occupants as needed. The building can function as a large, expanding and contracting "canopy" depending on the required use and audience size. Along the northern elevation, the building opens to the oval, terraced grassed steps and a viewing area. The steps create places to sit, study and relax. This external area is partly covered by an impressive cantilevered awning that offers shade and shelter. A series of north-facing, sawtooth windows on the roof let daylight into all of the interior spaces of the main stadium.

The building's mass is broken into two distinctive yet connected volumes. The primary volume of the stadium tapers down to the reduced scale of a suburban street in the areas that house the administrative offices, gymnasium and other amenities. This black-steel-clad volume is to be read as a "suburban silhouette" providing a visual relationship between the larger building and the residential houses along the small side street adjoining the campus. The typical internal height of the main stadium space is eight metres, which yields a relatable scale to its occupants, its context within the school and the local neighbourhood. Similarly, the lower volume is proportioned relative to the surrounding house heights. The building is also further grounded within its site by a rich native Australian palette of trees and landscaping to the extent of its perimeter.

The series of structural systems are conceived entirely in steel. The lower area columns and beams comprise portal frames; compression zig-zag trusses support the upper zones of the main sports gym and lower street façade; inverted trusses underpin the cantilevered external roof; and counterweighted structures are expressed through operable doors to lower areas.

The external façades are clad in three primary materials. The lower sections are predominately composed of operable glass doors to allow flexibility and permeability between the internal/external spaces, and the middle level is clad in concrete, which wraps the south, east and west façades to gently terminate in the ground at the northern edge of the building. High-level façades are sheathed in translucent polycarbonate to introduce filtered light to the interior. At night they create a glowing band around the building, revealing its internal structural language to the street and surrounding context.

Previous pages | Interior

Opposite top | Interior with central choir loft

Opposite bottom | Northern cantilevered canopy with internal court areas opening out onto sports ovals beyond

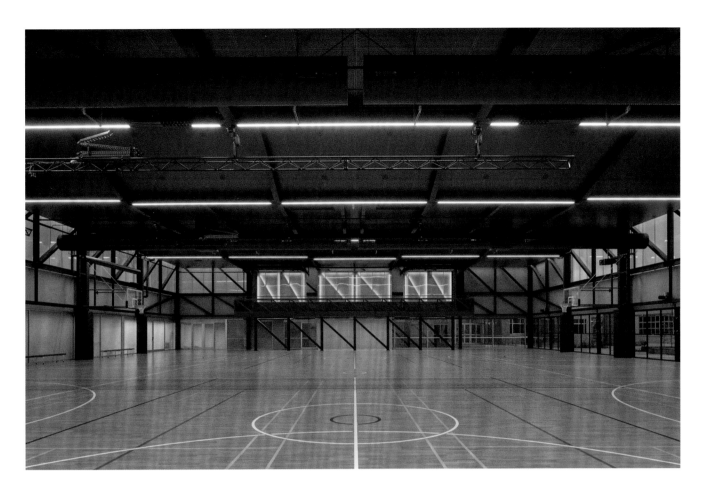

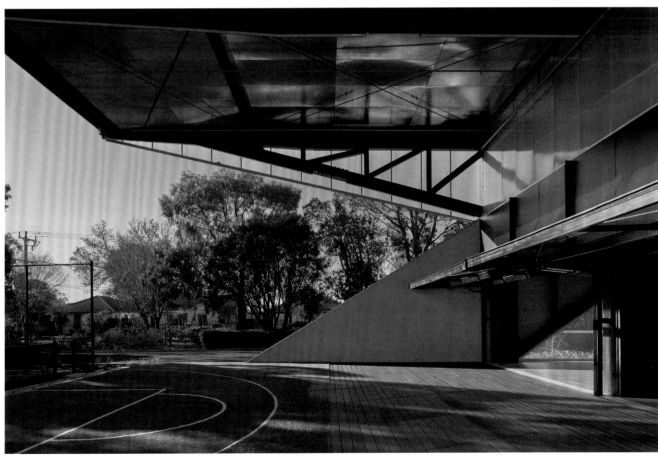

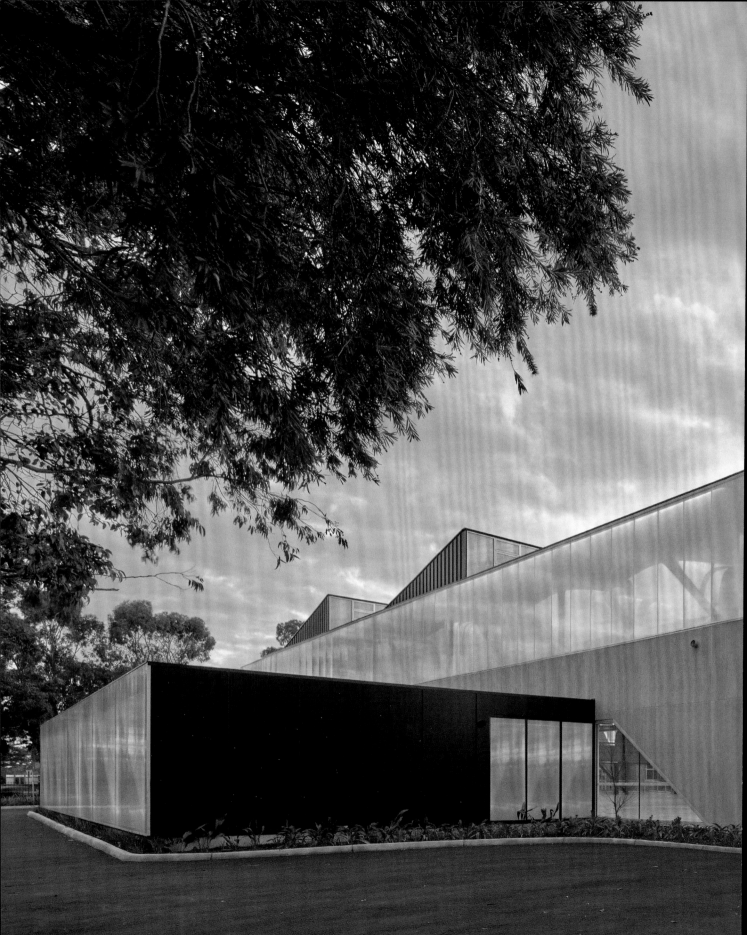

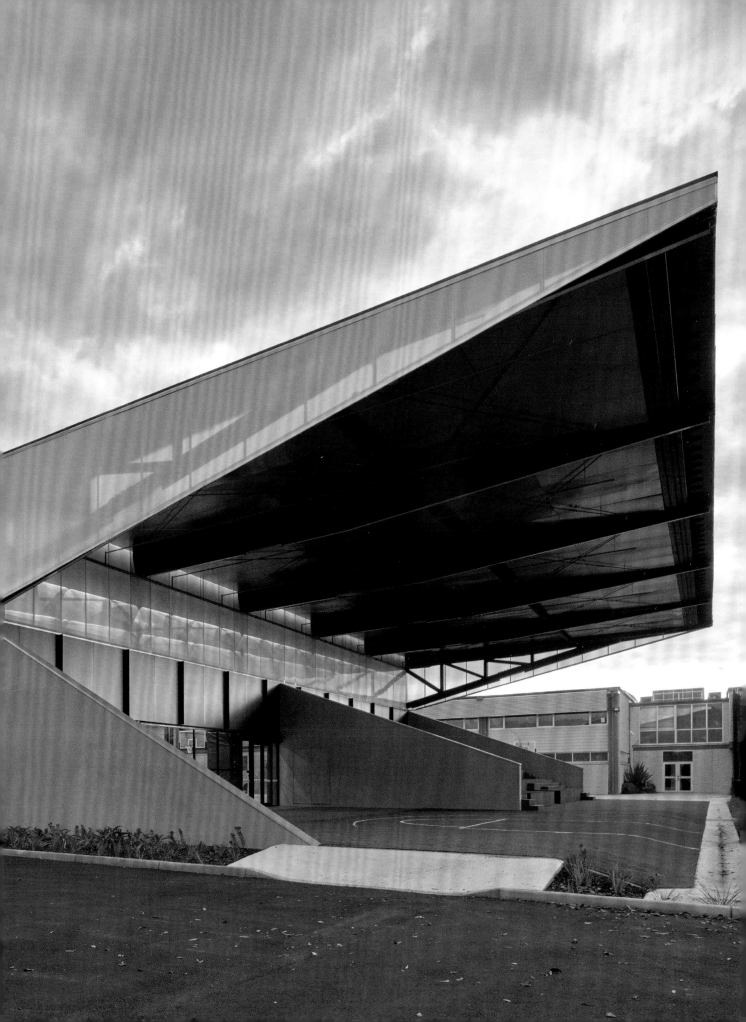

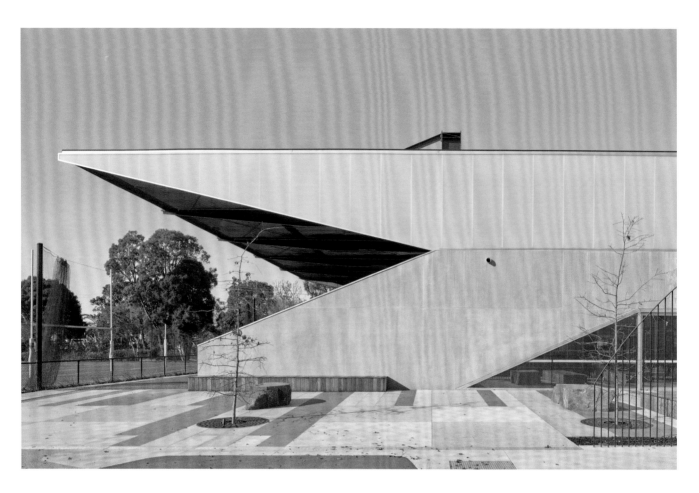

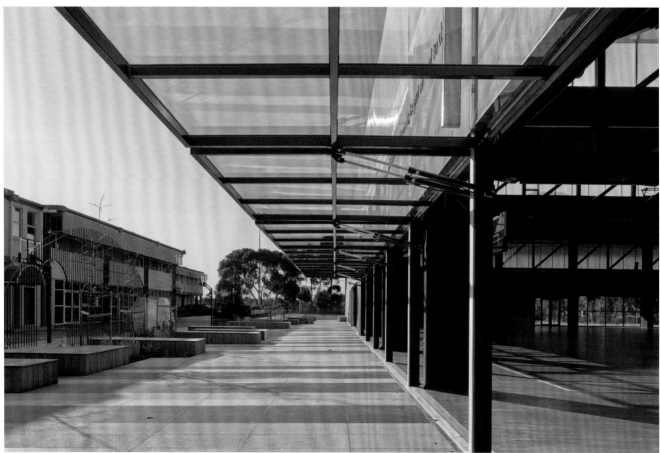

Previous pages | Exterior from north-eastern edge of site with cantilevered canopy and lower change room volume to streetscape.

Above top | Detail of upper choir loft

Right | Detail of behind upper choir loft

Opposite top | West Façade

Opposite bottom | Glass garage doors open up internal court spaces to external landscaped student areas

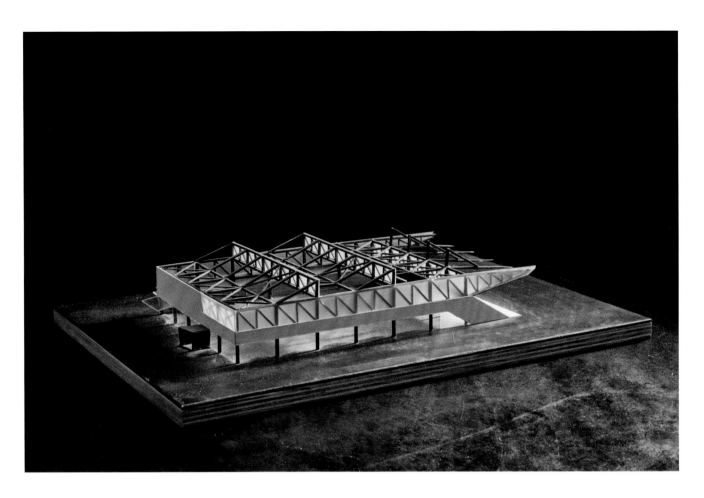

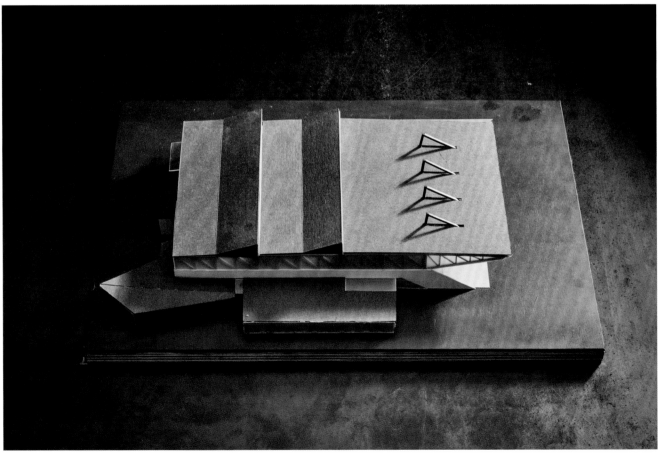

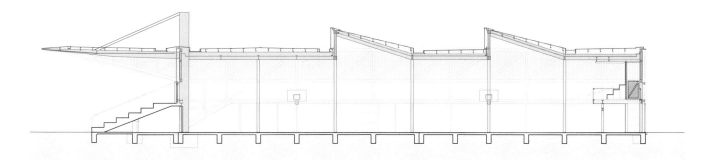

SECTION A

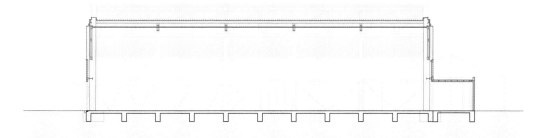

SECTION B

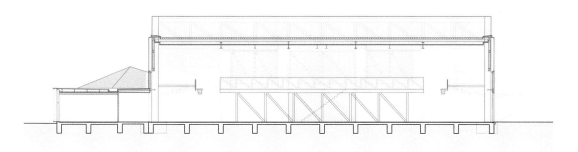

SECTION C

Opposite | Physical model

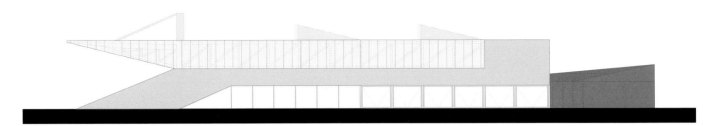

WEST ELEVATION

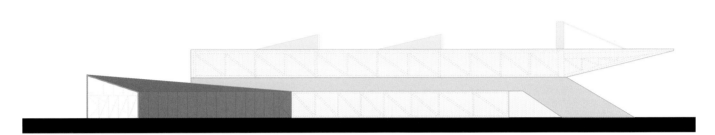

WEST ELEVATION – DARNLEY STREET

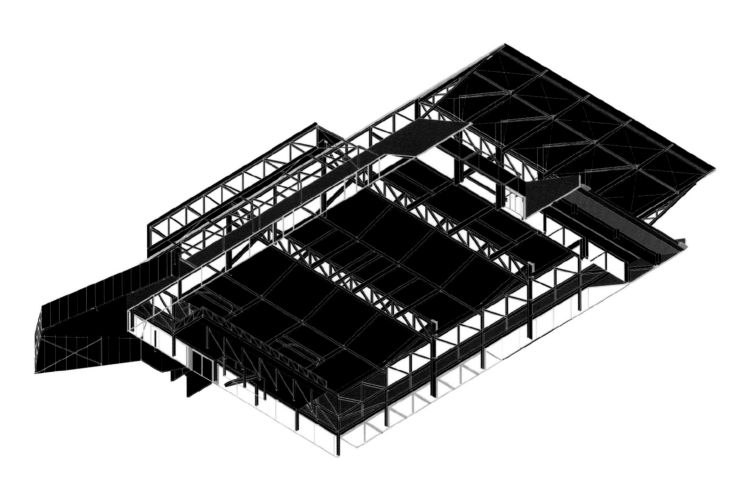

UNDERSIDE STRUCTURAL ISOMETRIC

PLAN 1:400
01. Entry
02. Trainning gym
03. Change
04. Staff offices
05. Equipment store
06. Primary open courts
07. Choir loft
08. External seating
09. Deck
10. Canopy over
11. Linkway to existing building

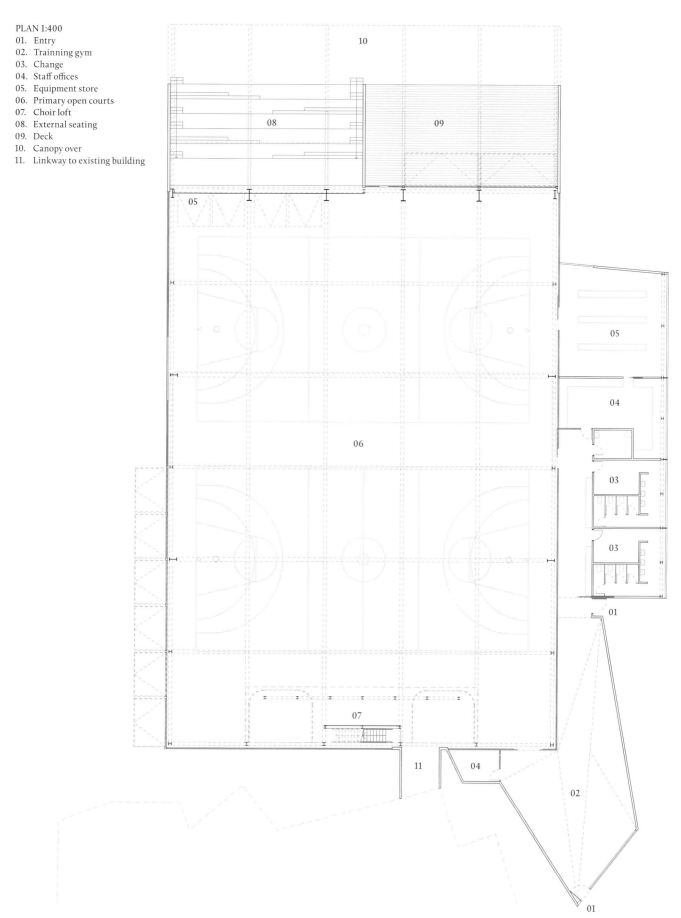

Overleaf | Multi-Purpose Hall within
the context of Greater Melbourne

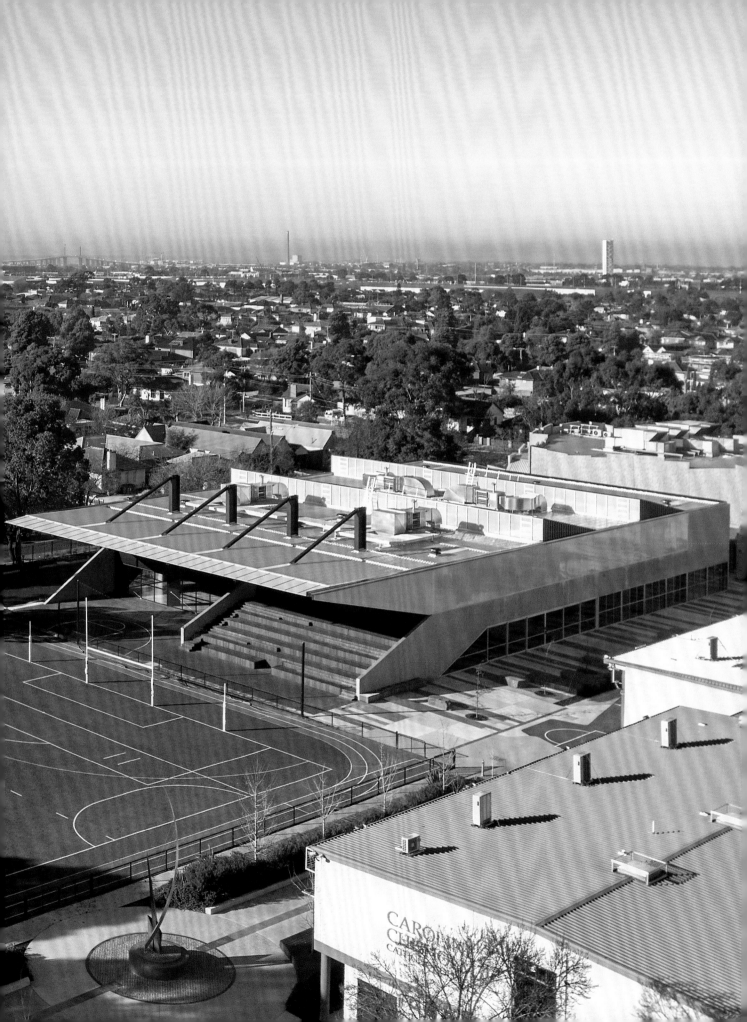

Project	GPFLA LEARNING CENTRE
Type	Educational
Location	St Francis Xavier College, Beaconsfield, Victoria, Australia
Project duration	2015–19

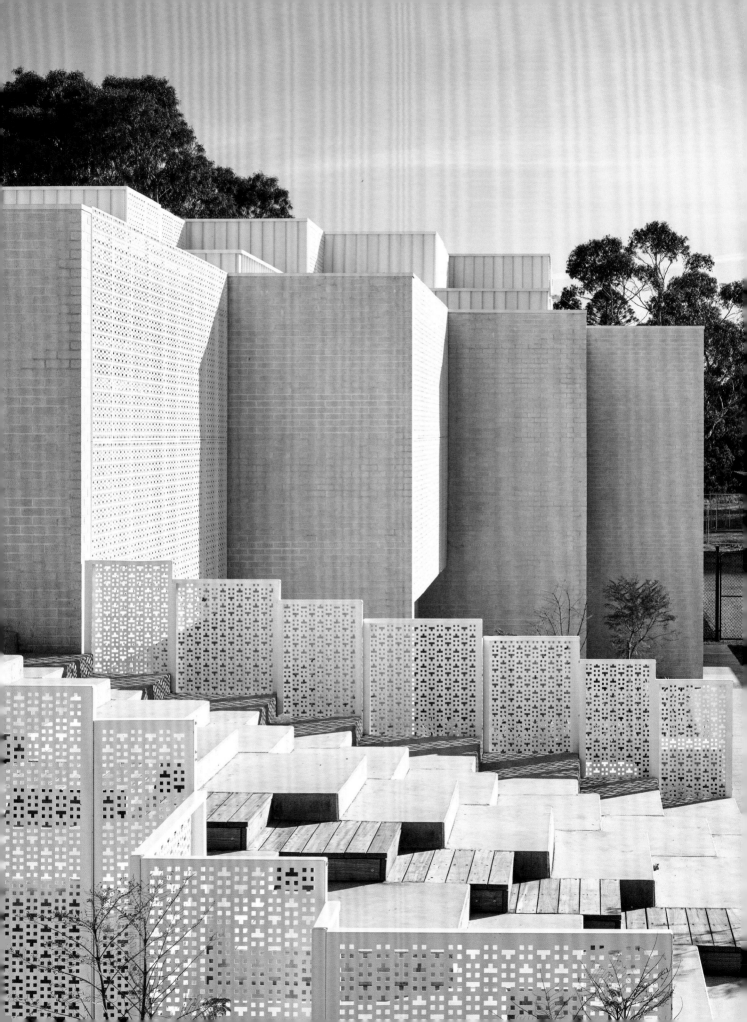

The General Purpose Flexible Learning Areas (GPFLA) consist of 18 new classrooms, associated learning commons, breakout areas and landscaping. Imagined as a "learning landscape", the complex extends itself along a narrow plot between previously existing buildings and the site boundary. The brief was for a building that would further develop St Francis Xavier College's flexible pedagogical practices within the classroom environment. An alternative classroom model was conceived that incorporates a series of central learning cores linked by various interconnected spaces.

Formally, the classroom module was rationalised into an interlocking "cell", with multiple cells repeated and arranged on the site, stacking along its boundary. The same modular language was used to rationalise the integrated landscaped spaces. The repetitious building methodology and a restrained material palette ensured the concept remained embodied in the final built form, and meant the project could be realised for a modest budget of 2,865 Australian dollars per square metre.

The building is conceived as a series of layers, with the building fabric becoming less solid as the spaces become less formal. The layers begin with solid concrete walls to the south and transition to the light and transparent northern elevation. The cores are 360-degree non-directional spaces. Large panels of glazing dissect the spaces, either separating or uniting the breakout areas with the main learning spaces while also acting as writable surfaces for group problem-solving and key academic messages and themes. The teaching is decentralised, and the use of display screens allows the learning environment to fit the requirements of the curriculum being taught.

The "learning landscape" theme is embodied throughout the building; mossy green carpets, lower ceilings and a "forest" of study trees at ground-floor level give the sensation of being under the tree canopy, while the first floor is washed with natural light and soft greys referencing the open sky above a snow-capped mountain top. As if navigating a landscape, students can wander freely between classrooms via the interlinking breakout spaces. This allows for a transparent setting that assists the promotion of cross-stream engagement and student-directed learning.

Rhythmic roof "pop-ups" bring light into the first-floor spaces while creating an inverted ceiling 'landscape' that imposes internal volumetric conditions referencing the various study environments and student activities. These range from intimate cave-like spaces with subdued lighting, to the taller, more expansive "open sky" light-filled areas. Vertical connection is explored through first-floor voids that allow light to penetrate the building's volumes and visually connect the internal spaces.

Another practical element of the brief required direct access to Level 1 from the main courtyard. Inspired by the basalt columns of the Giant's Causeway in Northern Ireland, external terraces have been built that function both as a stairway and as a sequence of informal learning and social areas.

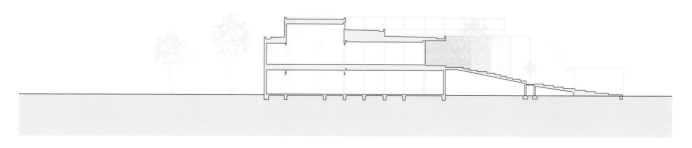

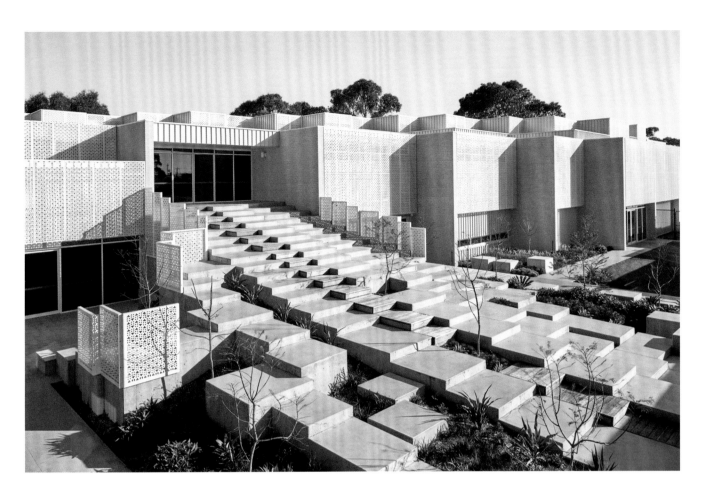

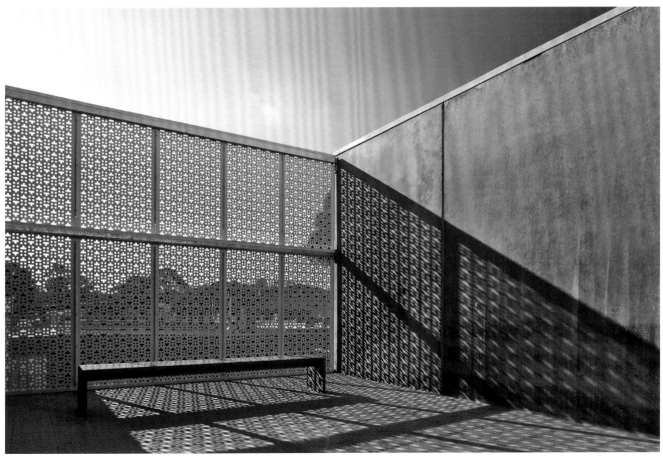

CONSTRUCTION PROGRESS SHOTS

Above top | Double height volumes within

Above left | Zig-zagged concrete slab edge profile to ground floor

Left | Landscape steps being formed and poured

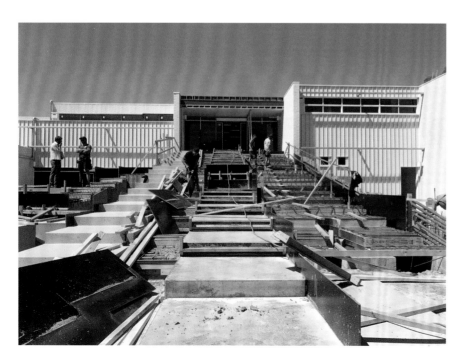

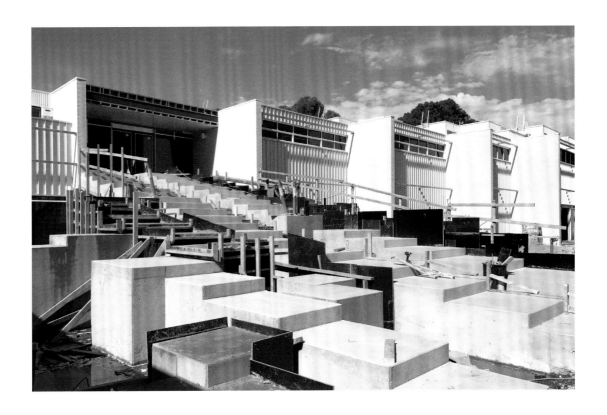

Above top | Standardised building volumes before the installation of veiled screens

Left | Vertical walls forming the upper level

Below | Terracing of concrete volumes before soft landscape

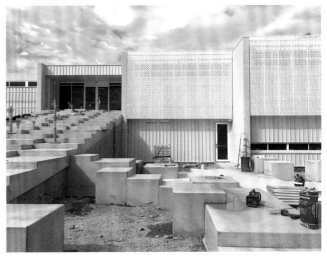

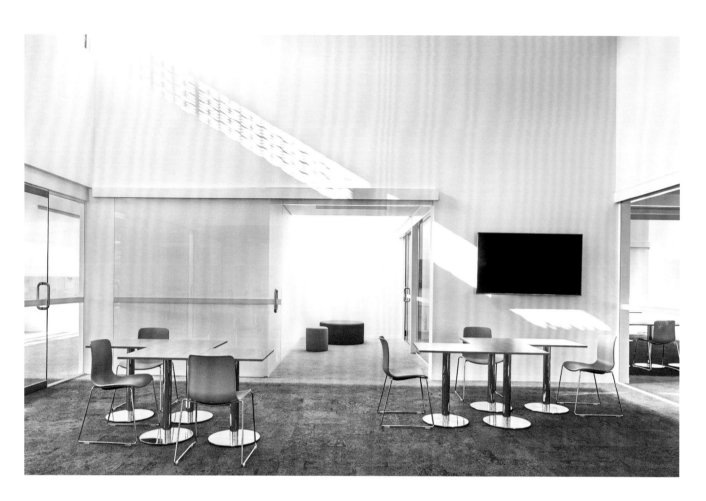

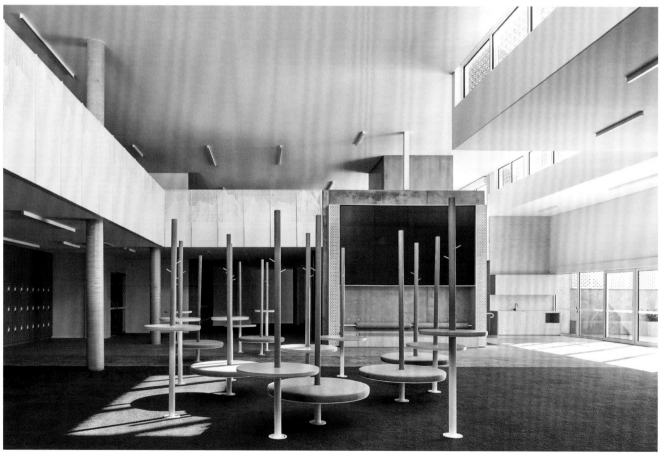

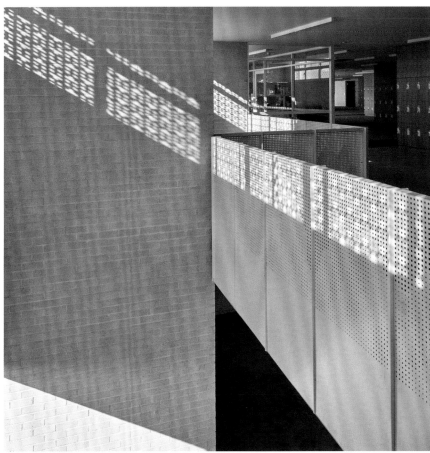

Opposite top | Internal classroom
with shared central breakout space

Opposite bottom | Ground floor
tree study laptop seats and tables

Above | Detail of stairwell

Right | Light play through external
screens into interior spaces

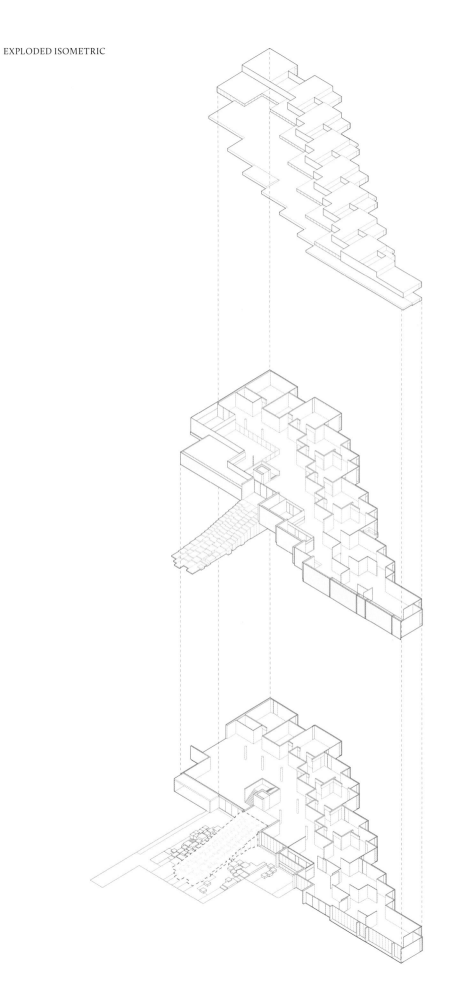

Opposite top | Physical model

Opposite bottom | Aerial perspective within site context. Building as landscape

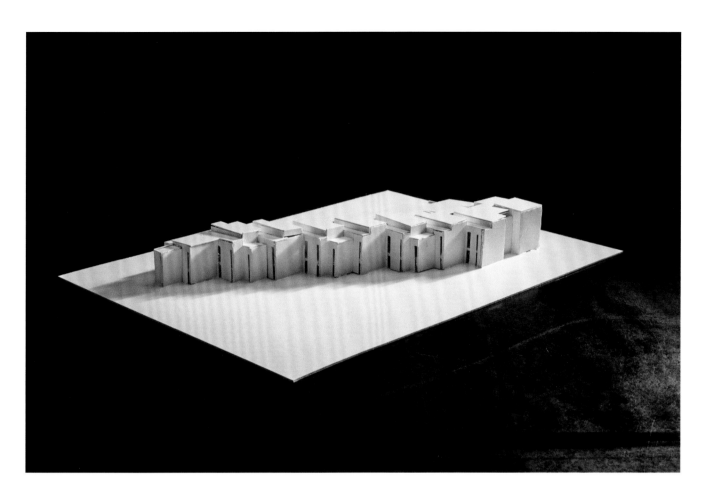

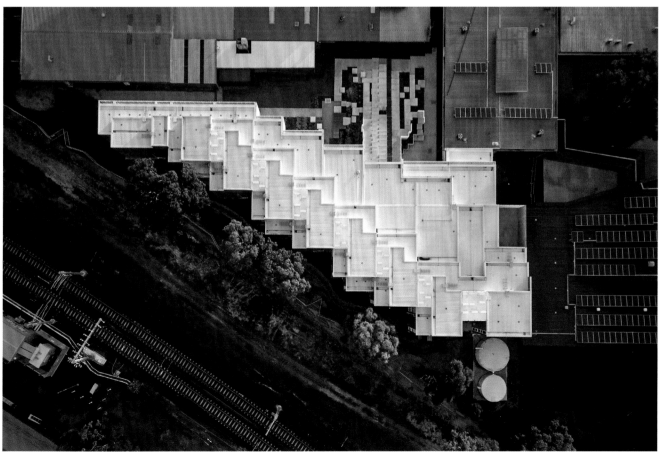

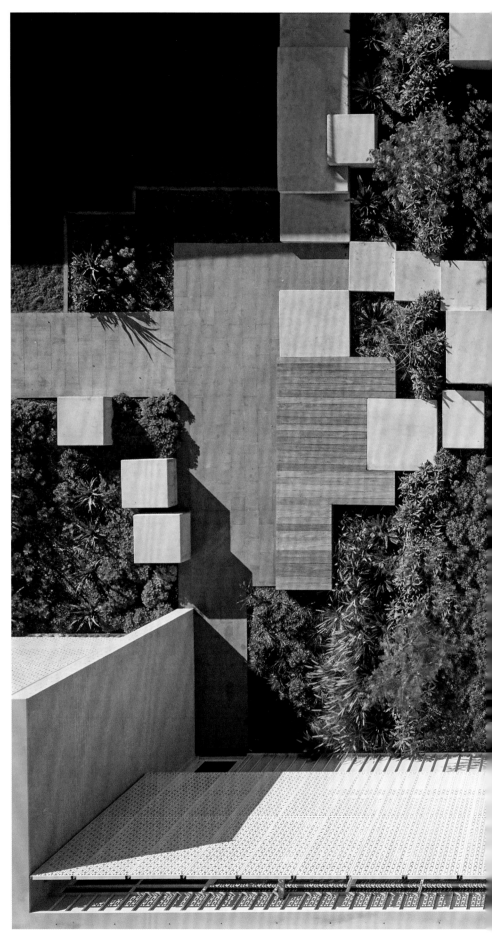

Right | Aerial detail of entry terrace landscape
inspired by the Giant's Causeway in Northern Ireland

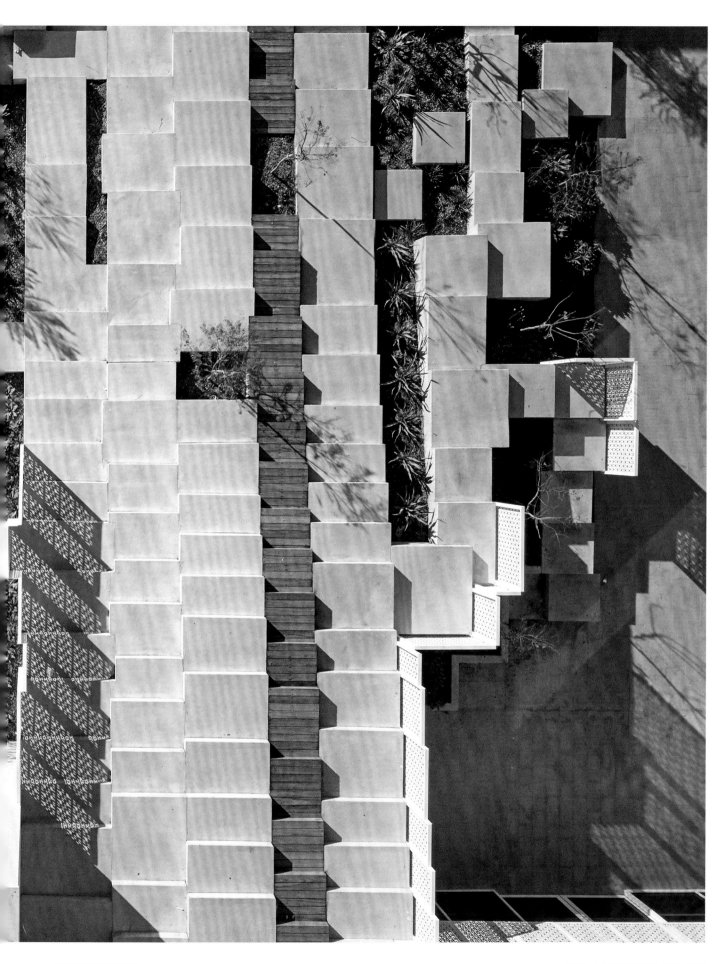

Project	PLACIDUS STUDENT WELFARE SPACES
Type	Educational
Location	Marcellin College, Bulleen, Victoria, Australia
Project duration	2021–23

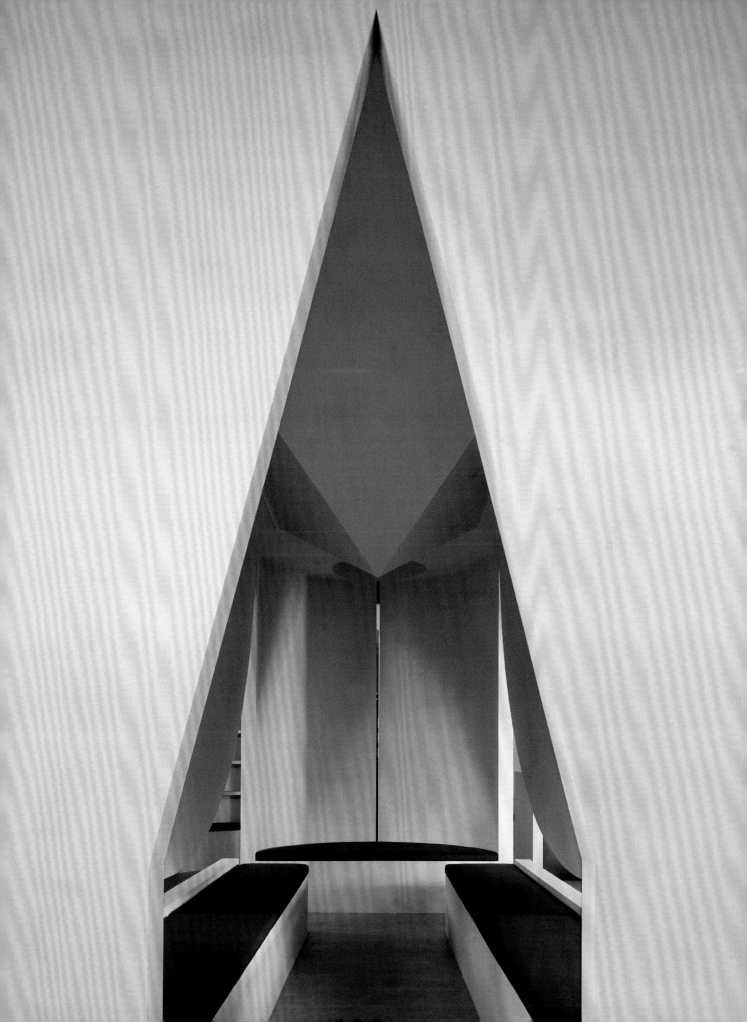

A long-term client, recently appointed Principal of Marcellin College in Bulleen, realised the need to invest in upgrading the college's mental health programmes and facilities following the Covid-19 pandemic, which had seen a substantial rise in mental health issues across the country, and especially among young people. He approached the practice with a brief to transform an existing lower-ground-floor space, previously used as classrooms and staff offices, into a variety of student welfare spaces, where they could relax, study, contemplate and meet with specialist staff members. Additionally, there would be specialist learning spaces, associated staff areas and counselling rooms, careers offices, meeting rooms and a shared kitchenette.

It was decided that student spaces, located centrally as the heart of the project, would take priority over individual staff offices and meeting rooms, which form the periphery of the plan. Instead, roaming and hot-desk areas would create an environment within which students and staff could work more closely and comfortably, particularly from a student perspective, when opening up and discussing mental health issues. The environment thus created embodied a sense of a "home away from home", where students would feel more comfortable through direct, familiar visual associations, such as a kitchen island bench where day-to-day discussions at home might happen.

From its early conception, the almost "subterranean" feeling of the existing space, both from the perspective of light and of spatial qualities, was embraced. The subdued light qualities could be reframed to create a calming atmosphere throughout, especially in more intimate and individual areas, whereas in the public open spaces the best of natural light sources were maximised.

The relationships of light with physical spatial qualities were enhanced by "carving out" spaces, which are further enhanced in section through a continuous ceiling bulkhead that provides moments of compression and relief throughout. Occasional circular recesses in the ceiling create and enhance spaces of importance.

A single colour – dusty rose – in the form of a light textural render creates a sense of material cohesion throughout. The choice of colour was notable because Marcellin College is an all-boys school; there was a keen interest from early on in pushing the boundaries of gender-based colour stereotypes. Spaces are softened through the use of curved forms in joinery and ceilings, and various upholstered areas create moments of physical softness.

Marcellin College is a Marist Catholic school established in the 1950s, named after Saint Marcellin Champagnat, who founded The Hermitage (1894) near Lyons, France, which is now a pilgrimage site for many Marist Catholics. A series of direct references to this important historical and liturgical link to the college were translated and used to create a narrative throughout the space in the form of ten architectural interventions.

The Entry: Referenced from the cavernous and ribbed textural rock foundations of the Hermitage, translated in the form of a hand-trowel textural render and formal archway.

Student Booth Seat: Referenced from the Hermitage's primary entry door, translated planometrically and extruded to create a semicircular booth seat and ceiling hood above.

Copy Pedestal: Referenced from Champagnat's personal Sacristy Cabinet, translated into a pedestal for communal printing.

The Theatre: Referenced from the natural rock and stone amphitheatre surrounding the Hermitage, translated into a communal student and staff amphitheatre for discussion and group activities.

Rest Bite Nook: Again, this references the rocky terrain with carved-out caves surrounding the Hermitage, translated into an intimate and contemplative area for students who need personal quiet space.

Contemplative Room: The same reference to caves, but translated into a more formal private room for students who need personal quiet space to regroup and who require one-on-one staff support.

The Chapel: References the original small chapel and first building on the Hermitage site, translated as a specifically non-religious space for all faiths and belief systems, for student contemplation and reflection.

Lounge: References Champagnat's own fireplace, which was a primary space for discussion and ideas, translated planometrically and extruded into a custom modular student lounge sofa.

Island Bench: Referenced from the wall recess which Champagnat used to store and display sacred artefacts, translated planometrically into a student kitchenette island bench, for eating, studying and discussion.

Laptop Bench: References one of Champagnat's personal sacred relics, displayed in his personal study. It has been translated as a geometric relic within the space – a student laptop bench and spatial divider between the student lounge and kitchenette area.

The architects are under no illusions that architecture can solve student mental health problems. However, it is hoped the new spaces will facilitate a positive experience and create a calm and relaxing place within which dialogues between students and staff can unfold naturally.

The next stage is a larger project to transform the college library, which sits directly above, to ultimately define the Placidus building as the central heart of the campus.

Opposite top | Student areas are the heart of the project. View looking towards chapel

Opposite bottom | Detail of student laptop desk and spatial divider between lounge and kitchenette spaces

Overleaf | Interior of the chapel

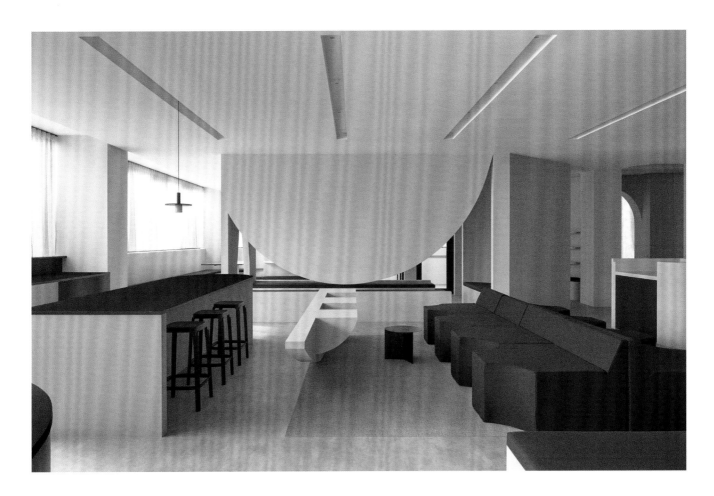

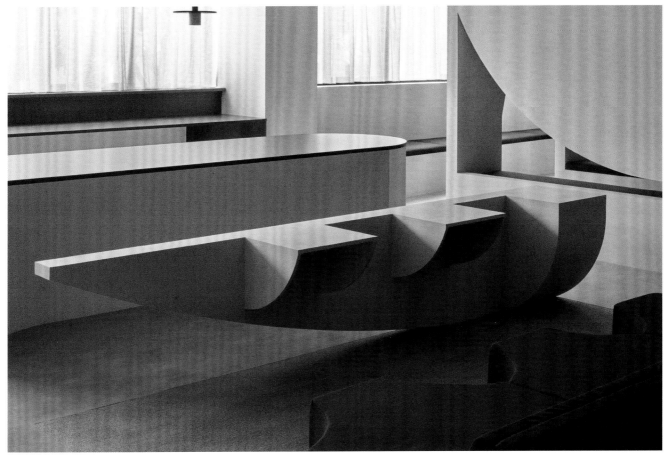

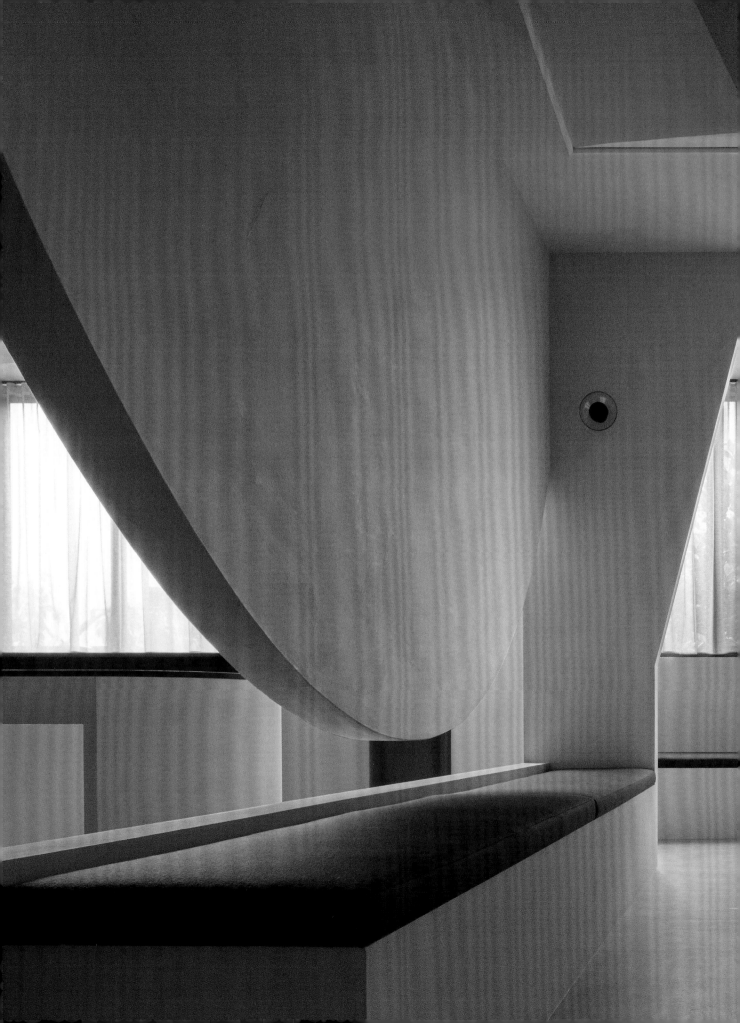

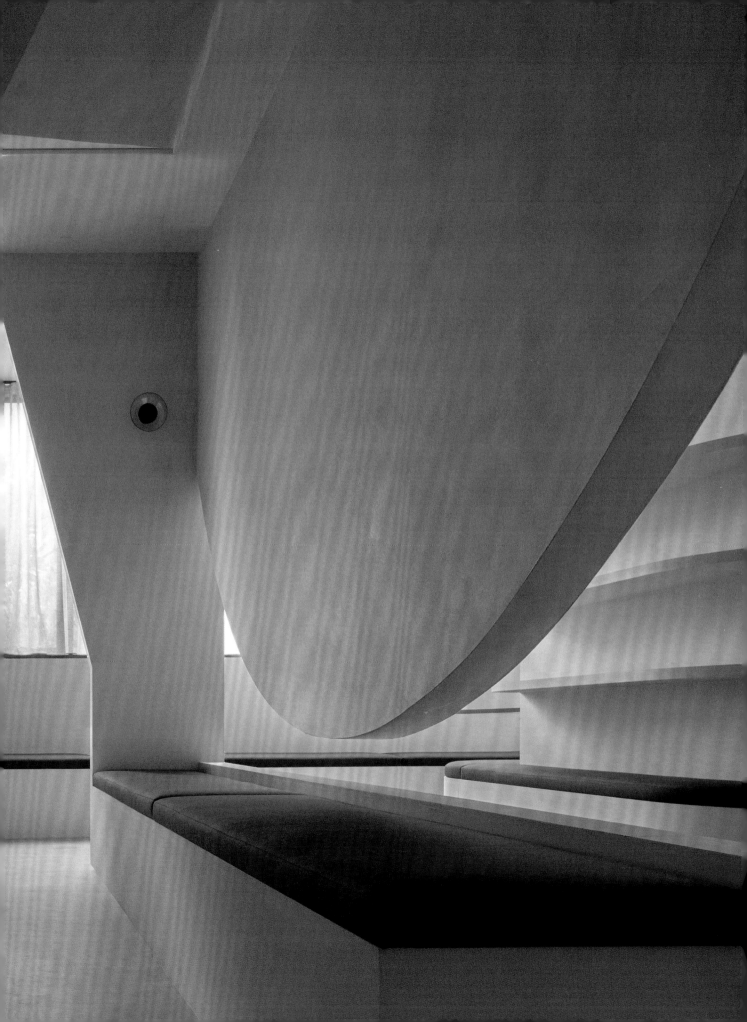

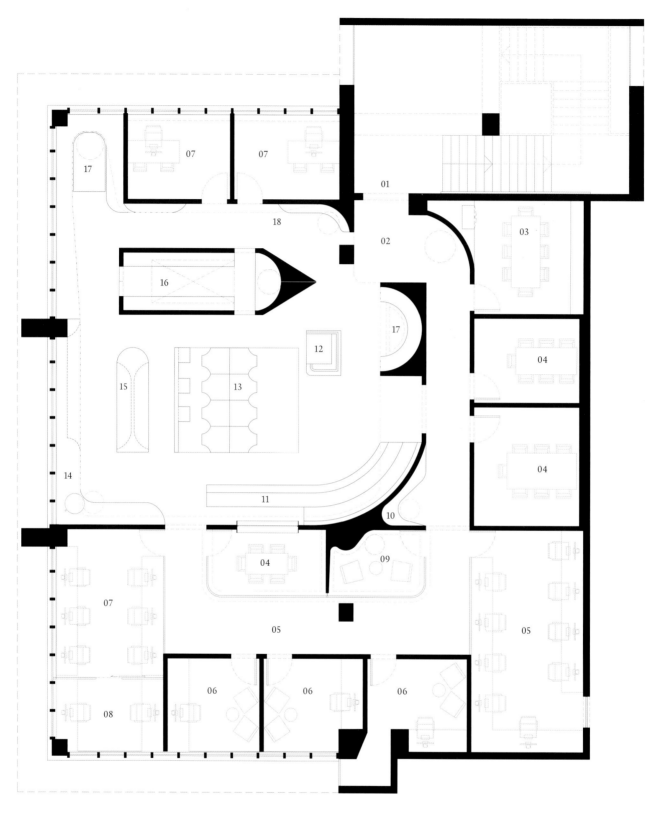

PLAN – LOWER GROUND LEVEL 1:100

01. Entry
02. Foyer
03. Meeting and training
04. Meeting
05. Roaming staff base
06. Counsellor's office
07. Staff office
08. Senior staff office
09. Contemplative room
10. Rest bite nook
11. The theatre
12. Copy pedestal
13. Lounge
14. Kitchenette
15. Island bench
16. The chapel
17. Booth seat
18. The library

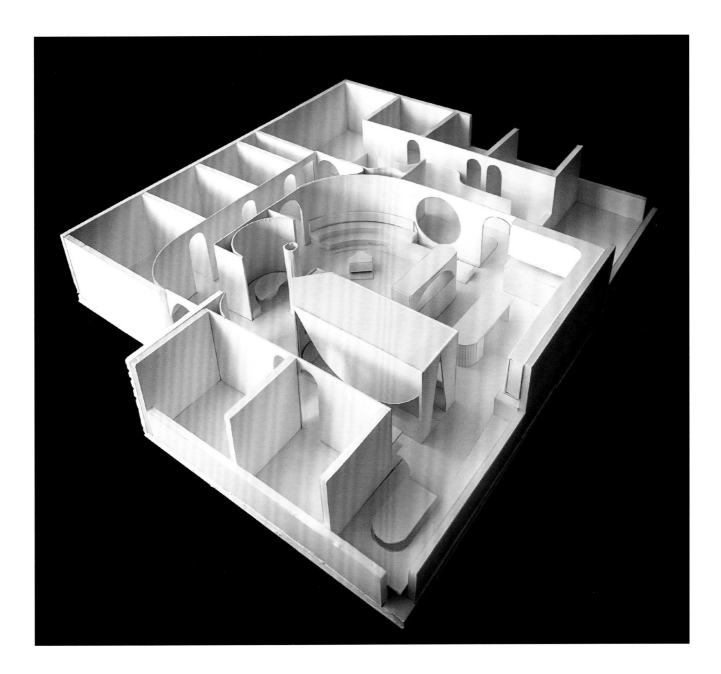

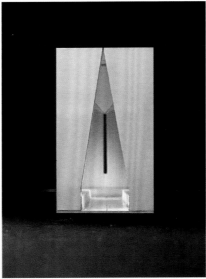

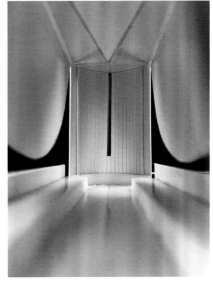

Above top | Physical model

Right | Physical model
– the chapel entry

Far right | Physical model
– the chapel interior

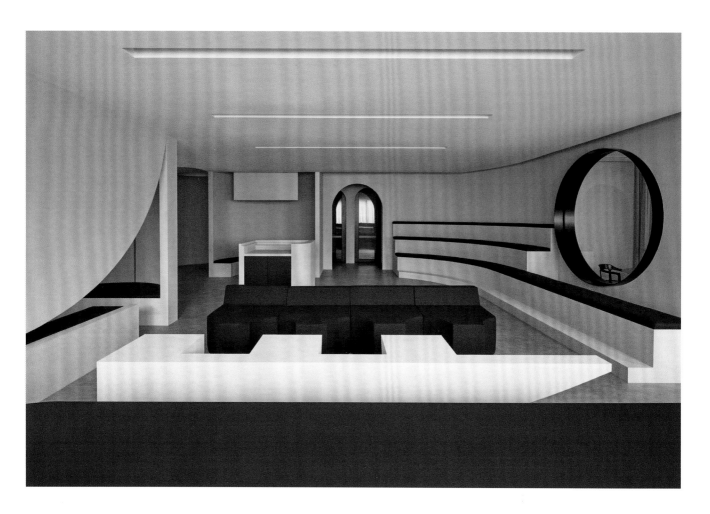

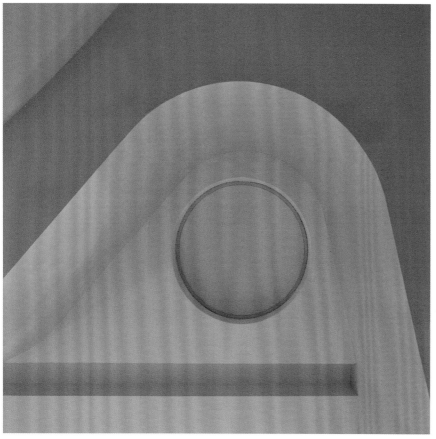

Above top | Student areas from kitchenette

Left | Detail of ceiling recess above rest bite nook

Opposite | View looking towards the theatre
with circular window into meeting room

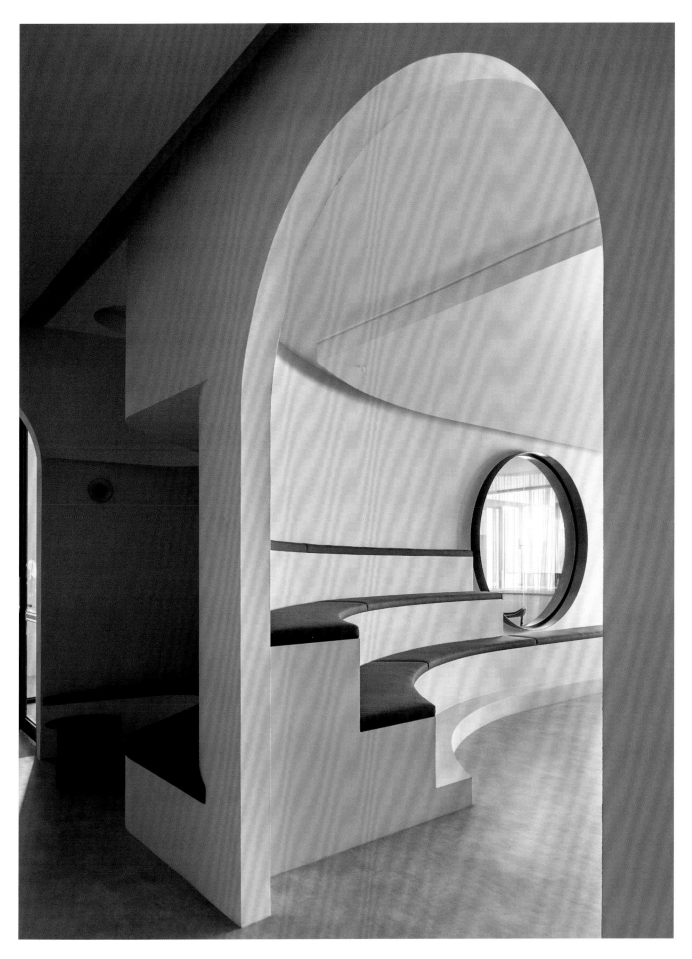

Project	THE URBAN SANCTUARY
Type	Pier pavilion
Location	Watermans Cove, Barangaroo, Sydney, Australia
Project duration	Competition design 2020; unbuilt

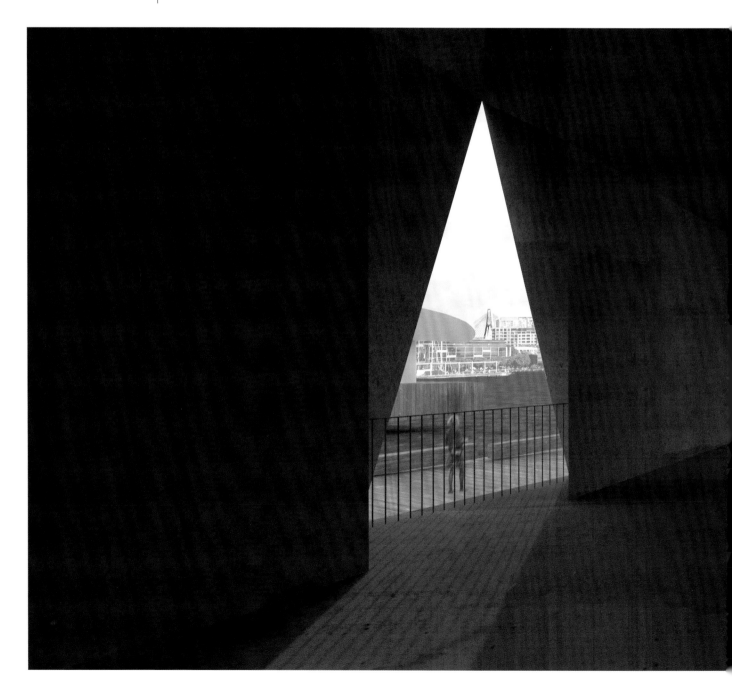

Branch Studio Architects used the physical and cultural narrative of the Australian landscape to root their pavilion design proposal within the context of the Barangaroo waterside precinct site on the edge of Sydney's central business district. The competition was a perfect opportunity to enhance this cultural framework, particularly from the important perspective of Indigenous heritage, referencing traditions that have a relevant role in Australian society today. The distinct conceptual and contextual narratives are amalgamated into a single cohesive scheme, beginning with a simple "dialogue circle" at its heart. A "yarning" or dialogue circle is an important process within Aboriginal and Torres Strait Islander culture, used to create a non-hierarchical forum to build respectful relationships and to preserve and pass on cultural knowledge.

Given the quite particular formal area of the site, the initial strategy was to redefine it to give it a definitive and contextual logic. This resulted in the formal rationalisation of an isosceles triangle, geometrically uniting the different narratives – a circle inside a triangle – and opened a path of experimentation and

Below | Interior view with triangular apertures framing specific site and context components

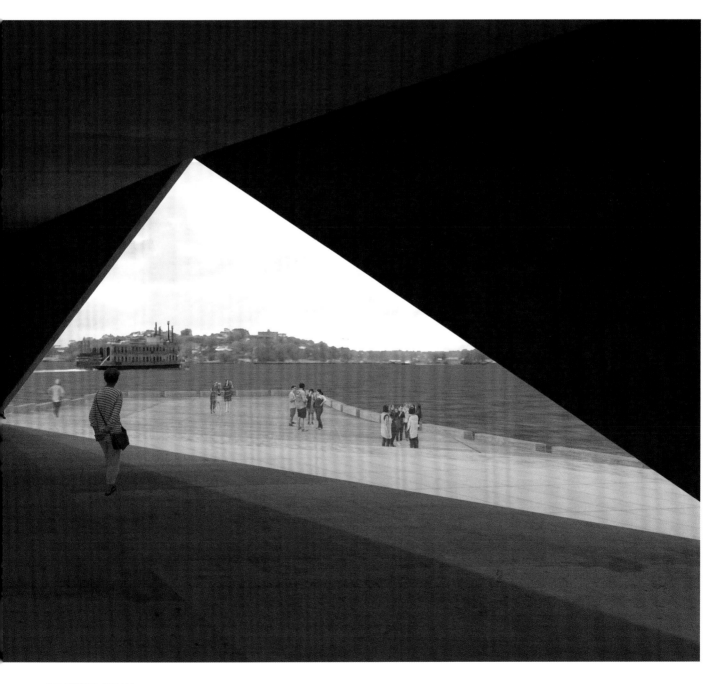

investigation into the history of geometric abstraction in art and architecture, specifically in the work of Kazimir Malevich and Lazar Khidekel. The proposed design is therefore an abstraction of ideas revealed through a series of moments, and not fully comprehensible at first glance.

The project's materiality creates a visual narrative linked to the wide and iconic red Australian landscape. Conceived in red-pigmented glass-reinforced concrete, the pavilion appears visually heavy yet physically light in construction to suit the site's structural load capacities. The floor of the central dialogue circle is rammed soil from the Central Australian Outback – literally a piece of red earth embedded into ground. The conceptual origin of the sun/light-screen element over the dialogue circle is the inverted Indigenous "humpy" (a traditional temporary shelter). Re-created in lightweight, perforated red anodised aluminium, it is partly open to the elements, allowing rain to enter through the centre while light comes in only through the patterned perforations.

Views are intentionally captured and geometrically framed to move away from the stereotypical open, continuous vista. The pavilion is programmatically adaptable, able to accommodate an extremely broad range of functions, from the intimate to the celebratory. The café component has the potential to be permanent, to activate the promenade, while the areas for the containerised kitchen could be used as a small studio space, perhaps for an artist-in-residence, when not in use for a function. The eastern elevation has the possibility of being made fully operable through sliding panels while still appearing as a solid and richly textural backdrop to the city. The architects see the pavilion as an urban sanctuary, a place for people to gather together, talk, reflect and enjoy a quiet moment at the edge of the hustle and bustle of the city.

Below | Circular aperture and seat within reflection space

Opposite top | Interior space with central circular perforated light oculus

Opposite bottom | View looking up towards central light oculus

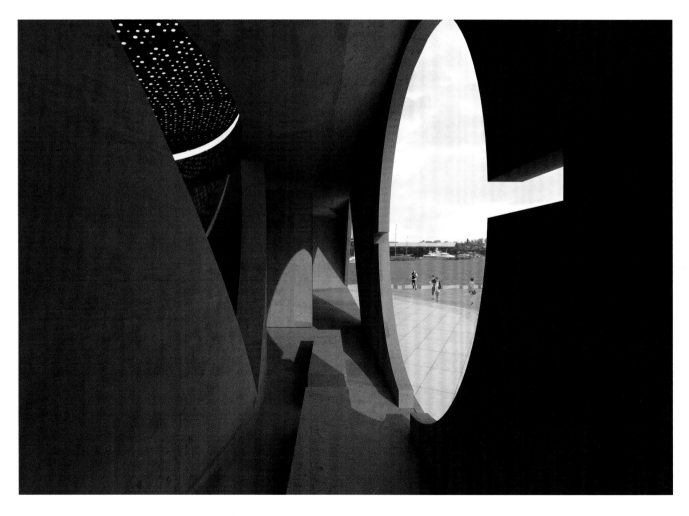

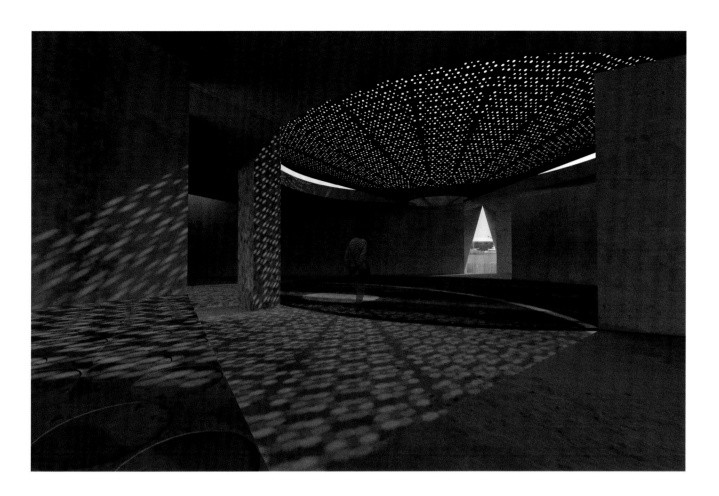

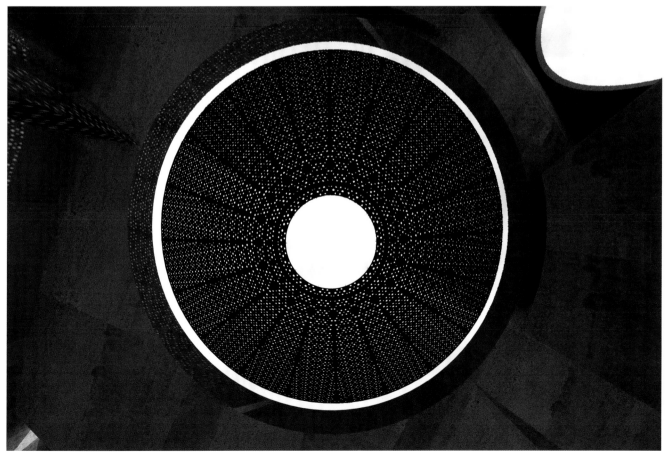

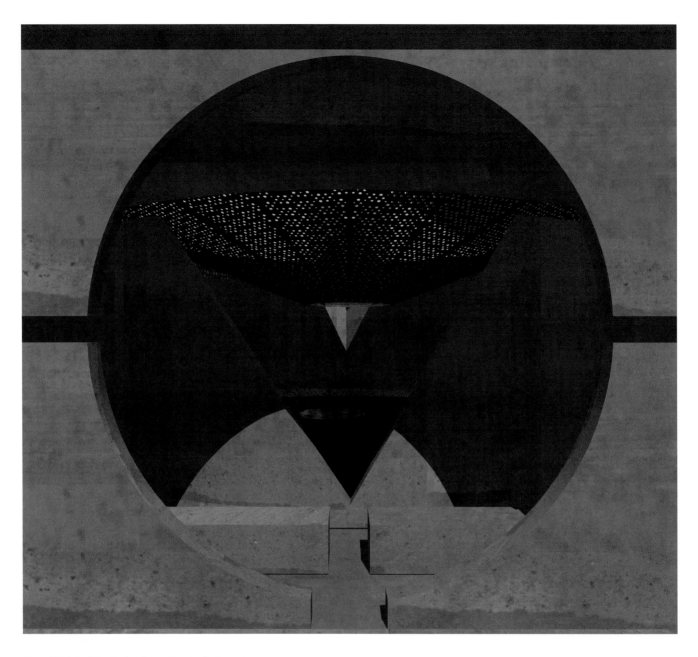

Above | Detail of circular façade opening at reflection space
Below | Section

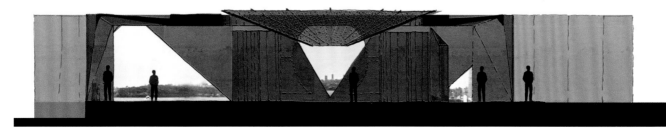

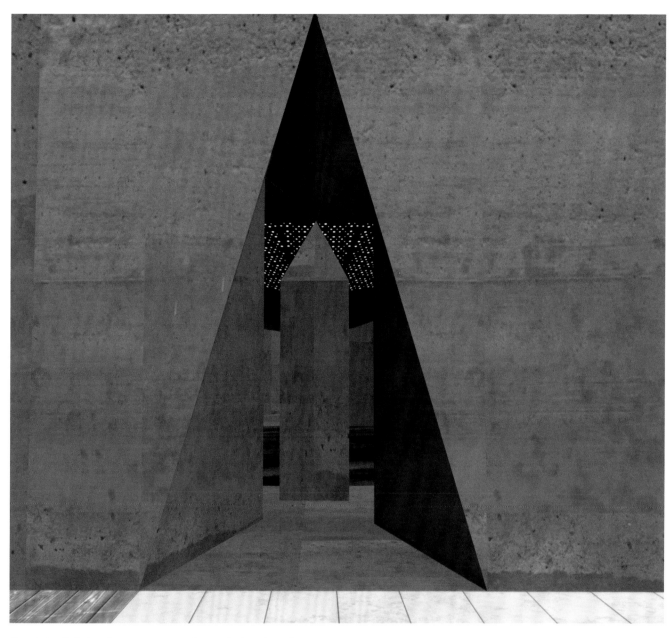

Above | Detail of triangular entry aperture with pointed column beyond

Below | Section

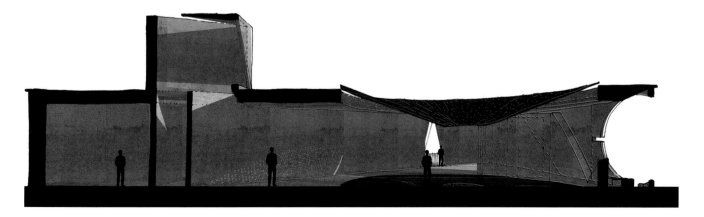

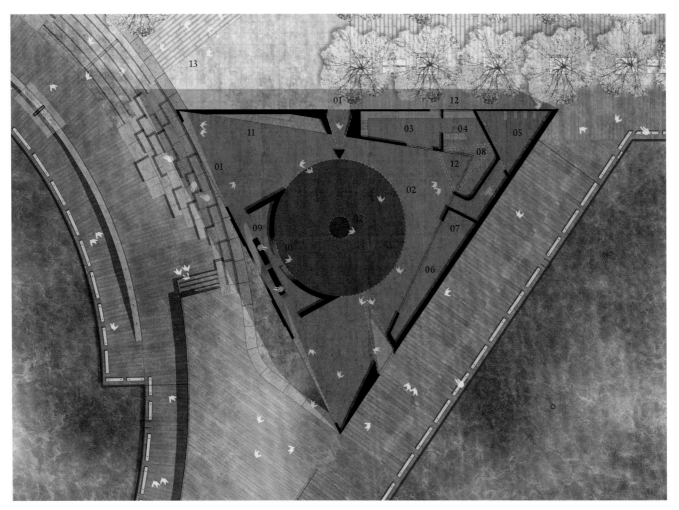

PLAN 1:200

01. Entry
02. Primary event space and dialogue circle
03. Kitchen and service/ studio space
04. Bar (hole in the wall café)
05. Washrooms W/C
06. Temporary screen
07. Temporary FF&E store
08. Cooling tower over
09. Reflection space
10. Fixed screen
11. Fixed and interlocking moveable seating
12. Servery
13. External temporary waste

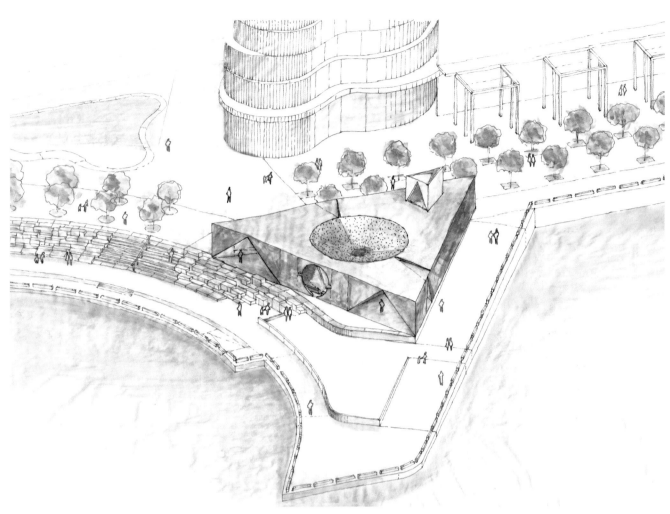

Opposite top | Plan

Opposite bottom | Sketch of entry and café servery
from upper promenade

Above | Sketch perspective within site context

Below | View from eastern lower boardwalk terrace

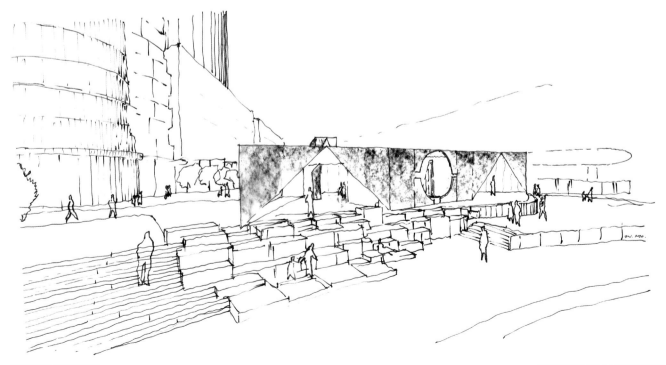

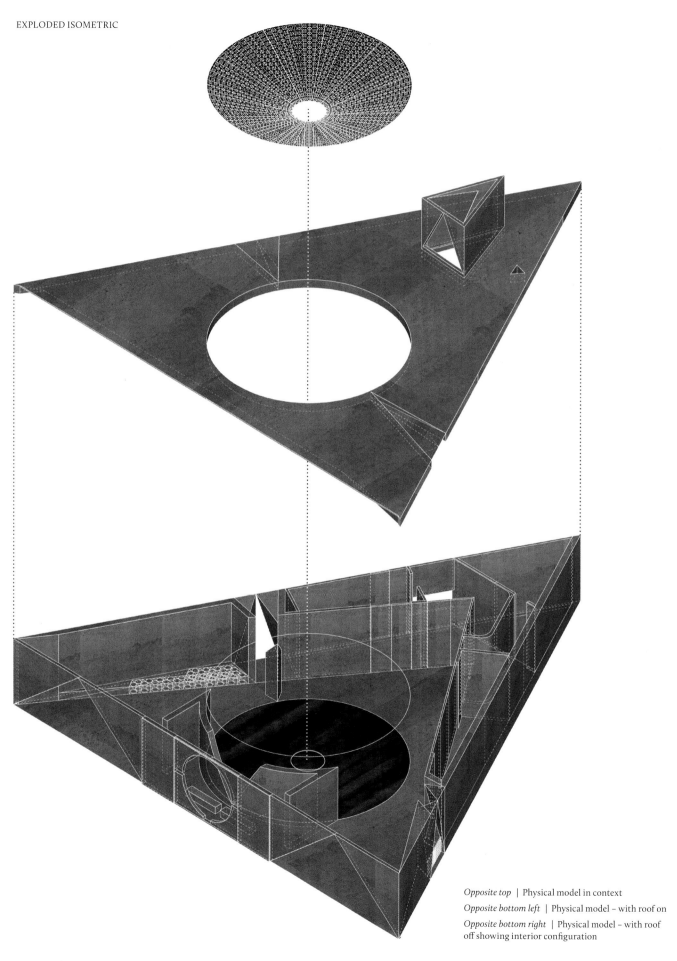

Opposite top | Physical model in context

Opposite bottom left | Physical model – with roof on

Opposite bottom right | Physical model – with roof off showing interior configuration

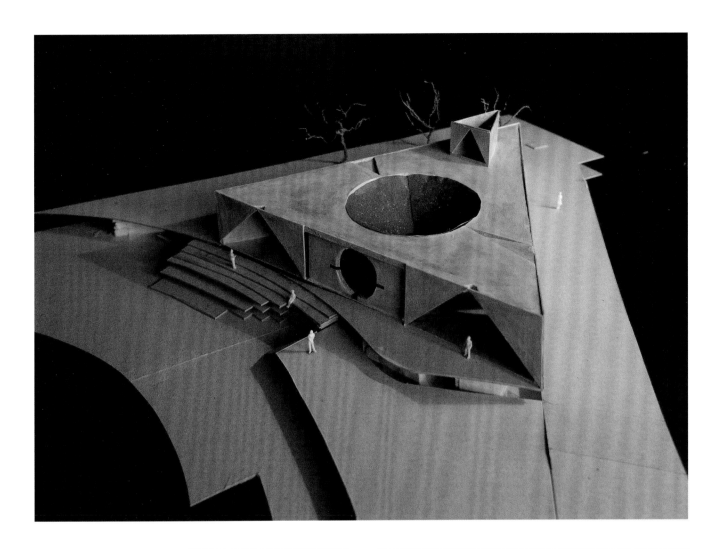

SELECTED AWARDS

2020 Australian Institute of Architects – Victorian Chapter Awards
GPFLA Learning Centre – Education (Commendation)

2020 Australian Institute of Architects – Victorian Chapter Awards
Arts Epicentre – Education (Shortlisted Finalist)

2020 Australian Institute of Architects – Victorian Chapter Awards
Arts Epicentre – Interiors (Shortlisted Finalist)

2020 Australian Interior Design Awards
Arts Epicentre (Honourable Mention)

2019 Dezeen Awards
Piazza Dell'Ufficio – Interior Project of the Year (Winner)

2019 Dezeen Awards
Piazza Dell'Ufficio – Small Workplace Interior of the Year (Winner)

2019 Australian Interior Design Awards
Piazza Dell'Ufficio – Workplace Design (Commendation)

2019 INDE Awards
Piazza Dell'Ufficio – The Work Place (Honourable Mention)

2019 Idea Awards
Piazza Dell'Ufficio – Workplace under 1,000 m² (Winner)

2019 Idea Awards
Piazza Dell'Ufficio – Sustainability (Highly Commended)

2018 Idea Awards
Quaine Library – Institutional (Shortlisted Finalist)

2018 INDE Awards
Branch Studio Architects – The Design Studio (Shortlisted Finalist)

2018 INDE Awards
Quaine Library – The Learning Space (Shortlisted Finalist)

2017 Australian Institute of Architects – Victorian Chapter Awards
Balnarring Retreat – Small Project Architecture (Winner)

2017 Houses Awards
Balnarring Retreat – New House under 200 m² (Winner)

2017 Houses Awards
Pavilion Between Trees – House Alteration & Addition under 200 m² (Winner)

2016 Australian Institute of Architects – Victorian Chapter Awards
Flyover Gallery – Small Project Architecture (Commendation)

2015 Australian Institute of Architects – Victorian Chapter Awards
Pamela Coyne Library – Award in Education (Winner)

2013 Think Brick Awards
"Bridging Brick Babylon" (Unbuilt) – Open Face Award (Winner)

DEDICATION

Branch Studio Architects would like to thank:
Our many amazing clients who have entrusted us
with their projects over the years.

With special thanks to:
Marco Di Cesare – Thank you for your trust,
vision and support over the last ten years.

Contributors:
Peter Clarke, Michael White, Stephen Varady,
Conrad Hamann and Manuel Aires Mateus.

A very special thanks to our brilliant and talented staff:
Jax Lam, Simon Dinh and Arun Lakshmanan.

Our parents, family and friends for their continued
support in both business and life.
/

Brad Wray would like to thank:
My wife Ellie for her support both in life and work.
My little loves – Vivienne, Franklin and Albert.
/

Nicholas Russo would like to thank:
My wife Lauren and our amazing children Alfie, Coco,
Remy and Goldie for their unconditional love and support.

Cover
Detail of circular concrete skylight
aperture – Casa Bobbanarring

Page 1
Detail study of chapel wall ARCO

Page 2
House with earthen walls

Page 4
Ceiling detail study
Placidus Student Welfare Spaces

Page 6
Detail study
House With Earthen Walls

Page 205
Multi-Purpose Hall

Page 206
Casa Bobbanarring

Page 208
Multi-Purpose Hall – detail of choir loft

All Photography by Peter Clarke

This book is published by Artifice Press Limited, a company registered
in England and Wales with company number 11182108. Artifice Press is
an imprint within the SJH Group. Copyright is owned by the SJH Group
Limited. All rights reserved.

Artifice Press
The Maple Building
39–51 Highgate Road
London NW5 1RT
United Kingdom

+44 (0)20 8371 4047
office@artificeonline.com
www.artificeonline.com

Creative direction and design by Anton Jacques
Edited by Caroline Ellerby

Printed in Latvia by Amber Book Print

ISBN 978-1-911339-48-9

British Library Cataloguing in Publication data:
A CIP record for this book is available from the British Library.

Artifice

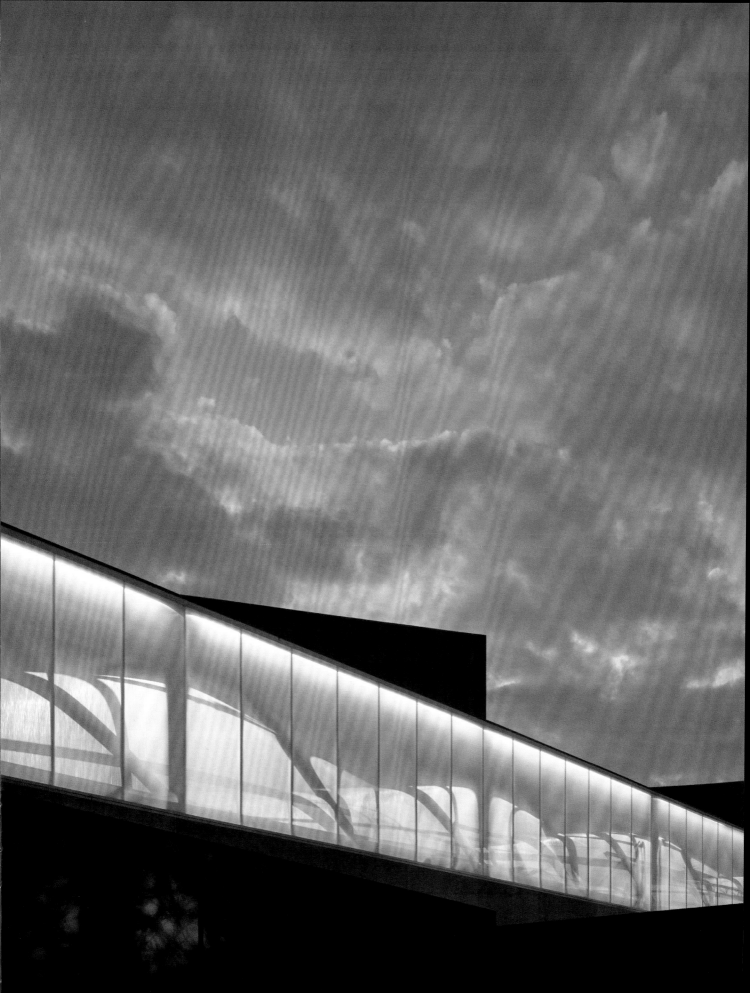

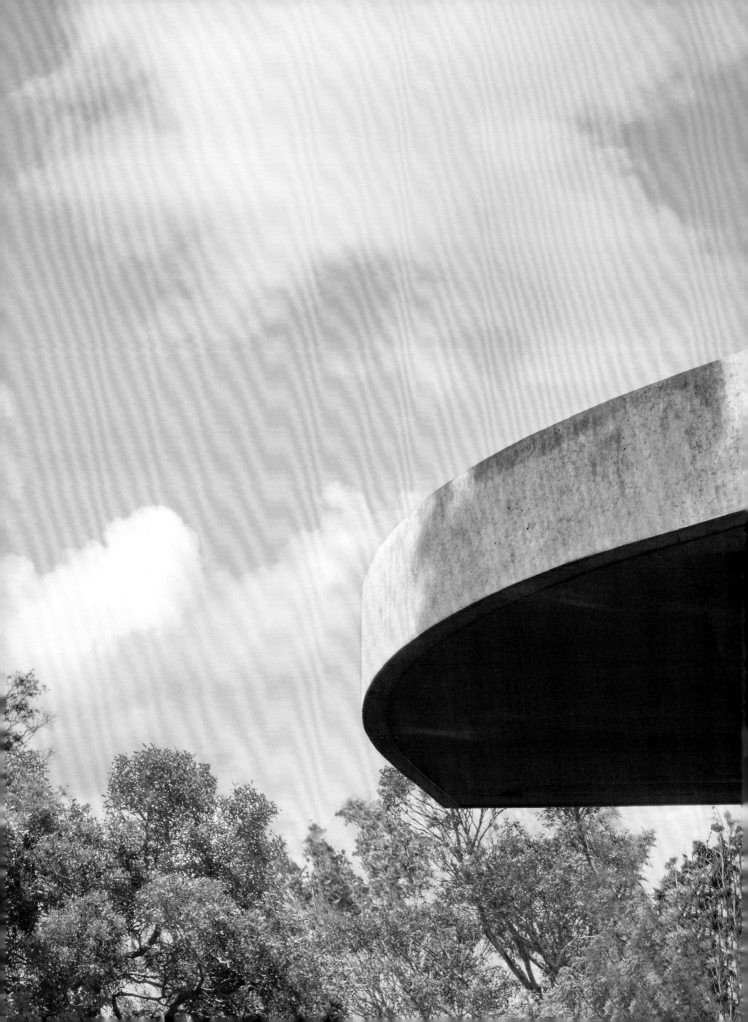

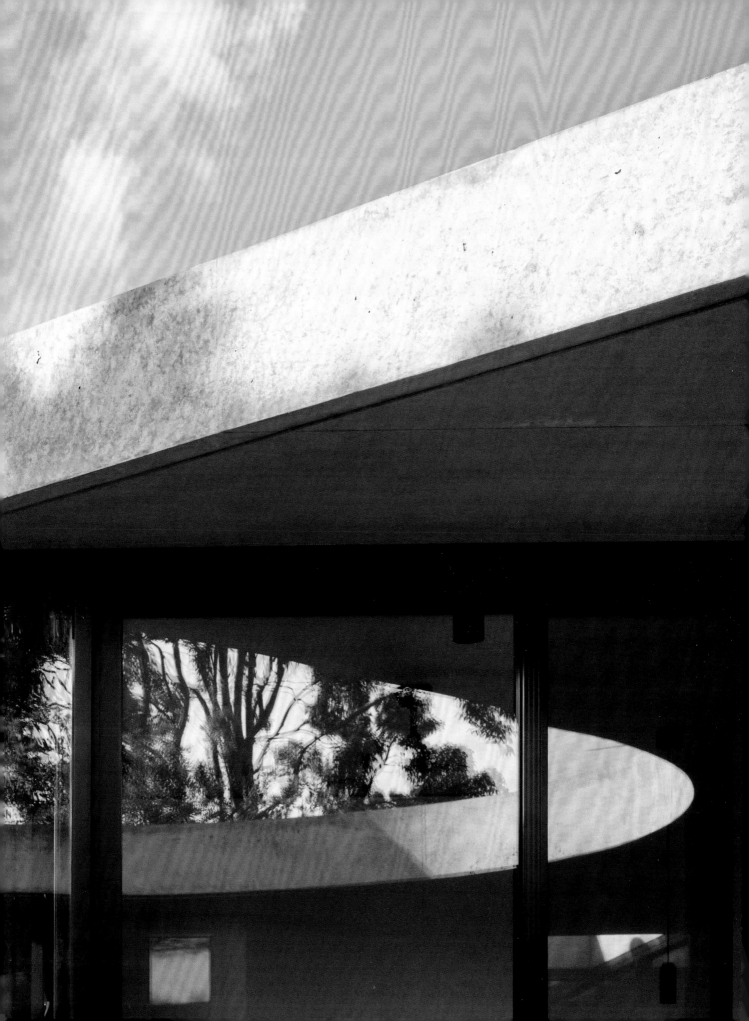

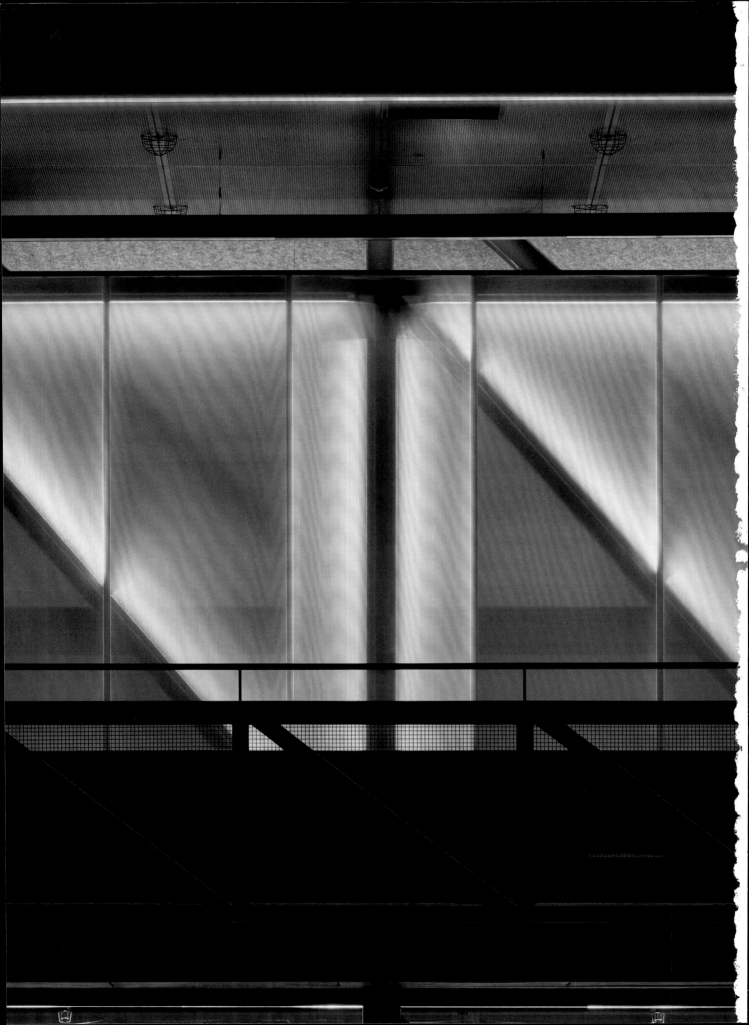